LOVE IMMORTAL

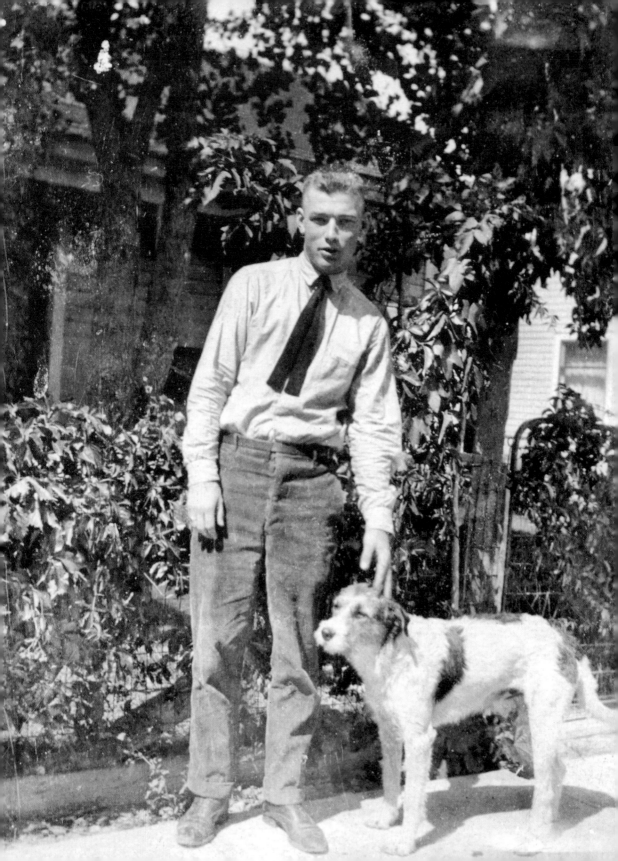

# LOVE
# IMMORTAL

## ANTIQUE PHOTOGRAPHS
*and* STORIES *of*
DOGS *and* THEIR PEOPLE

ANTHONY J. CAVO

HARPER
DESIGN

*An Imprint of HarperCollinsPublishers*

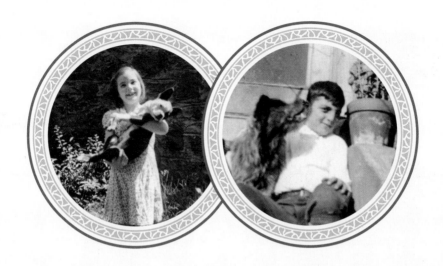

For my beloved parents,
who taught us to rescue, love, and
care for all creatures.

*Te voglio bene assai.*

*Above, left:* Patricia Blossfeld Cavo, age seven, with her dog Teddy, 1940.

. . . . . . . . . . . . . . . . . . . . . . . . . . . . . . . . . . . . . . . . . . . . . . . . . . . . . . . . . . . . . . . . . . . . . . . . . . . .

*Above, right:* Anthony C. Cavo, age ten, with his dog Brownie, 1940.

. . . . . . . . . . . . . . . . . . . . . . . . . . . . . . . . . . . . . . . . . . . . . . . . . . . . . . . . . . . . . . . . . . . . . . . . . . . .

*Page 2:* A snapshot of a young man and his terrier mixed breed, circa 1930s.

. . . . . . . . . . . . . . . . . . . . . . . . . . . . . . . . . . . . . . . . . . . . . . . . . . . . . . . . . . . . . . . . . . . . . . . . . . . .

*Page 6:* Young girl from Virginia with her mix breed terrier, circa 1890.

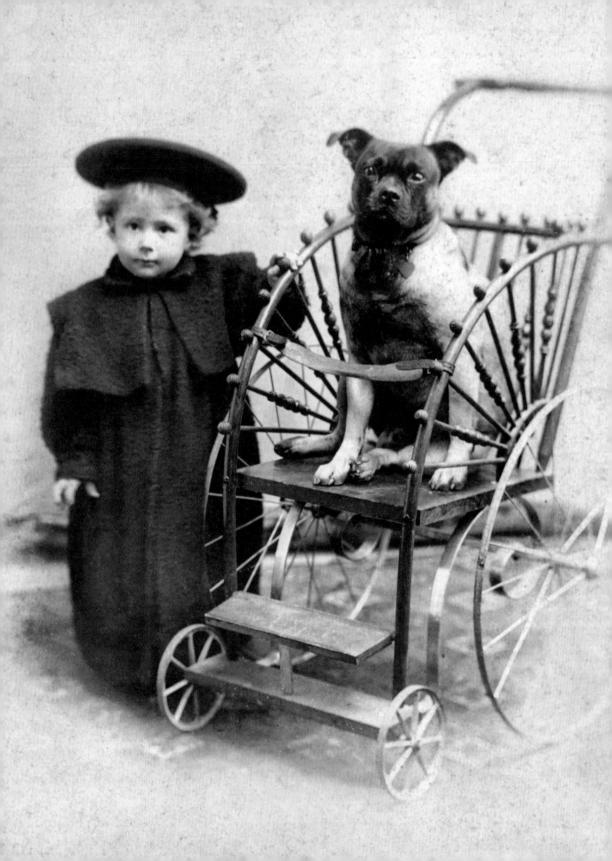

# CONTENTS

---

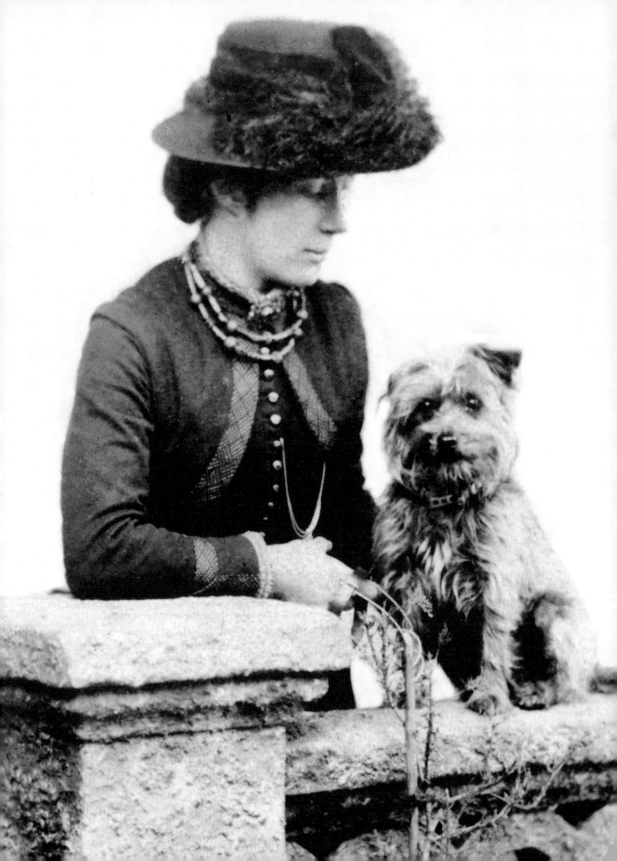

# INTRODUCTION

———————

SEVERAL YEARS AGO, WHILE CATALOGING the thousands of photographs in my collection of antique images, I found that I had hundreds of photographs of people with their dogs. While intrigued, I was not surprised that my love for dogs seemed to have become integrated with my passion for antique photographs, if even on a subconscious level. Animals, especially dogs, had always been part of my family. Around the time I was eleven years old we had a rescue border collie who became impregnated by a stray dog who jumped our fence. She was less than a year old at the time and eventually delivered a litter of ten pups. During their birth, my mother enlisted our help in the delivery. Many of the pups were born still in their amniotic sacs; my mother showed me and my siblings how to open the sacs, clean their nostrils, and blow in their faces. We suctioned their airways with a turkey baster and even performed artificial respiration on two who were not breathing.

........................................................................................

*Opposite:* This young Englishwoman gazes lovingly at her cairn terrier, who appears to have eyes only for the photographer. Circa 1880s.

———

It is difficult to recall a time in my life when I was not involved with dogs or antiques, and especially antique photographs. My mother, a nurse by profession, became enamored with antiques in the early 1960s during our vacations in Pennsylvania. My father had a printing company in Manhattan and only a passing interest in antiques, but he enjoyed traveling with my mom to little towns in upstate New York, Connecticut, and especially to rural Pennsylvania on her quests for the rare and unusual.

I often accompanied my parents on their drives to Pennsylvania, to visit Ann, or "Ann the Duck Lady," as I knew her, who operated a duck farm and an antique business out of a group of barns on her property. I was fascinated by the way hundreds of ducks appeared to move as one unit, a white wave breaking over the landscape, and even more fascinated by the treasures heaped chaotically within the barns. One day in 1963, among the piles of horsehair-stuffed Victorian chairs, marble-topped furniture, pier mirrors, and primitive furniture, I found a wooden box, its exterior stenciled in black: "From G. Cramer Dry Plate Co., St. Louis, MO."

I moved the box to a hazy patch of sunlight that entered the barn through a dirty, cracked window alive with fluttering cobwebs and opened it to find hundreds of people dressed like the people in my school history books. Some of the men looked like Abraham Lincoln, and all the women wore big gowns. By the time I finished digging through the box and examining every image, I was hooked, a photoholic; I had to have them. I wanted them all, but, as a kid, I had only enough money to buy a few. I carefully selected and paid for my photos, then went out to the barnyard to examine them in full sunlight.

My excitement at discovering these images and my keen interest in them did not escape my parents' attention. They soon joined me as I extracted

each photo and conveyed to them what I had learned about them from Ann—that we were looking into the faces of people who lived more than one hundred years before. That evening, when we arrived home, my parents surprised me with the wooden box and its mysterious contents. I spread the photos out on our dining room table and began to examine each one with a magnifying glass, calling out to my parents and siblings each time I found something interesting. Finally, my older sister, who was the self-appointed spokesperson for us six children, seemed to sum up my siblings' disinterest by asking, "Why are you collecting dead people, why can't you collect baseball cards like a normal kid?" And so began a lifetime of collecting photographs. I still have that box and all the photographs it held.

While other kids spent their weekends attending sporting events, going to the movies, visiting the beach, or simply hanging out, I sold antiques with my parents at the 26th Street Flea Market in Manhattan. My main objective at these flea markets was to make money and buy more photographs. While searching the vendors' booths for photographs, other types of antiques began to interest me. I bought a belt from a Civil War uniform, then Civil War–era newspapers. I also discovered a seventeenth-century book in a calfskin cover, a small bronze statue of a boy carrying a basket on his back, and an inkwell in the form of a boy with a fishing rod. My interest in antiques gradually expanded to include anything intriguing that was in my price range. Shortly after graduating from high school, I attended the Reisch College of Auctioneering in Mason City, Iowa. Upon my graduation from Reisch, I secured a job in a Manhattan gallery as a buyer, consignor, and auctioneer.

My mother, who was also an auctioneer, had an antique shop in Ridgewood, New Jersey, during the 1970s and another along Connecticut's

Antique Trail in Woodbury during the 1990s, which she kept well stocked with antiques from her two-story warehouse. On our never-ending hunt for antiques I have been in hundreds of attics, basements, barns, crawl spaces, defunct factories, and lopsided buildings, as well as several funeral parlors and even a caretaker's cottage on cemetery grounds, all the while expanding my photo collection. It was on these jaunts that we acquired our pug, Winston, and schnauzer, Schatzi. Winston was destined to be put down because his owner was moving and he had outlived his usefulness as a stud. We took Winston home, along with an eighteenth-century Chippendale chest of drawers. He is long gone, but I still have that chest of drawers—a constant reminder of him.

While buying antiques at another estate where the owner had died, we heard whimpering from the direction of the basement. The executor of the estate explained that in addition to the house and furniture, the owner left behind a dog who no one wanted. My mother promptly went into the dark cellar and returned with a frightened, undernourished schnauzer named Schatzi, whom we took home with us. In fact, in our search for antiques, we acquired many abandoned animals, including Caesar, one of our parrots. No Pet Left Behind.

At one point we had several rescue dogs: a poodle, a pug, and a schnauzer with her five pups. We also had a miniature Alpine goat, two barn cats, two rescued Amazon parrots, a pair of mourning doves, a Nanday Conure with one leg, and a rescued blue goose who had been injured in the wild and was no longer able to fly.

Dogs had been important in our home, but I never realized or even considered they might have been as important in the homes and lives of people who lived during the nineteenth century. I always assumed that

during that time dogs were treated like, well, dogs. I imagined that they lived in doghouses and were treated much like any other animal. I never supposed, in the harsh conditions of that time, that a dog could have been as loved and treated as a true companion; the concept and pictorial evidence were intriguing. I wasn't far off, actually: Throughout most of history, the relationship between dogs and humans was primarily based on the dog's usefulness to its owner. The notion of breed was not so important to the average person as the type of dog. Dogs were classified as hunters, ratters, herders, guardians, and even saviors. Many of these dogs had distinct, identifiable characteristics and were easily recognizable as a "ratter" or "herder," but if a dog was good at their job, their looks were not especially important—then came the Victorians.

The Victorians applied knowledge about breeding livestock to breeding dogs. Dogs had been bred to perform certain tasks like hunting, herding, and pointing. For the first time, they were also bred for beauty and companionship. This breeding gave rise to the many varieties of dog breeds existing today.

As I cataloged my collection, I began showing the dog and people images to my family and friends who were initially fascinated, but after a while began to hide, feign illness, or take sudden vacations. I was left with no other choice but to share these images with the rest of the world in book form.

In the pages of *Love Immortal* are images of dogs and their humans from twenty-four countries and ranging from the 1840s to the 1940s. These captivating and engaging photographs depict the affinity and bond that have existed between dogs and humans for thousands of years but had never been accurately preserved until the advent of photography. A March 2018

article in the *Journal of Anthropological Archaeology* reported that recent archaeological discoveries in northwestern Saudi Arabia uncovered depictions of domesticated dogs and their human partners from about 7000 to 8000 BCE in what may be the first visual documentation of the human–dog bond, but true-to-life images portraying that connection weren't available until the daguerreotype was made available to the public at large in 1839.

Named after French panorama painter and inventor Louis-Jacques-Mandé Daguerre, the daguerreotype is a photographic technique developed as a result of collaborative work in the early 1830s between Daguerre and Joseph-Nicéphore Niépce, a scientifically minded man who experimented with image-making at his home in Chalon-sur-Saône. Niépce is credited with producing the first permanent photographic image, or at least what is thought to be the world's oldest surviving one—a heliograph (sun drawing) of the view from a window at his family home in 1826.

After Niépce's sudden death in 1833, Daguerre kept on with his research, which led to the invention of the daguerreotype process, which in turn reduced exposure time enormously. By 1840, having a photographic portrait made became more affordable and thus available to more people. Capturing an image of a human alone was both a process and a commitment during photography's first twenty years, so it is a testimony to the human–dog bond that owners included their pets in the process of having their "picture made," as it was called at the time.

Though unfathomable to most people today—who are accustomed to the cell phone camera technology that makes creating a great-looking image child's play—in the mid-nineteenth century, having a photograph taken was an event, even a significant undertaking. People often had to

visit a large city to locate a photographer, which could mean hours of travel. Once in the studio, the camera had to be set up, the client posed, and the photographic plate prepared, developed, and finished. The availability of ambient light was often the limiting factor as to whether a photo shoot proceeded or was even successful.

The amount of available sunlight, time, and preparation required for a photograph were not the only factors to consider, either. During the first twenty years of photography, most people were not able to afford the cost of a portrait of themselves, let alone one of a dog.

In those days, exposure times were critical to obtaining clear, true-to-life images. Exposure time depended on the time of day and the amount of sunlight. There were no artificial sources of light other than candles and oil lamps. Obtaining a clear image during the optimal hours of 11:00 a.m. to 1:00 p.m., even in bright sunlight, was a challenge that required the subject to remain still for anywhere between thirty and ninety seconds. Imagine expecting the average dog not to move for a minute and a half! Any movement during this exposure time resulted in a blurred image—in fact, you may notice a few in this book. Consequently, the ability to obtain a clear image of a typical dog was a remarkable achievement and why many photographers waited for the dog to lie down. The proper alignment of all these mitigating circumstances and requirements is what makes images of people with their dogs in photography's early days a unique and cherished rarity.

The daguerreotype process was the dominant form of photography in the 1840s. The ambrotype, an image produced on glass, was introduced in 1851. The ferrotype (tintype) was introduced in 1852. Daguerreotypes, ambrotypes, and ferrotypes—three of the earliest types of

photographs—are all produced by direct positive photography and result in laterally reversed images. A direct positive photograph means that the image is produced directly on the photographic plate itself by exposing the plate to light. For daguerreotypes, the photographic plate is silver-coated copper; for ambrotypes, the plate is glass; and for ferrotypes, the plate is lacquered iron. The process of producing photographs by all three methods meant that plates had to be prepared while the client waited.

The daguerreotype and ambrotype prevailed until the late 1850s, when they were supplanted by the ferrotype (tintype) and albumen (paper) print. By the late 1850s, technological advancement decreased exposure time to mere seconds, reducing both the cost of making an image and the risk of creating a blurred one. The average person could easily afford the cost of a photograph, and for the first time, photographs were reproducible.

These photographs of people and their dogs are more than simple visual documents of our association with pets. In many of these images, both professional and amateur photographers have managed to catch a moment in time that displays the sense of intimacy that existed between a person and their dog. Other photos clearly depict the interaction between the photographer and the dog who, with wide eyes and tilted head, stares directly into the lens. The people and dogs in these images are not strangers to us—they are any of us who has ever loved a dog. In looking at these images we will recognize that special bond and feel a kinship with these long-gone partners.

Most of the photographs in this book have been in my collection for many years; others are recent additions. In many cases the dates accompanying the images were recorded on the backs of the photos; in others, a

date was determined using a variety of criteria including the photographic mediums, card stock, shape and design, the clothing and hairstyles of the subjects, and the dates the photographers were known to work.

Because the appearance of dogs has changed over the past 150 years, identifying dogs photographed during the mid-nineteenth century using today's breeds as a reference can be complicated. With the help of Dr. Barry Buchalter, DVM, who has been in practice for more than thirty years, I have attempted to identify the dog's breed in these photographs whenever possible. In the end, however, whether purebred or mixed breed, well-groomed or mangy, our dogs have the same needs and deserve our love and attention.

While some of these people and their dogs are identified by names such as: "John and Tauser," "Aunt Bessie and Chow," "Alma and Psyche," "Mary and Peter the spaniel," and "Ernest and Sancho," I feel as though I know them all and I am thrilled to introduce them to you.

# DOGS
# AND THEIR
# PEOPLE

## 1840-1940

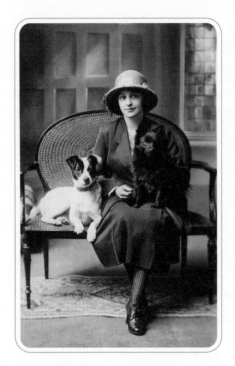 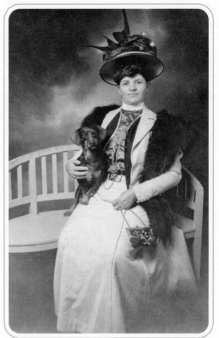

*Above, left:* It's called a love seat for a reason. A young woman with her schipperke and a mixed breed terrier, England, circa 1918.

. . . . . . . . . . . . . . . . . . . . . . . . . . . . . . . . . . . . . . . . . . . . . . . . . . . . . . . . . . . . . . . . . . . . . . . . . . . . . . . . . . . . . . .

*Above, right:* A curious dachshund looks directly into the camera lens while resting comfortably against its owner, Germany, circa 1908.

. . . . . . . . . . . . . . . . . . . . . . . . . . . . . . . . . . . . . . . . . . . . . . . . . . . . . . . . . . . . . . . . . . . . . . . . . . . . . . . . . . . . . . .

*Opposite:* This young boy from Québec posed with his cocker spaniel and cairn terrier sometime during the early 1870s.

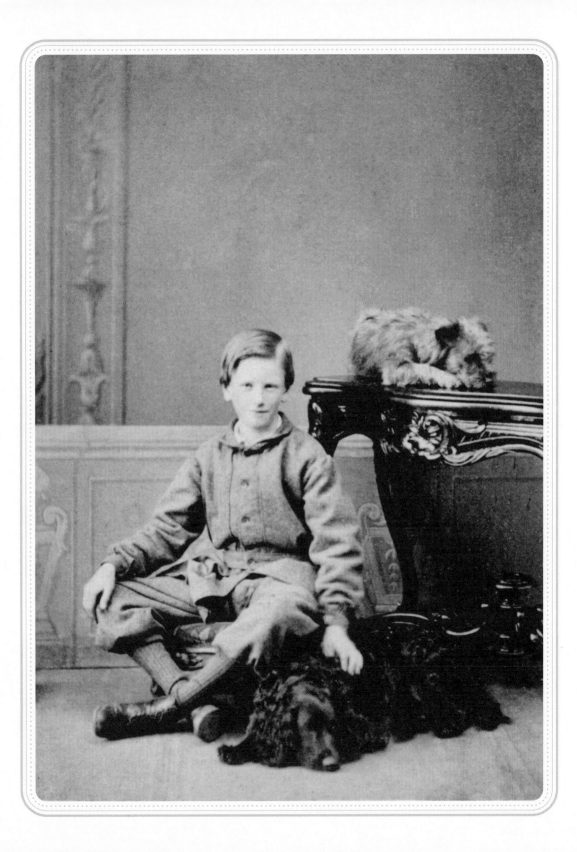

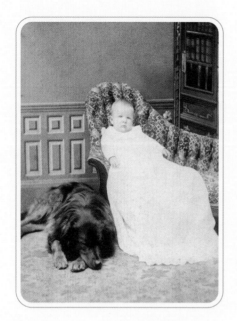 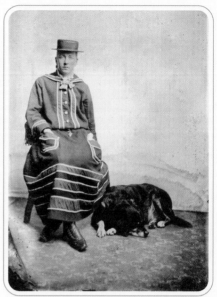

# Let Sleeping Dogs Lie

**T**HE WIDELY USED expression "let sleeping dogs lie" proved to be good literal—rather than figurative—advice during the early days of photography. Exposure time ranged from thirty to ninety seconds, making photographing children and pets difficult. Neither are renowned for an ability to sit still, and movement during exposure times resulted in blurred images. Consequently, many photographers encouraged dogs to settle down, as shown in these three images.

The images of these sleeping dogs span three decades and traverse three countries. The portrait of the woman in proper Victorian attire standing before a panoramic background *(opposite)* was taken at a photo studio in Québec in the 1860s; the image of a woman from Wales in traditional garb *(above, right)* was taken in the 1870s; and the portrait of the baby with his large canine pal *(above, left)* was taken in New Hampshire during the 1880s.

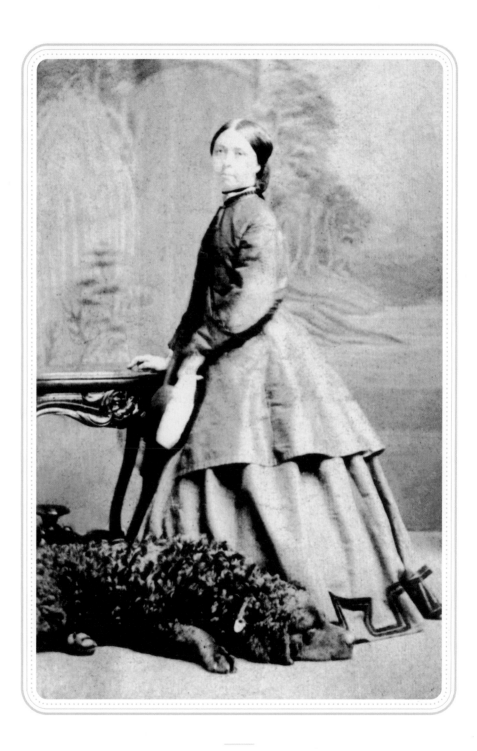

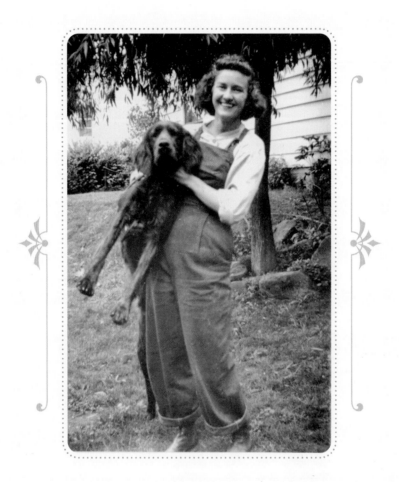

Whether they roam the fields of Florida or the yards of Philadelphia, dogs often reflect the personalities of their people. The smiling young woman in overalls *(above)* hoisted her agreeable hound for a candid snapshot while this more composed Philadelphia woman *(opposite)*, her waist clearly corseted into a highly diminutive form, poses her pup accordingly—just so on pillows in her garden.

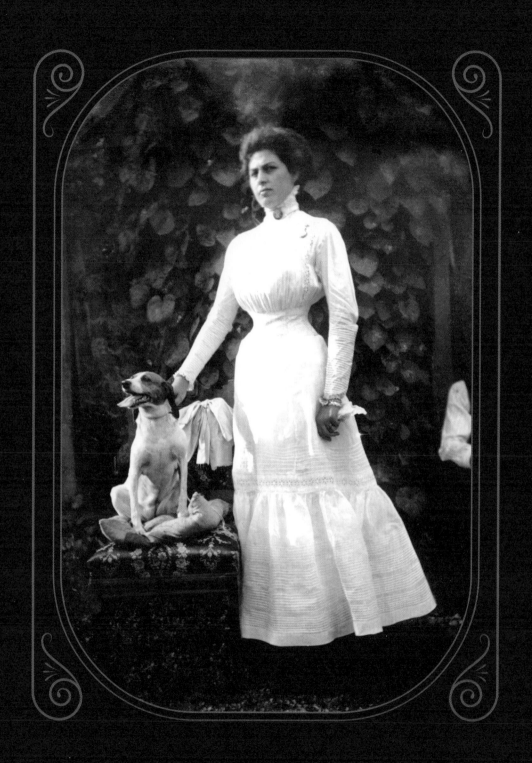

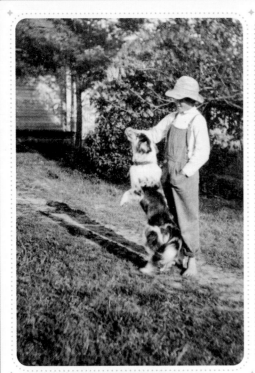
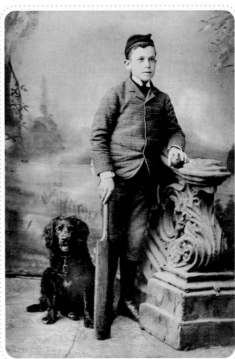
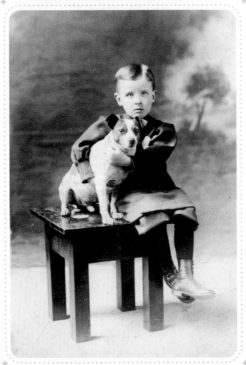
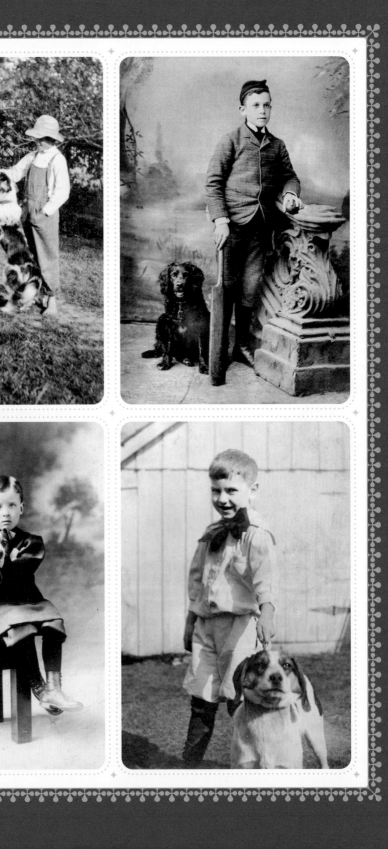

# Country Dog, City Dog

*Opposite, top left:* This Michigan farm boy's dog displayed his talents for an amateur photographer's snapshot on September 8, 1920. Farmlands and wide-open spaces make the countryside a paradise for many adventurous escapades. But the countryside also has some perils: Wild animals, farm equipment, poisons, the ability to roam free, and crossroads all pose serious risks to a dog's health and life, which is why country dogs do not live as long as city dogs.

. . . . . . . . . . . . . . . . . . . . . . . . . . . . . . . . . . . . . . . . . . . . . . . . . . . . . . . . . . . . . . . . . . . . . . . . . . . . . . . . . . . . . . . . . . . . . . . . . . . . . . . .

*Opposite, top right:* A boy named Ernest posed for this studio portrait in Orillia, Ontario, Canada, during the late 1880s. Ernest appears to have chosen two very personal elements to make a statement: his beloved cocker spaniel, Sancho, and his cricket bat and ball.

. . . . . . . . . . . . . . . . . . . . . . . . . . . . . . . . . . . . . . . . . . . . . . . . . . . . . . . . . . . . . . . . . . . . . . . . . . . . . . . . . . . . . . . . . . . . . . . . . . . . . . . .

*Opposite, bottom left:* This city dog, photographed with his human friend in 1910s Philadelphia, seemed right at home with cobblestone roads, stoops, streetcars, and hordes of people. With a choice of trees, electric poles, and the many fire hydrants installed in the city between Girard Avenue and South Street, there were plenty of places to mark—and a smorgasbord of smells.

. . . . . . . . . . . . . . . . . . . . . . . . . . . . . . . . . . . . . . . . . . . . . . . . . . . . . . . . . . . . . . . . . . . . . . . . . . . . . . . . . . . . . . . . . . . . . . . . . . . . . . . .

*Opposite, bottom right:* David proudly posed with his dog on this Ohio farm circa 1914. The farm boy's large bow tie suggests the picture was taken for a special occasion, perhaps his birthday or the first day of school. Whatever the commemorative moment might have been, he chose to share it with his best friend.

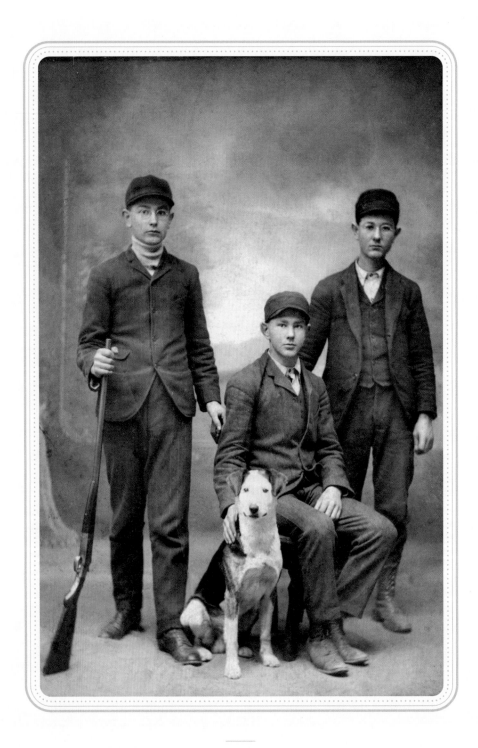

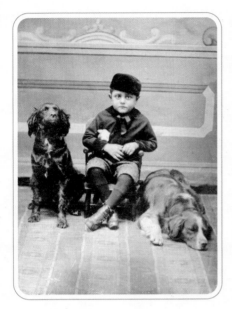 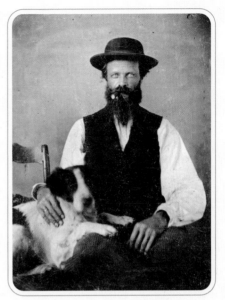

*Opposite:* During the early nineteenth century, hunting was a common pastime for boys in rural areas. The number of hunting licenses issued to Americans doubled between 1910 and 1920. Eight of the top ten most popular dog breeds listed by the American Kennel Club in 1900 were bred for hunting: the Boston terrier, English setter, pointer, cocker spaniel, bulldog, Airedale terrier, beagle, and Irish terrier.

*Above, left:* This young boy and his dogs posed for this photograph in the late 1850s. While their identities have been lost to time, their youth and companionship are fully present.

*Above, right:* Considering this image was most likely taken by an itinerant photographer, this pipe-smoking fellow and his beloved pup bring to mind a prospector and his pal. The bond is evident: The man had his arm around his dog, while the dog had both front paws firmly ensconced in his person's lap.

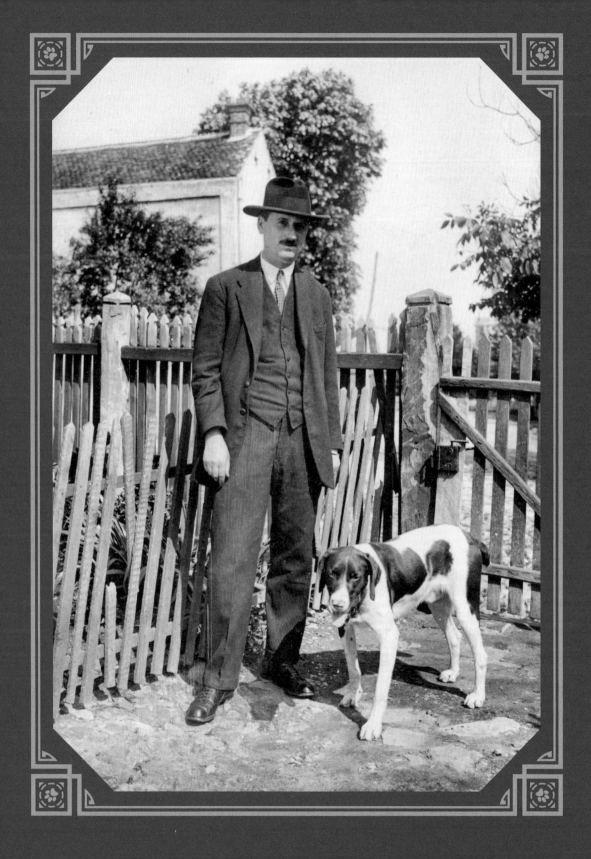

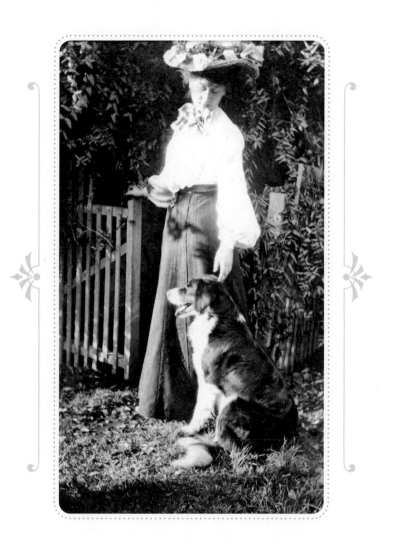

*Opposite:* The sharp contrast of the dog's dark and light coat is enhanced by the light and shadow in this image taken in France, circa 1930.

. . . . . . . . . . . . . . . . . . . . . . . . . . . . . . . . . . . . . . . . . . . . . . . . . . . . . . . . . . . .

*Above:* A Gibson Girl from Nevada City, California, invites her canine friend to pass through the garden gate.

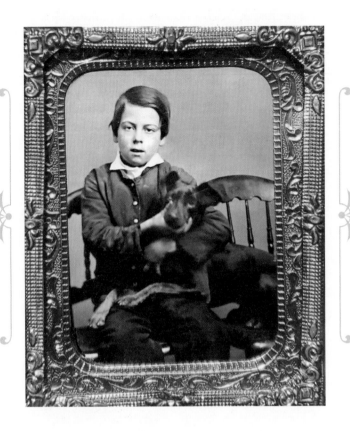

*Above:* This ambrotype of a young boy and his dog was taken during the mid-1850s, as was the ferrotype of the three women and their dog. Though they are more than 160 years old, these images are incredibly vibrant because ambrotypes and daguerreotypes were housed in cases with covers that protected them from the fading effects of light.

· · · · · · · · · · · · · · · · · · · · · · · · · · · · · · · · · · · · · · · · · · · · · · · · · · · · · · · · · · · · · · · · · · · · · · · · · · · · · · · · · · · · · · · ·

*Opposite:* The three women in the ferrotype wear the voluminous skirts that defined style for almost twenty years during the mid- to late Victorian era. Their clothing is made of gingham, a commonly used fabric at the time, and many photographs from this period show women all dressed in the same material. Family members would buy a bolt of material and make clothing for everyone at home. This image is most likely a mother with her two daughters and their family dog.

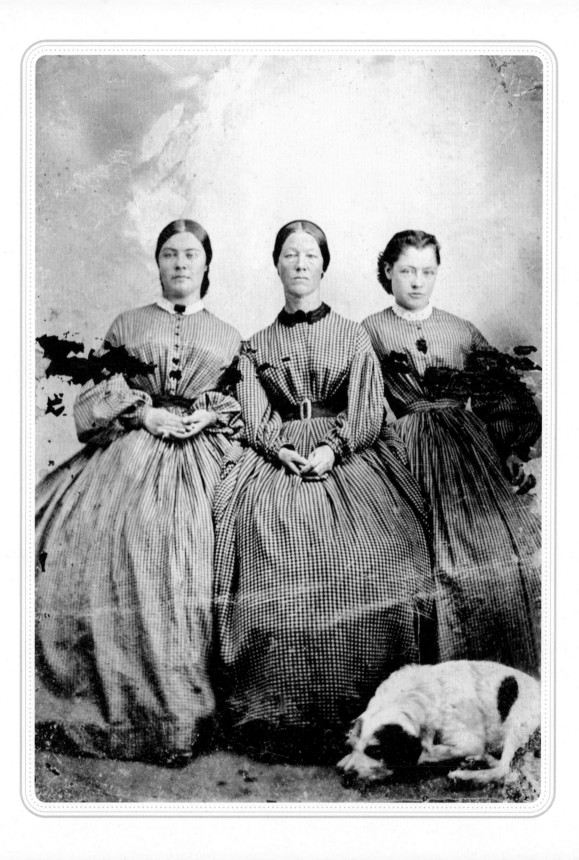

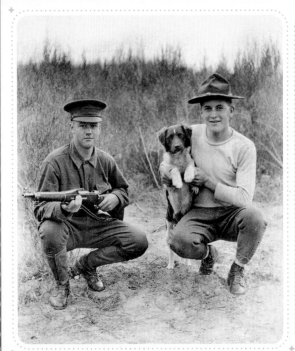

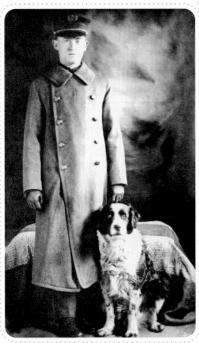

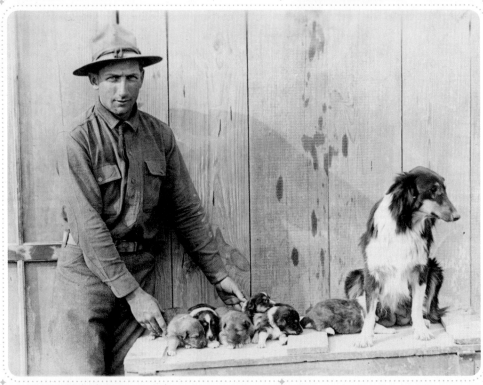

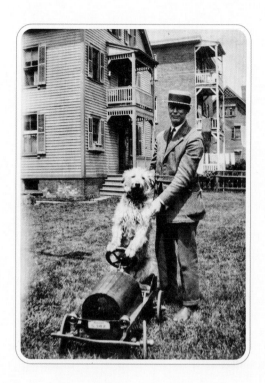

*Opposite, top left:* During World War I, dogs performed a variety of jobs. Those trained for guard duty were taught to stand at attention or growl rather than bark when sensing any unusual occurrence, such as the approach of strangers or even the presence of chemical weapons.

. . . . . . . . . . . . . . . . . . . . . . . . . . . . . . . . . . . . . . . . . . . . . . . . . . . . . . . . . . . . . . . . . . . . . . . . . . . .

*Opposite, top right:* Frank and his dog, Canada, circa 1910s.

. . . . . . . . . . . . . . . . . . . . . . . . . . . . . . . . . . . . . . . . . . . . . . . . . . . . . . . . . . . . . . . . . . . . . . . . . . . .

*Opposite, bottom:* This image of a proud military man with his dog and her six pups was taken at Camp Del Rio in Del Rio, Texas, January 1917. Here, one pup took advantage of the distracted soldier to sneak a snack. The average number of puppies in a litter is four to six.

. . . . . . . . . . . . . . . . . . . . . . . . . . . . . . . . . . . . . . . . . . . . . . . . . . . . . . . . . . . . . . . . . . . . . . . . . . . .

*Above:* Imagine having your own chauf-fur! This gentleman looks like Maurice Chevalier, and although he might not have been a star, this extraordinarily large photo (10 by 15 inches) tells us his dog was his star. Such a large photograph would have been quite costly during the 1910s.

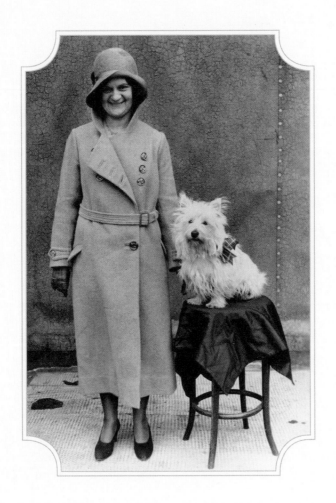

*Above:* "Susan" Australia, 1920s, is not only wearing a classic cloche hat and dropped-waist coat from the era; she beribboned her West Highland white terrier with a tartan plaid bow.

. . . . . . . . . . . . . . . . . . . . . . . . . . . . . . . . . . . . . . . . . . . . . . . . . . . . . . . . . . . . . . . . . . . . . . . . . . . . . . . . . . . . . . . . . . . .

*Opposite:* During the early twentieth century, photo studios offered a variety of props and elaborate trompe l'oeil backdrops depicting sunlit windows, well-stocked libraries, winding staircases, and rich natural scenes, as shown in this 1905 Pennsylvania studio.

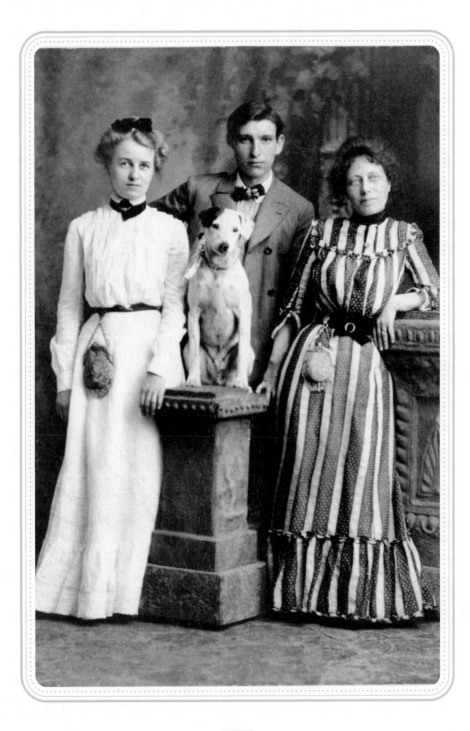

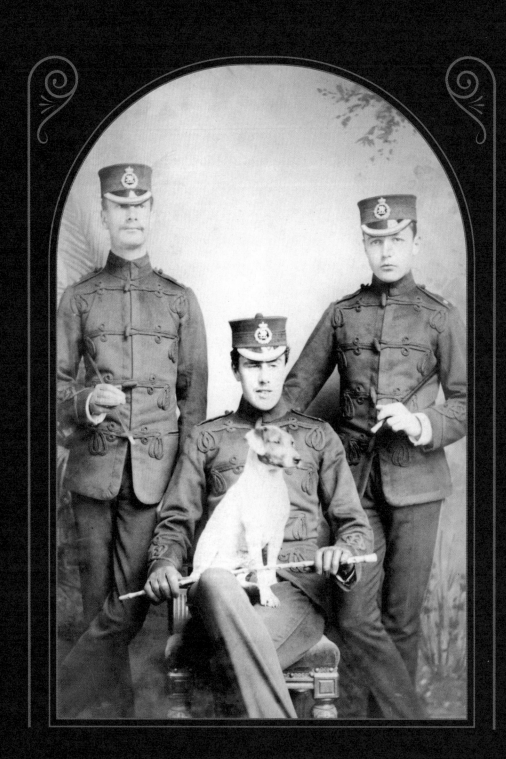

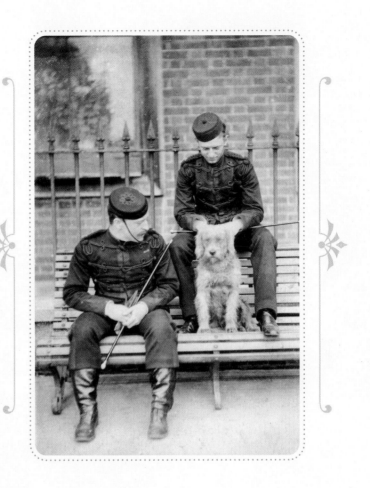

*Opposite:* Three members of the South Wales Borderers and their mascot. Their forage caps indicate the photograph was taken between 1881 and 1902, however, the thicker card stock is typical of that used during the 1880s. This regiment fought in many wars, including the American Revolution, the Anglo-Zulu War, and World Wars I and II. They are now part of the Royal Regiment of Wales.

........................................................................

*Above:* Two Scottish Militia Artillery officers and their mascot, 1890s. Militia Artillery units of the United Kingdom were composed of peacetime volunteers who trained to assume the duties of the regular Royal Artillery in times of war.

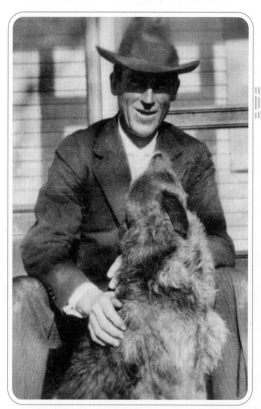

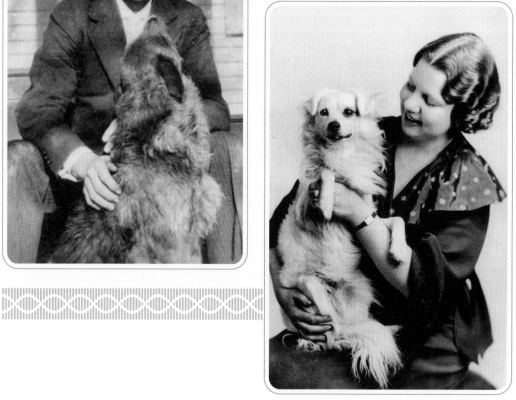

*Above, left:* We can readily excuse this dog from Colorado for not giving full attention to the photographer when the one they love the most is behind them.

. . . . . . . . . . . . . . . . . . . . . . . . . . . . . . . . . . . . . . . . . . . . . . . . . . . . . . . . . . . . . . . . . . . . . . . . . . . . . .

*Above, right:* While the photographer may have caught this pup's attention, he didn't have the same effect on the owner. He was, however, able to capture the joy she felt for her dog.

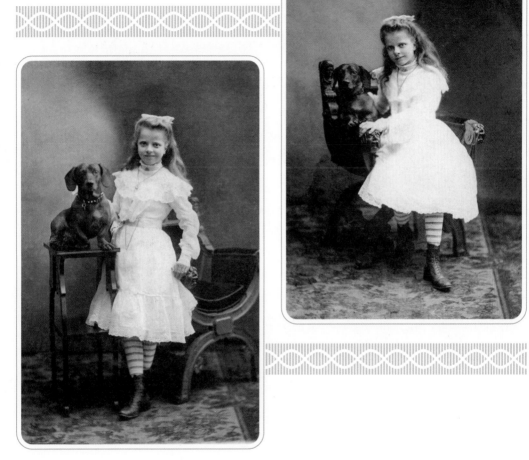
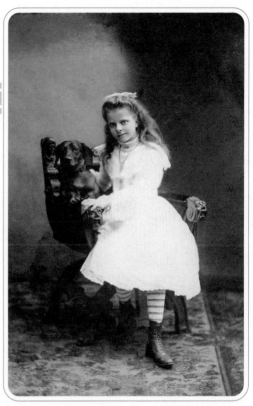

*Above:* These two photographs, taken in Germany and dated October 17, 1905, show the same girl and dog in different poses, which is unusual. There is no question that she is dressed for a special occasion. Perhaps the photographer had one vision and she had another—we'll never know. From the perspective of a longtime photograph collector, it's remarkable that these photographs have remained together for more than a century.

.........................................................................................................

*Pages 42–43:* Winter fun in Massachusetts and Germany, circa 1910.

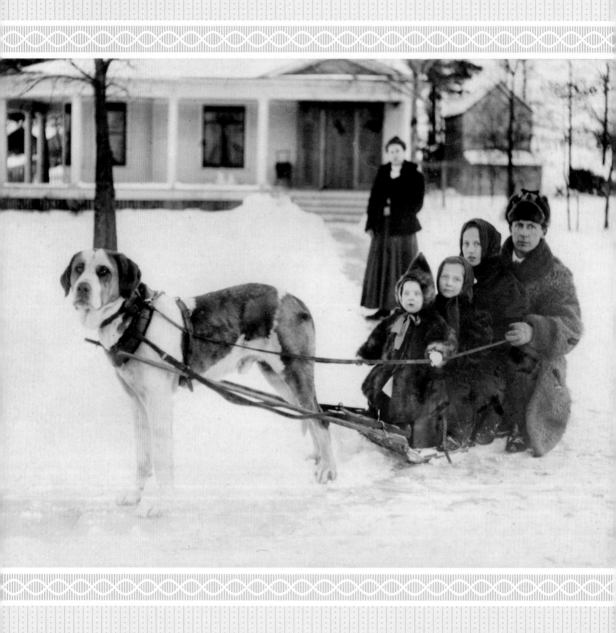

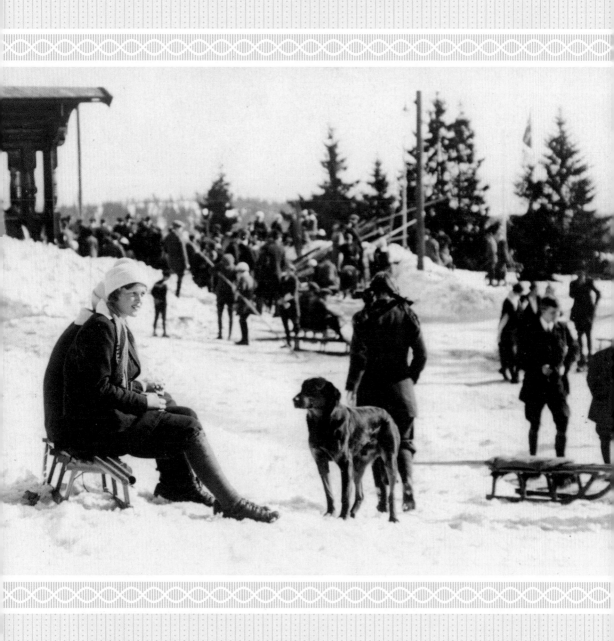

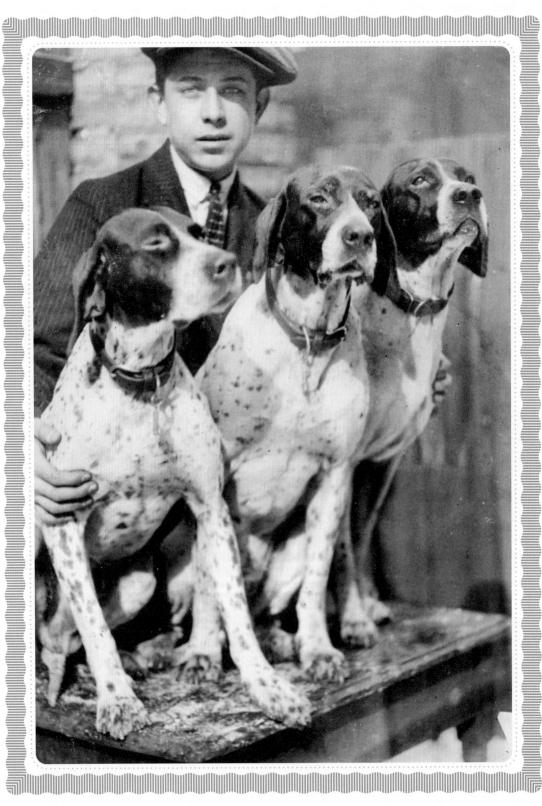

# The Nose Knows

**T**HE POINTER, SHOWN here, is one dog who tells us the duty for which this breed was bred: pointing to game birds. Specifically, they indicate the presence and direction of game birds they detect through their keen sense of smell.

A dog's nose is a wondrous feature that is capable of amazing feats. The nature of the nose is stereoscopic—its two nostrils act independently of each other, not only allowing dogs to smell two scents at once, but also allowing them to determine the direction from which a smell emanates or derives. Their ability to detect scents is not interrupted when they exhale, either, because they do so through slits at the sides of their nose.

Dogs' sense of smell is up to one hundred thousand times stronger than humans, because they have nine hundred genes coded for smell and up to three hundred million olfactory receptors, whereas humans have about four hundred genes coded for smell and six million olfactory receptors. Hound dogs have the strongest sense of smell among dog breeds. A bloodhound who has been specifically trained for tracking is the only animal who can provide evidence admissible in a court of law. Their ability to determine the age of a scent enables them to decide in what direction the scent leads.

*Opposite:* Snapshot, circa-1910s, of a young man with his three German shorthaired pointers.

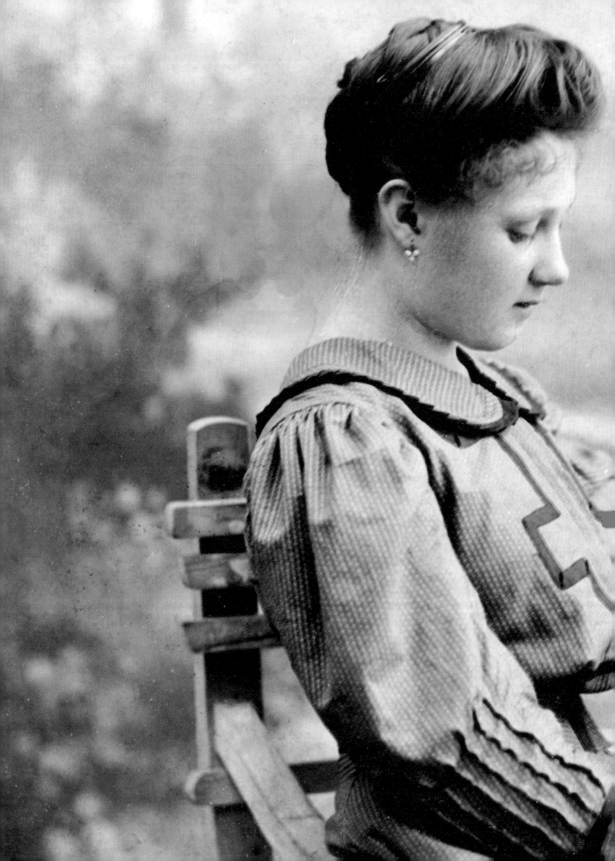

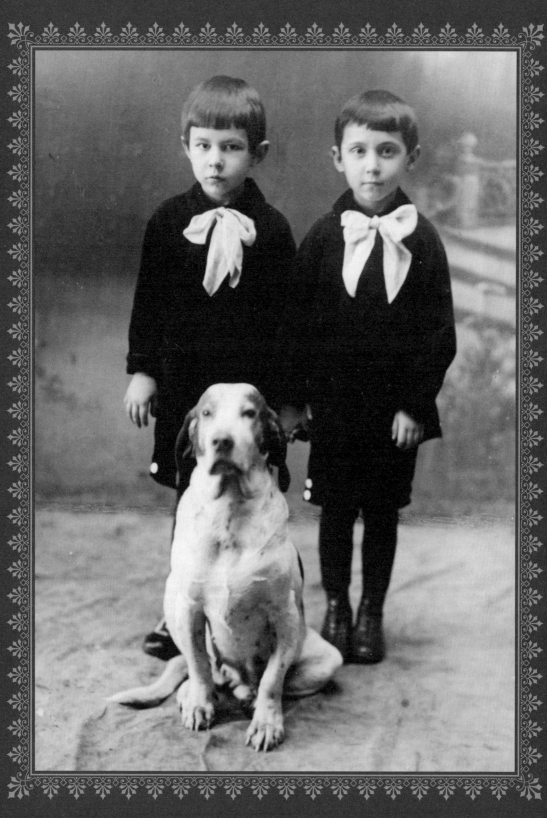

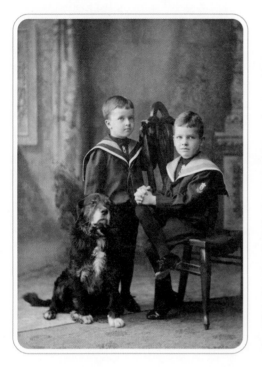

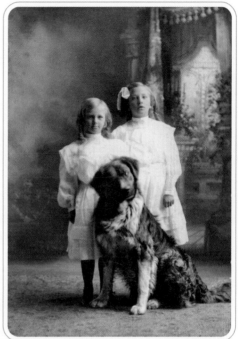

*Pages 46–47:* "Lyza," in Romania, 1907.

........................................................

*Opposite:* Brothers with big bows and a big bow-wow, 1910s, Italy.

........................................................

*Above, left:* Brothers in matching sailor suits posed with their Newfoundland in Connecticut, circa late 1890s.

........................................................

*Above, right:* This studio portrait with its bucolic background captures sisters "Effie and Stella Reich" and their dog. Formal yet serene, the girls seem to welcome the presence of their large protector. This photograph was taken in Minnesota circa 1900.

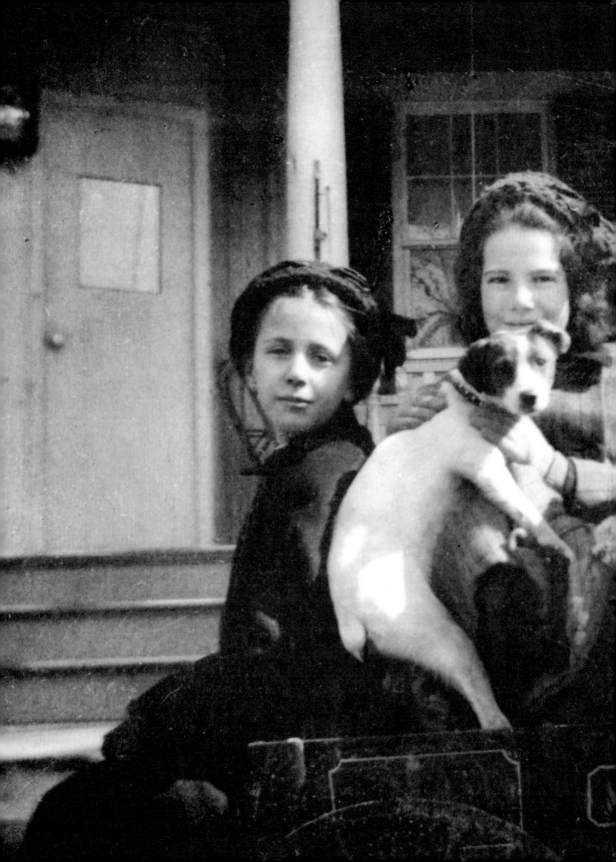

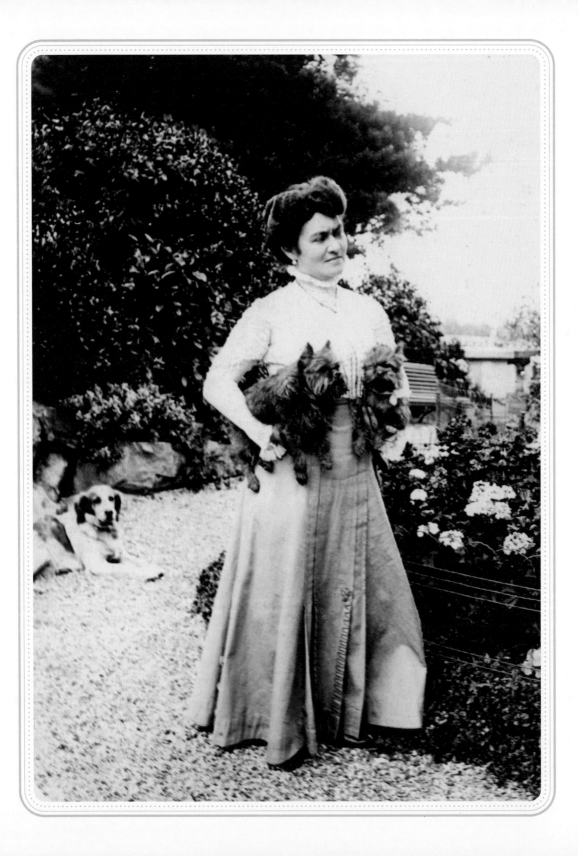

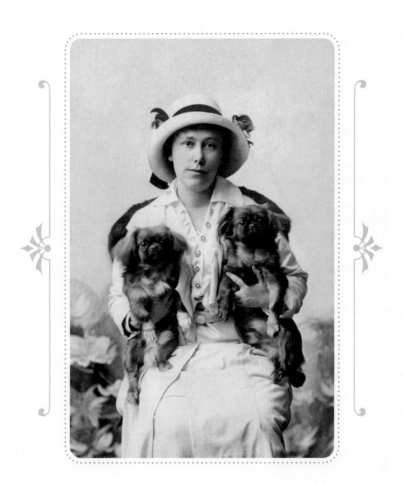

*Pages 50–51:* Snapshots that capture the everyday activities of life, also known as candid or vernacular photography, show us life unadorned. At the turn of the century these girls in New York included their dog in the fun.

. . . . . . . . . . . . . . . . . . . . . . . . . . . . . . . . . . . . . . . . . . . . . . . . . . . . . . . . . . . . . . . . . . . . . .

*Opposite:* Affenpinschers were originally bred during the seventeenth century in Germany as ratters. This photograph was taken in France around 1905.

. . . . . . . . . . . . . . . . . . . . . . . . . . . . . . . . . . . . . . . . . . . . . . . . . . . . . . . . . . . . . . . . . . . . . .

*Above:* A pair of Pekingese added symmetry to this image of a young woman in Canada during the 1910s.

*Above:* This small terrier mix appears to be guarding his young companion in this circa 1870s photograph.

. . . . . . . . . . . . . . . . . . . . . . . . . . . . . . . . . . . . . . . . . . . . . . . . . . . . . . . . . . . . . . . . . . . . . . . . . . . . . . . . . . . . . . . . . . . . . . .

*Opposite, top:* In this photograph taken in Michigan, posted to the left of the open door, is an advertisement for the musical *Three Twins*, which opened on March 7, 1908, at the Whitney Opera House in Detroit. By June 1908, the play had moved to New York City. Based on this information, we know this guard dog was on duty at Finley's Feed Barn in the spring of 1908.

. . . . . . . . . . . . . . . . . . . . . . . . . . . . . . . . . . . . . . . . . . . . . . . . . . . . . . . . . . . . . . . . . . . . . . . . . . . . . . . . . . . . . . . . . . . . . . .

*Opposite, bottom left and right:* Both images of these working dogs were taken in Ireland during the 1920s. The American Kennel Club recognizes thirty-one dog breeds bred specifically to work as opposed to providing companionship. Many of these hunters, haulers, herders, heroes, and guardians have worked alongside humans for thousands of years. Rottweilers and mastiffs are descendants of ancient Roman herding dogs. Great Danes, Akitas, and boxers were developed to hunt, while malamutes, Chinooks, and Siberian huskies were bred to haul. Dogs raised to herd domestic livestock include collies, shepherds, Bernese mountain dogs, and even the Portuguese water dog, which developed the ability to herd fish into nets. Heading the list of heroes are the Saint Bernard and the Newfoundland; the latter is capable of not only daring water rescues, but also helping fishermen haul in nets.

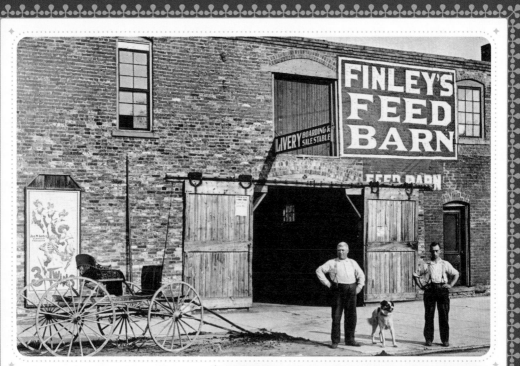

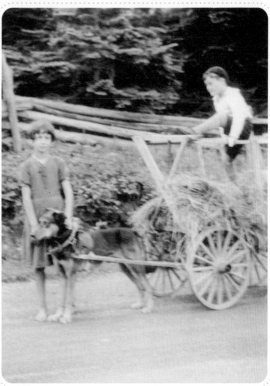

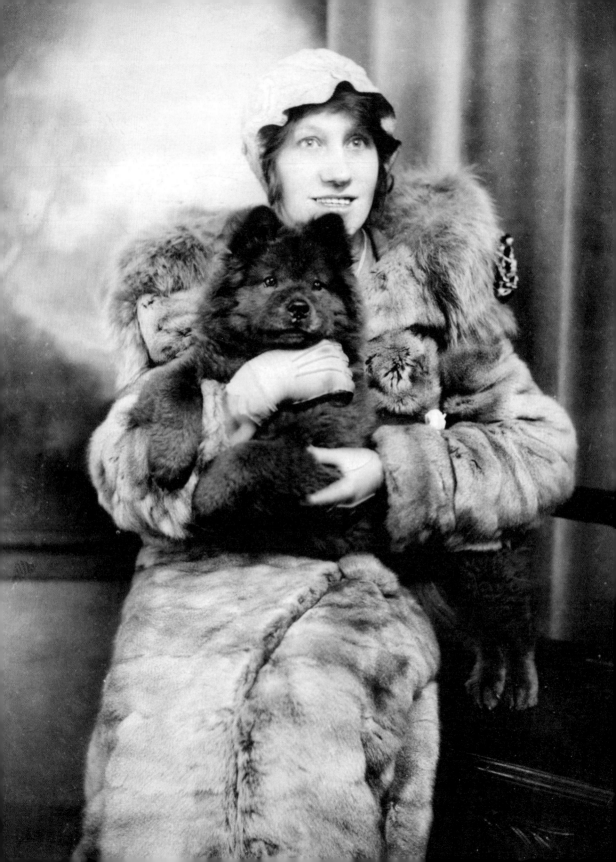

"*It is quite a three-pipe problem.*"

—ARTHUR CONAN DOYLE, "The Red-Headed League,"
*Strand Magazine*, August 1891

*Opposite:* "Aunt Bessie and Chow," 1920s. When this photo of Bessie and Chow was taken, chow chows were the third most popular breed of dog, according to the American Kennel Club. German shepherds and Boston terriers ranked at numbers one and two, respectively.

*Above:* This gentleman from Ottawa, Canada, must have been given three wishes—and they seem to have been granted.

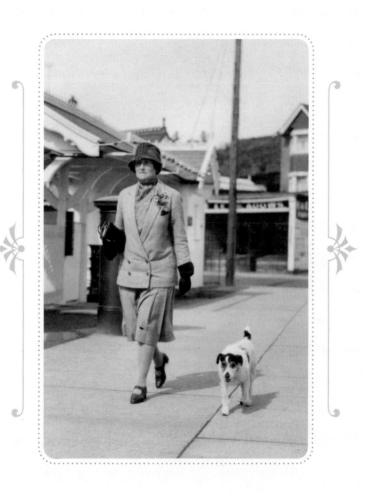

*Opposite:* It is often remarked that couples who remain together long enough begin to resemble each other, and it's also said that couples who have similar physical attributes are more likely to stay together. Either way, the similar demeanor of this pair in this 1920s photograph suggests they've been together for some time.

........................................................................................................

*Above:* "Aunt Amy & Nipper, 1928." This pair means business.

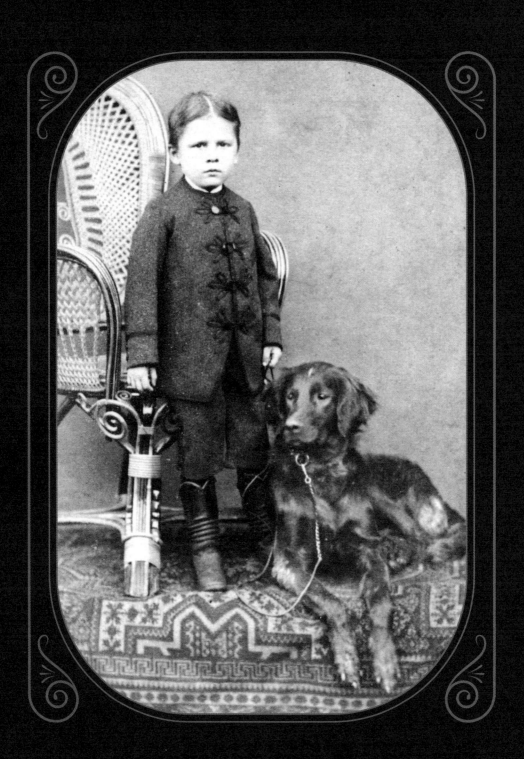

*Opposite:* This Irish setter mixed breed, photographed during the 1870s with his young Russian master, eschewed the comfort of a chair to lounge on a handmade Kazak or Caucasian carpet. These carpets were made in Armenia and Azerbaijan.

*Above:* In 1907, this Ohio puppy sat on a fancy upholstered chair next to his young mistress and posed patiently. Whether they prefer to lie on cushions, couches, or carpets, our dogs have acclimated well to the comforts of the human home.

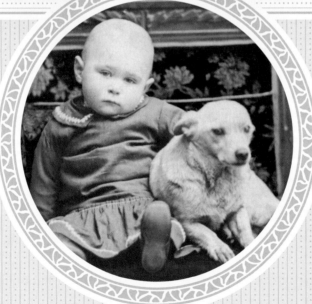

# Bedtime Tails

SOME DOGS HAVE bedtime rituals, such as scratching the floor or pillow, or circling endlessly, not unlike an airplane that isn't allowed to land.

Scratching floors and bedding before settling in to sleep is instinctive, a remnant of ancient times when dogs were not provided with the beds cushioned with orthopedic memory foam they so deserve. We have managed to take the dog out of the wild, but we have not managed to take all the wild out of the dog. To make their beds, wild dogs burrowed in the earth to help regulate their body temperature from excessive heat or cold; scratching floors and bedding before lying down reflects that instinct. Similarly, spinning ensures dogs that they are obtaining the most comfortable and safest position in the event of attack from another animal. So next time you see a dog perform these bedtime rituals, know you are seeing a primeval instinct in action.

*Opposite, top:* This photograph taken in Arizona around the turn of the twentieth century is unusual in that the children posed with their dogs while wearing their nightgowns. Images like this one, as opposed to the posed studio photographs, give us a true sense of everyday life at the time.

*Opposite, bottom:* When you grow up with a dog, you learn to share everything, perhaps even the same groomer.

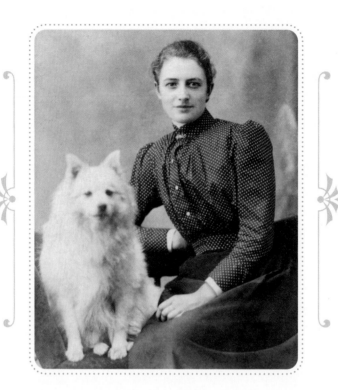

**D**URING THE EARLY nineteenth century, it could take years for women in remote parts of the world to obtain the latest fashions from Europe and the United States. Advances in communication and printing during the latter part of the nineteenth century ensured that women from most large cities could obtain the latest fashions soon after they were produced. The mid-nineteenth century also saw great innovations in the mass production of clothing. In 1863 Ebenezer Butterick, an American tailor, offered the world's first mass-produced dress patterns.

These two photographs were taken around the turn of the twentieth century in different hemispheres, yet the women wear bodices with the same fashionable puff sleeves. The young woman from Australia seated with her Spitz *(above)* is dressed in a fashionable bodice of Swiss dot fabric, while the older woman from Canada *(opposite)* chose a sober black dress with a simple white collar; both dogs went with white.

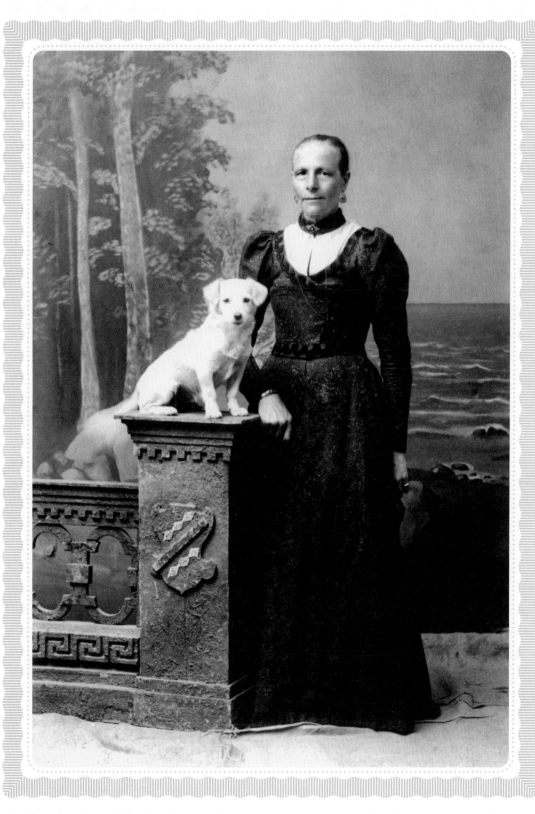

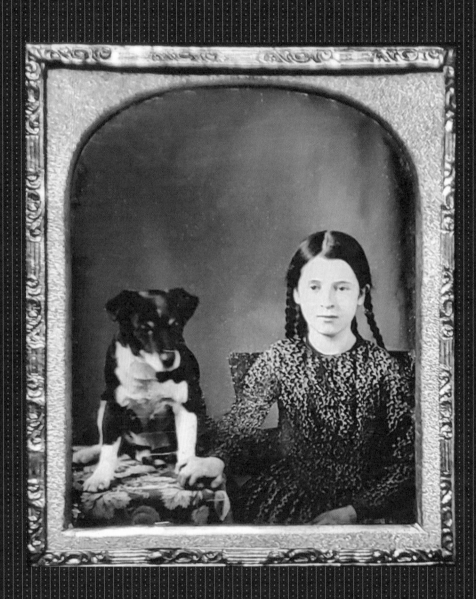

*Opposite:* Sometime in 1848, this young pigtailed girl with freckles, age nine, according to the inscription within the case of her portrait, sat for a photograph with her puppy. She placed a comforting hand on its paw, a gesture which may have reassured the pup sufficiently to keep him still long enough for the photographer to capture this remarkably clear daguerreotype. It's more likely that the puppy's calm attitude in front of the camera is due to his ability to sense his owner's tranquil demeanor. Dogs can sense emotions by detecting clues in a person's sweat.

One of the earliest forms of photography, the daguerreotype is often referred to as "a mirror with a memory," a reference to its silver plating, which gives the image a highly reflective appearance. At the time this photograph was taken, a daguerreotype cost about three dollars, or ninety dollars today.

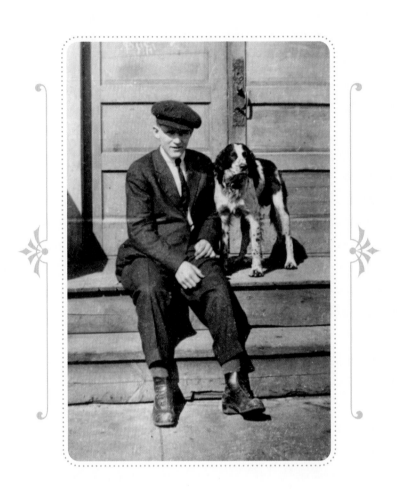

*Above:* In this photo, taken in Idaho in 1910, the black-and-white coat of this good-looking springer spaniel stands in stark contrast to the gray horizontal lines of the steps and panels in the doors. The architecture of the doors is highlighted by the shading beneath them. The creeping shadow to the left adds a kind of symmetry to this image.

*"A door is what a dog is perpetually on the wrong side of."*

—OGDEN NASH, from *The Private Dining Room and Other Verses*, 1953

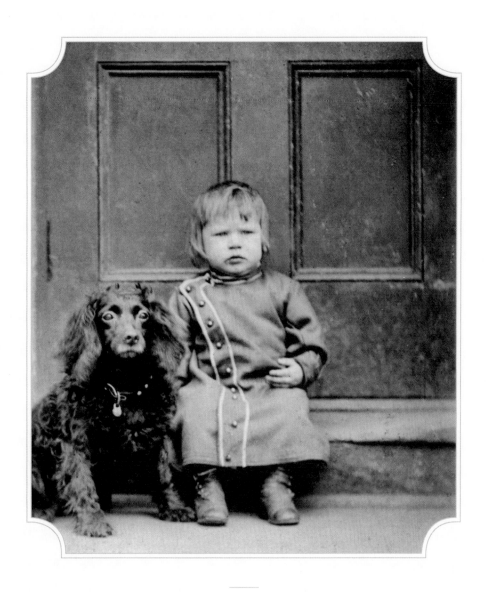

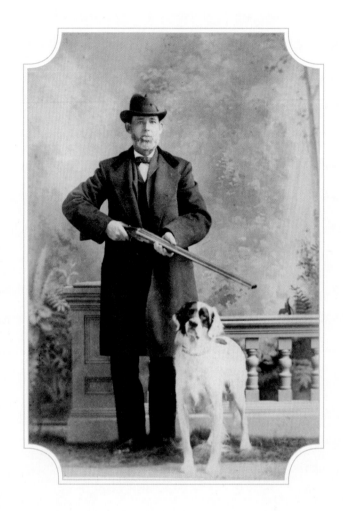

*Above:* There is no doubt this mixed breed setter was put to work by his owner who identifies strongly enough as a hunter that he posed with his gun in this 1880s photo.

. . . . . . . . . . . . . . . . . . . . . . . . . . . . . . . . . . . . . . . . . . . . . . . . . . . . . . . . . . . . . . . . . . . . . . . . . . . . . . . . . . .

*Opposite:* Charles, a sharp fellow, posed with his even sharper mixed breed terrier in Boulder, Colorado, 1881. Charles's felt hat with ribbon band, three-piece suit, watch chain, clean-shaven face, and handlebar mustache tell us he was quite fashionable.

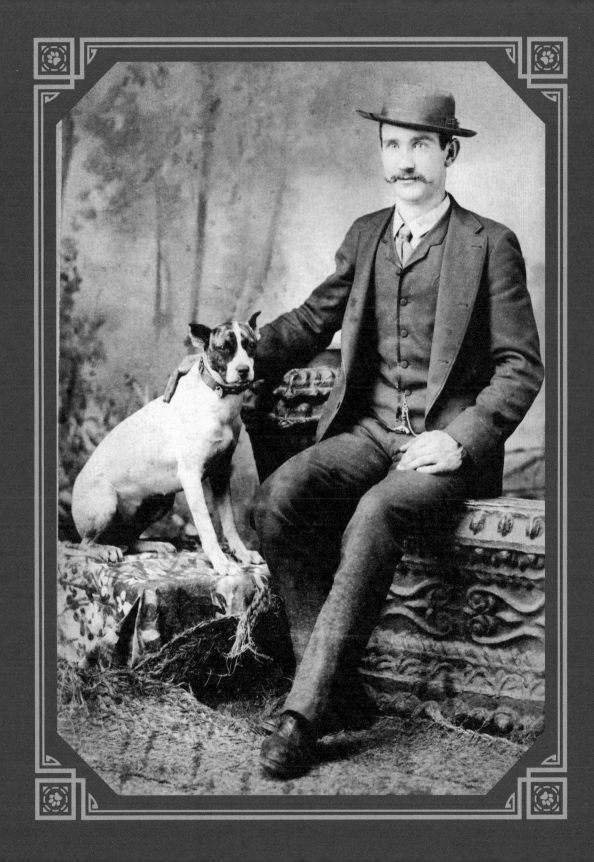

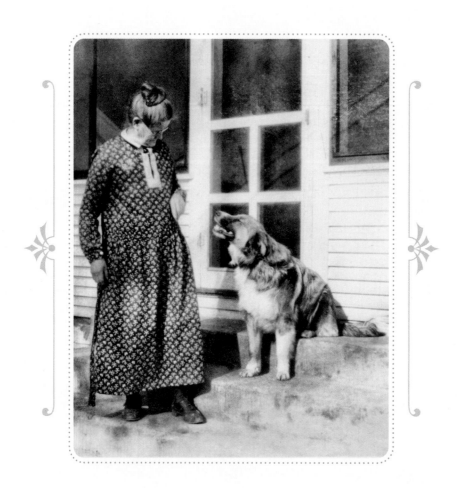

*Above:* One look at this image from around 1920 tells us there is complete understanding between these two. Something, perhaps the size of the dog, suggests this woman is an excellent cook. Can't you imagine a freshly baked pie sitting on that back porch to cool?

. . . . . . . . . . . . . . . . . . . . . . . . . . . . . . . . . . . . . . . . . . . . . . . . . . . . . . . . . . . . . . . . . . . . . . . . . . . . .

*Opposite:* A photographer caught this stylishly dressed 1920s flapper feeding her dalmatian a treat. Renowned for rebelling against what was considered social propriety at the time by bobbing their hair, wearing shorter skirts, smoking, and drinking, flappers were more likely to be found cutting a rug in a jazz club rather than cutting strips of dough to make a lattice-topped pie.

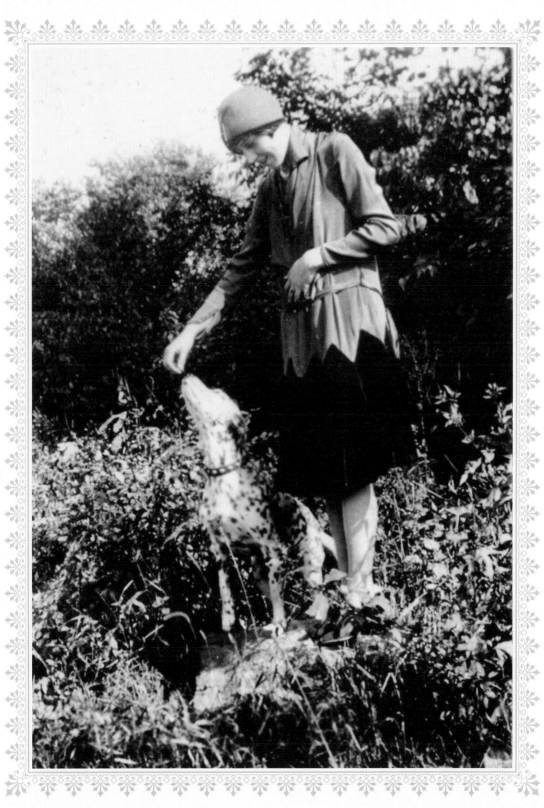

*Opposite:* If you didn't have a dog, many photo studios were able to supply a prop dog that often appeared genuine. It is difficult to determine when photographers began to use prop dogs in their photographs, but these lifelike dogs were typically made in Austria complete with every detail including foot pads, nails, glass eyes, and collars.

After 1885, Friedrich Goldscheider, an artisan in Vienna known for his fine ceramics and his porcelain and terra-cotta figures, began to produce top-quality terra-cotta dogs for export throughout the world. Goldscheider had branches in Florence, Leipzig, and Paris. The dogs in these images may well be Goldscheider figures. In very good condition, these antique terra-cotta dogs can easily sell in the six-to-ten-thousand-dollar range today.

This ferrotype of a young boy with a studio prop bulldog was taken during the 1870s.

*Above:* The studio prop dog in this 1880s image is perhaps the most realistic-appearing prop dog I've seen in any vintage photograph.

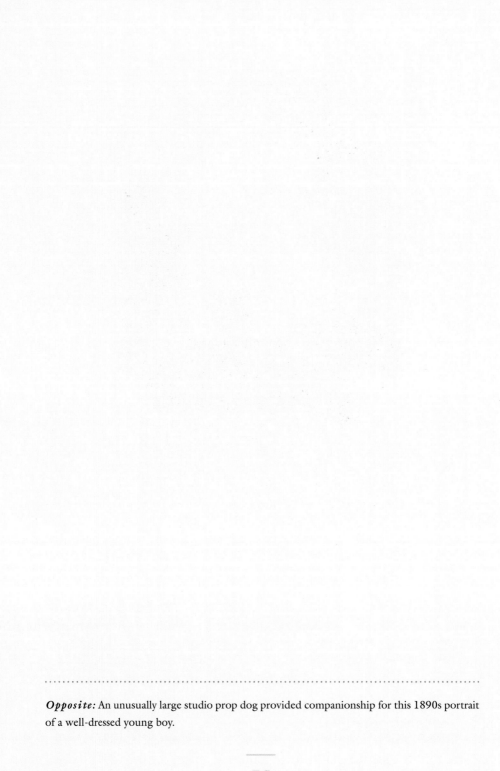

*Opposite:* An unusually large studio prop dog provided companionship for this 1890s portrait of a well-dressed young boy.

*Above:* The fancy pillow on which this rat terrier rests belies the fact that rat terriers were bred to exterminate rodents, primarily mice and rats. It is difficult to imagine this pampered pooch leaping from such luxury to chase vermin.

*Opposite:* The puff sleeve began to balloon in the early 1890s. By the middle of the decade, it had grown to almost ridiculous proportions, which dates this photograph to about 1895. Shortly thereafter, the sleeve began to deflate. The dog is timeless.

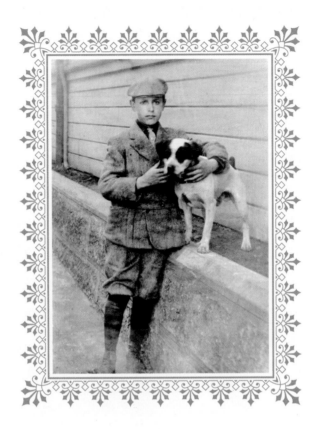

*Above:* "Ned, 12 years, 11 months old, Nebraska," and his dog were captured in a candid snapshot around the same time as the sailor boy from Ohio *(opposite)*. Ned's knicker suit was more practical, durable, and popular among boys.

. . . . . . . . . . . . . . . . . . . . . . . . . . . . . . . . . . . . . . . . . . . . . . . . . . . . . . . . . . . . . . . . . . . . . . . . . . . . . . . . . . . . . . . .

*Opposite:* Despite being from the landlocked state of Ohio, this sailor boy posed with his dog for this circa-1910s photograph. British parents in the nineteenth century commonly dressed children in sailor suits, especially boys. The style increased in popularity after Queen Victoria regularly dressed her sons and daughters in sailor suits. In 1861, *The Englishwoman's Domestic Magazine* suggested sailor suits for boys of six or seven. By the 1870s, sailor suits were one of the most popular styles for boys up to twelve or thirteen throughout Europe, Australia, New Zealand, Canada, and the United States.

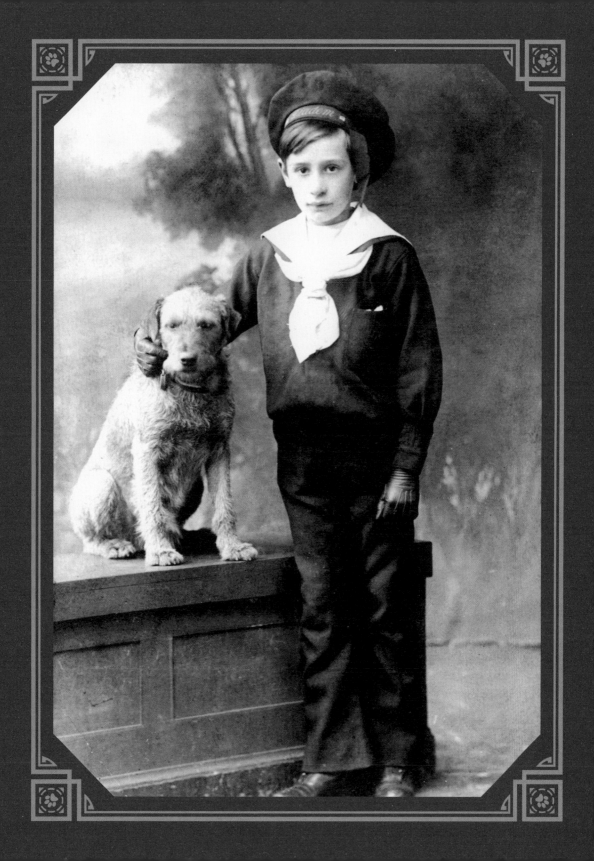

# Is There a Dog in the House?

**A** STUDY BY Dr. Eija Bergroth and others, published in *Pediatrics* in August 2012, examined the relationship between infants and dogs. Performed at Kuopio University Hospital in Finland, the study showed that children who lived in a home with a dog were healthier than their counterparts without dogs. These infants and children were less prone to asthma and other respiratory problems. Furthermore, these children had better immunity throughout childhood. Infants who lived with dogs were 31 percent healthier than their non-pet-having counterparts and infants who lived with cats were only 6 percent healthier. The study also showed that the more time a dog spent outside, the more beneficial the effect on the child's immunity, due to the introduction of a greater variety of microbes into the home.

*"A small pet is often an excellent companion for the sick, for long chronic cases especially."*

—FLORENCE NIGHTINGALE, *Notes on Nursing: What It Is, and What It Is Not*, 1860

*Above:* Although the first formal research into animal therapy did not occur until the 1960s, animals have been used for this purpose since the mid-nineteenth century. In the 1860s, Florence Nightingale observed that pets reduced anxiety in psychiatric patients. During the 1930s, the "father of psychoanalysis," Sigmund Freud, made the same observation and began to use his dog, Jofi, during his psychotherapy sessions.

It's possible that the dog in this 1915 photograph taken in Canada is a therapy dog accompanied by its costumed owner on a mission to raise the spirits of hospitalized patients.

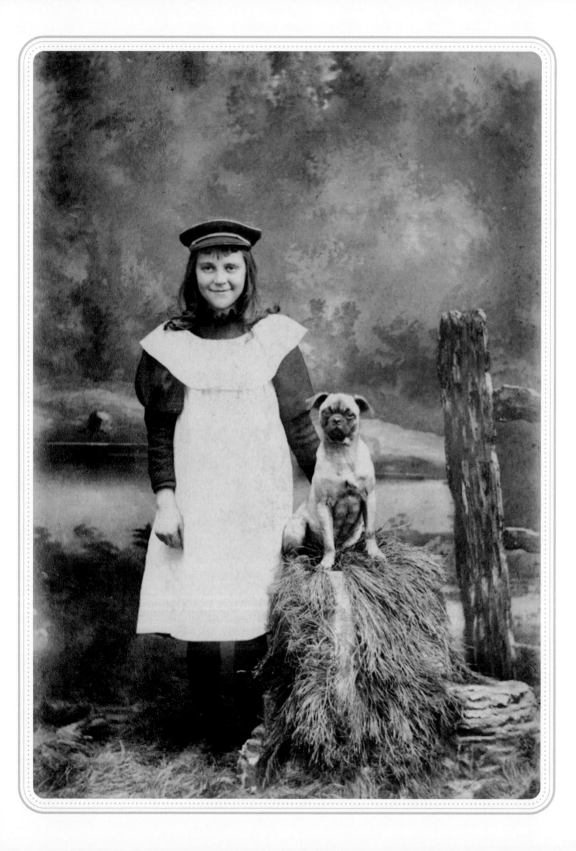

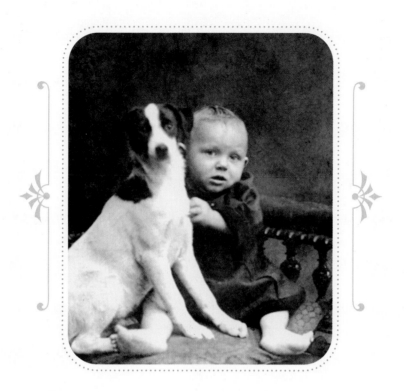

*Opposite:* Pugs originated in China. In the sixteenth century, they were brought to Europe, where they became popular with royalty. Queen Victoria developed a passion for pugs, which she bred herself. During her sixty-four-year reign she had thirty-eight of them, with unique names like Venus, Pedro, Olga, and Minka. Her enthusiasm for pugs led to an increase in the breed's popularity among the wealthy.

Of course, whatever Queen Victoria did soon became the rage. Another royal who shared Victoria's passion for pugs was Edward VIII, the Duke of Windsor. He and his wife, Wallis Simpson, had numerous pugs who traveled with them. The dogs were pampered excessively, were fed from silver bowls, and wore a scent by Christian Dior.

*Above:* The love shared between this smooth fox terrier and young child is clearly evident in this photograph taken in England around 1900.

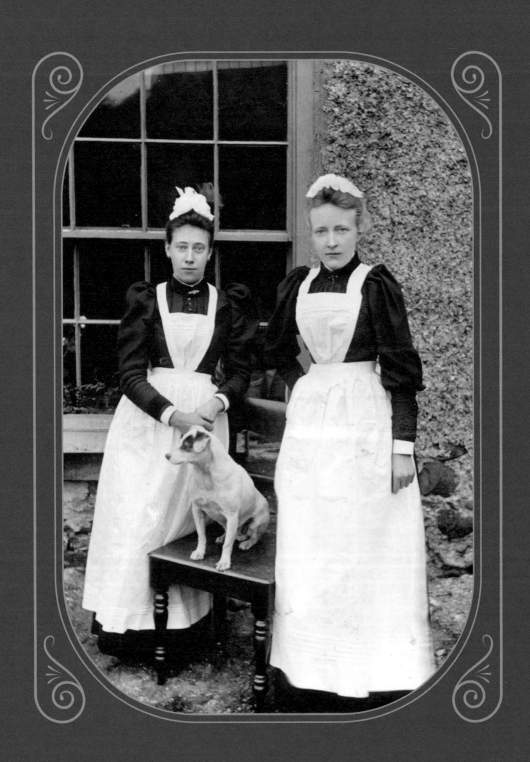

I T'S A SMART dog who makes friends with the household staff, especially those who work in the kitchen. Known for their calm demeanor and intelligence, small poodles were pampered lapdogs, a popular parlor companion during the Victorian era. In the days before refrigeration and impenetrable storage bins for items such as flour and grain, terriers were often kept in the kitchen because they kept the area free of rodents—even more so than cats.

Prior to the nineteenth century, animals served two purposes: They were used as guard dogs or for labor. The Victorians were the first to bring pets into the parlor. Dogs became true domestic creatures. Some breeds were simply ornamental accessories, while others earned their keep.

Butchers used bulldogs in slaughterhouses to drive animals from pen to pen, especially large animals such as cows. This ability led to the breed being referred to as "butcher dogs"; it also led to the sadistic practice of bullbaiting, a bloody sport in which a bulldog attacked a tethered bull, resulting in injury or death to the dog unless the dog subdued the bull by biting deeply into its nostrils.

Hunters had setters and pointers to direct them to prey and spaniels to flush it out. Chimney sweeps, who often had to contend with rodents and other animals who had taken up residence in flues, typically employed bull terriers as workmates able to efficiently dispatch these small creatures.

In the country, farmers used terriers to chase off rats, foxes, and badgers; without these dogs, a farmer might lose an entire season's grain. Farmers also used shepherds to herd their animals.

......................................................................

*Opposite:* Two English housemaids during the 1890s took a break from their duties to pose with the dog of the house.

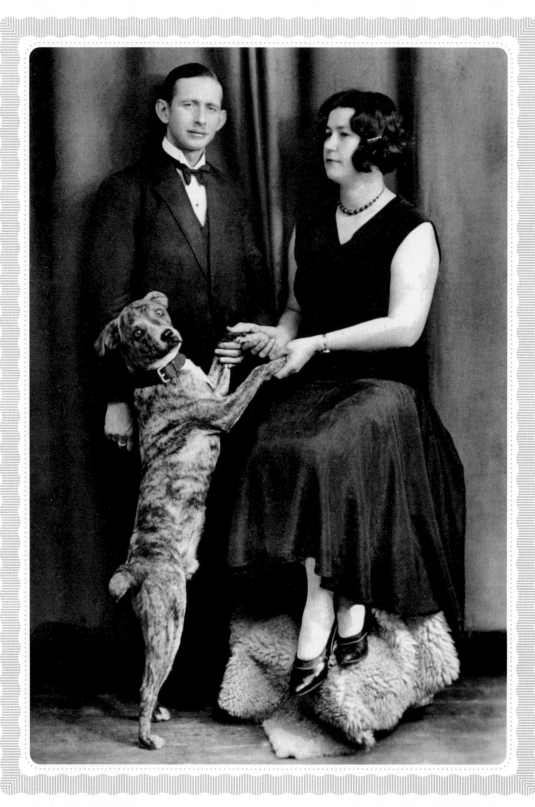

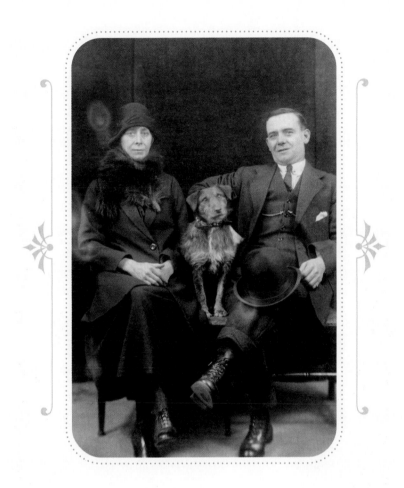

*Opposite:* It appears this fellow is trying to get on his mistress's dance card. This image was taken in Latvia in the 1920s.

........................................................................................

*Above:* This very curious dog, nestled between this couple from Portugal, shares his owners' direct gaze in this circa-1910s photograph.

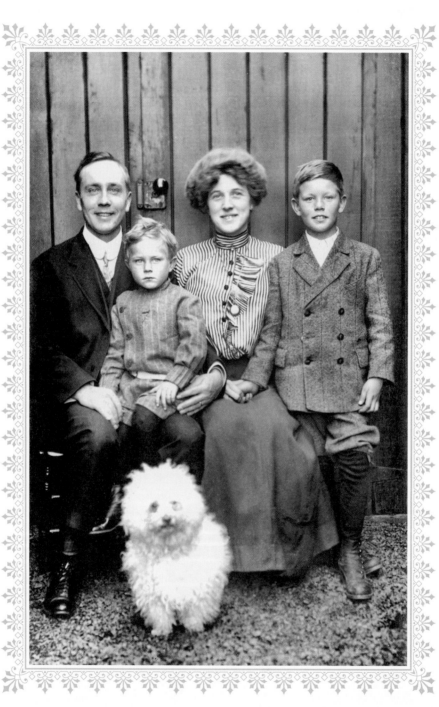

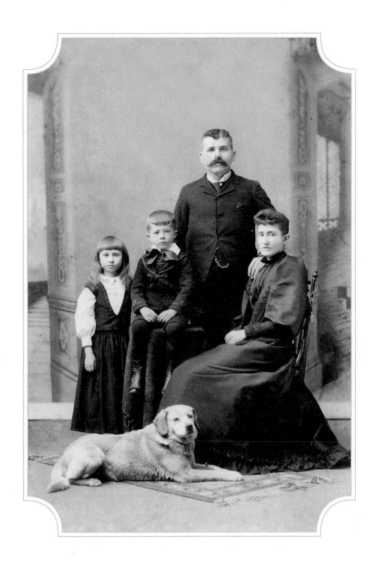

*Opposite:* California, "January 29, 1912. Here is the whole D— family."

. . . . . . . . . . . . . . . . . . . . . . . . . . . . . . . . . . . . . . . . . . . . . . . . . . . . . . . . . . . . . . . . . . . . . . . . . . . . . . . . . . . . . . . . . . . . . . . . . . . . . . . . .

*Above:* A. J. Schillare, a photographer active in Northampton, Massachusetts, during the 1880s and 1890s, photographed this well-dressed family with their Labrador retriever.

———

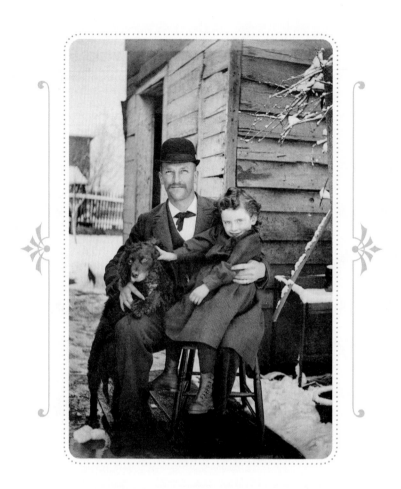

*Above:* This cocker spaniel enjoyed a winter afternoon with his family sometime in the 1880s.

*Opposite:* Snowballs aren't always cold. The inscription on the back of this photograph taken in California in 1908 reads, "Aren't the puppies cute? Baby was scared and he said, 'Oh!'"

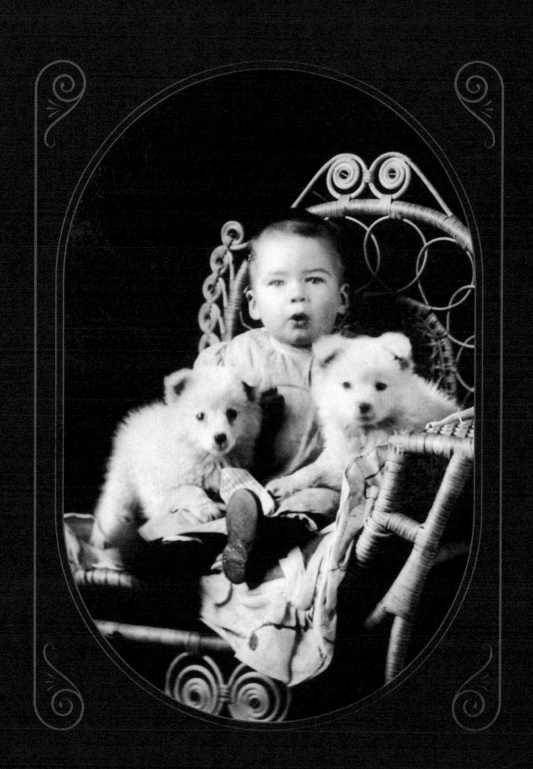

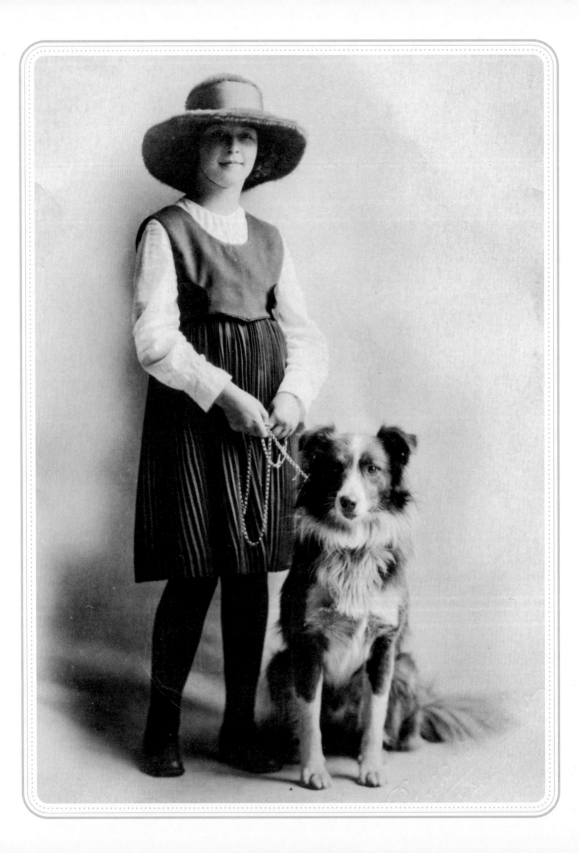

*Opposite:* Philadelphia, circa 1915.

. . . . . . . . . . . . . . . . . . . . . . . . . . . . . . . . . . . . . . . . . . . . . . . . . . . . . . . . . . . . . . . . . . . . . . . . . . . . . . . . . . . . . . . . . . . . . . . .

*Above:* The casual nature of this photograph of a barefoot, dusty-legged boy cavorting with his greyhound in Nevada during the 1910s is a sweet moment in time captured by an amateur photographer.

Greyhounds, the fastest breed of dog, are associated with racing. While running, a greyhound spends 75 percent of its time in the air. The only dog breed mentioned in the Bible (Proverbs 30:29–31, KJV), the greyhound was a favorite of Shakespeare, who mentioned them in several of his plays, including *Love's Labour's Lost*, *Much Ado About Nothing*, *Coriolanus*, *The Taming of the Shrew*, *Timon of Athens*, *Macbeth*, *The Merry Wives of Windsor*, *Henry IV*, and *Henry V*.

*Above:* This pair posing in California circa 1910 was serious when it came to their game of fetch. Guess who's the southpaw?

. . . . . . . . . . . . . . . . . . . . . . . . . . . . . . . . . . . . . . . . . . . . . . . . . . . . . . . . . . . . . . . . . . . . . . . . . . . . . . . . . . . . . . . . . . . . . . . . . . . . . . . . . . . . . . . . . . . . . .

*Opposite:* In 1908, these siblings posed with their family dog for photographs in which the photographer managed to capture more than just an image. The trusting relationship between this large dog and these small people is easy to appreciate as they gaze directly into the camera. These tender images may be the only remaining record of this remarkable connection. These real photo postcards (images printed on postcard stock per the customer's request) were mailed a distance of 50.6 miles on April 21 and June 13, 1908, from Whallonsburg, New York, to Miss Fannie Leslie of St. Albans, Vermont, with a simple message: "Do you know who this is?"

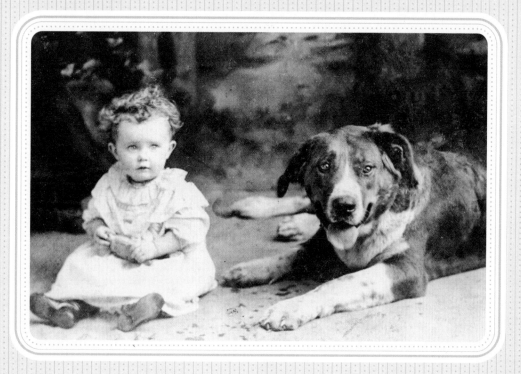

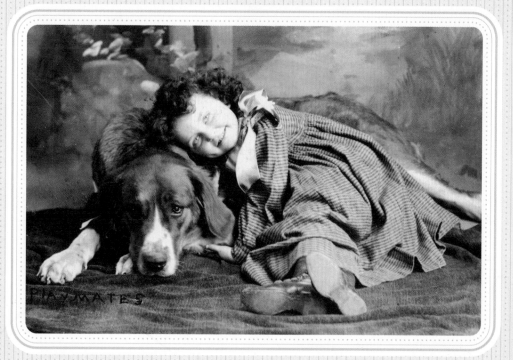

PLAYMATES

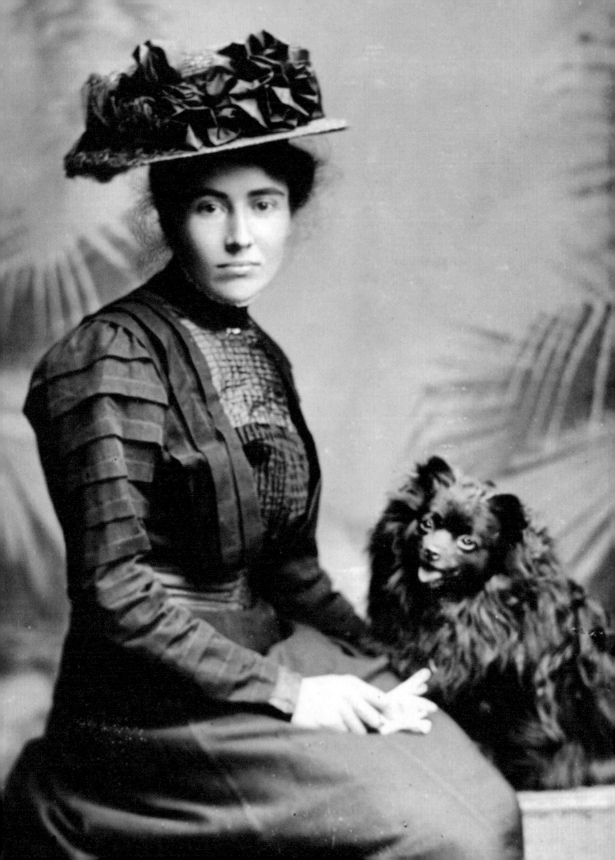

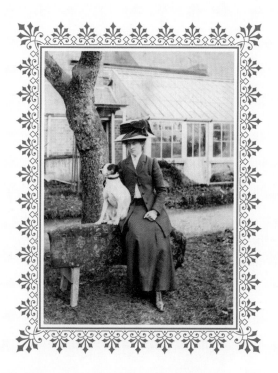

*Opposite:* The fancy bodice with vertical and horizontal shirring and the cap sleeves suggest this smartly dressed woman from England posed with her spitz during the late 1890s to early 1900s. Her beribboned straw hat appears to float above her head, as was the fashion at the time.

. . . . . . . . . . . . . . . . . . . . . . . . . . . . . . . . . . . . . . . . . . . . . . . . . . . . . . . . . . . . . . . . . . . . . . . . . . . . . . . .

*Above:* Until the 1960s, hats were one of the most important accessories in a woman's wardrobe. Throughout the eighteenth and early nineteenth centuries, milliners and hat shops thrived in large cities and small towns alike. During the first decade of the twentieth century, when this photo was taken, hats were all about size. In fact, this woman's hat almost completely distracts us from the dog sitting with her.

With large hats came large hat pins, usually in the range of 8 to 12 inches. To secure such large hats and prevent loss from the wind, these pins were pushed through the hat on one side, through the hair, and out the other side of the hat; this exposed point often caused injuries in close quarters such as streetcars and crowds.

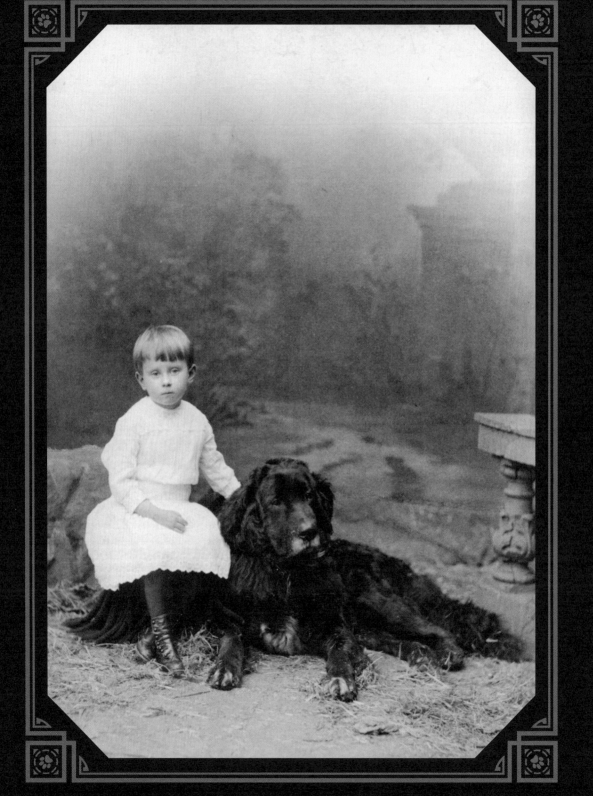

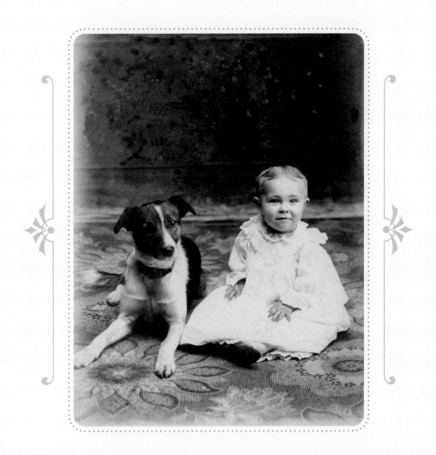

*Opposite:* Although massive in size, the Newfoundland is a breed that has been classified by the American Kennel Club as "lovey-dovey" and "good with kids." In fact, the organization says that "the most important single characteristic of the breed" is its "sweet temperament." This Newfoundland puppy, photographed in Germany during the 1880s, clearly displays the breed's size in relation to children. When fully grown, a male Newfoundland can weigh 150 pounds and stand 28 inches tall at the shoulder.

*Above:* The inscription on the back of this photo from 1890s Indiana simply reads, "Lester and Mork."

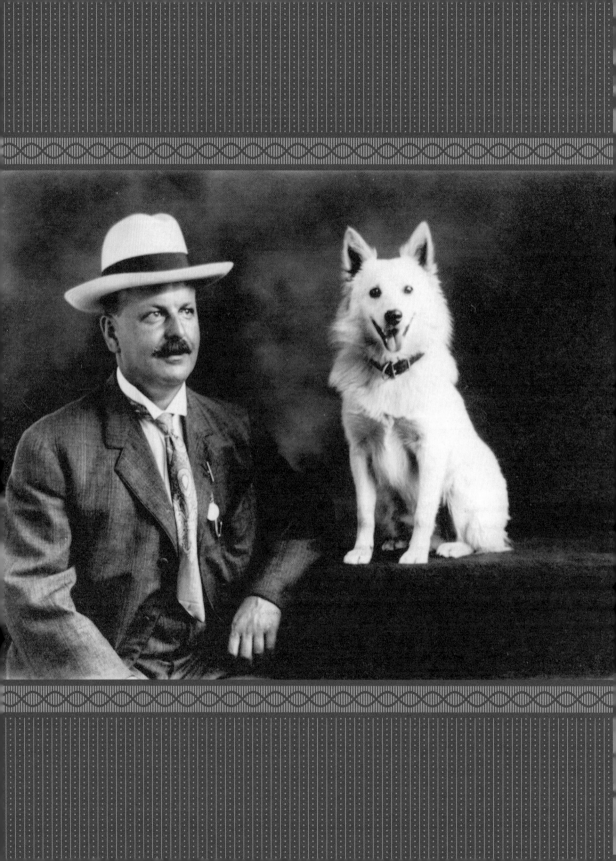

# Damp & Dis-stink-t

**T**HERE'S NOTHING LIKE a wet nose to warm the heart, but that moist muzzle does perform a function. Wet noses act like a sponge for chemical scents. Circulating odors are trapped on a dog's nose by secretions of a specific type of mucus, and dogs lick their noses to help them determine the identity of the scent. Dogs' noses are also as distinct as humans' fingerprints; no two noseprints are alike. A dog's noseprint can accurately identify the dog to which it belongs.

According to the Calgary Humane Society, the Canadian Kennel Club recognizes a dog's noseprint as a unique form of identification. In order to make a print of your dog's nose, they recommend using food coloring on a paper towel to apply color gently to the front of your dog's nose, then press a piece of white paper just as gently against the dog's nose and you have a print. Never use an ink pad.

According to Pet WebMD, "the common belief that a healthy dog has a cold, wet nose and a sick dog has a hot, dry nose is FALSE."

*Opposite:* In this photograph taken on September 25, 1912, in Minneapolis, Minnesota, this dog's dark nose juxtaposed against his white coat becomes the focus. The image is another where one can't help but think that dogs and their people may really have a similarity of expression.

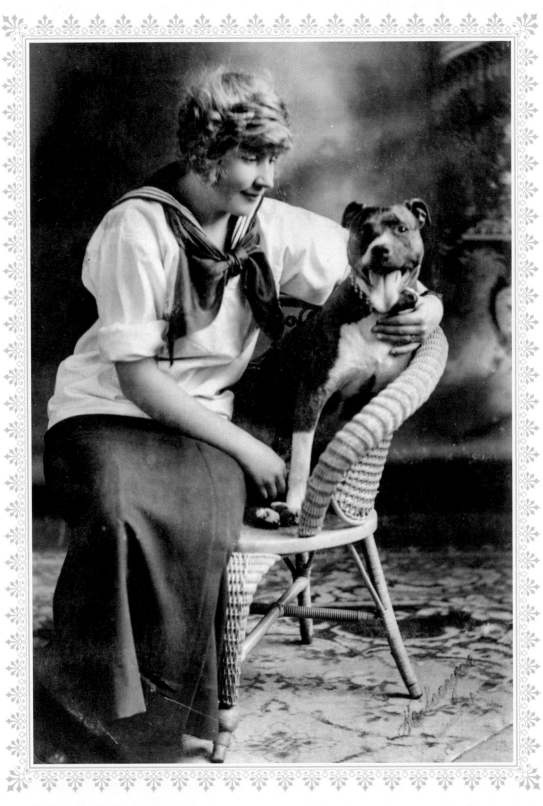

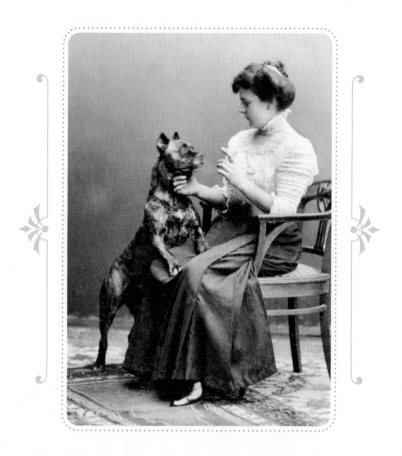

*Opposite:* Clothing designed after the uniforms of sailors became fashionable for young boys and girls during the 1850s and by the 1880s influenced women's fashion in the form of the middy. The middy, so named because it was adapted from the tops worn by midshipmen, became popular for women's bathing costumes and gymnasium uniforms. During the early twentieth century, the fashion found its way from the beach and gymnasium to everyday women's wear. A very chic version of the middy blouse is worn by this stylish young woman from Philadelphia posing with her pit bull during the 1910s.

*Above:* The pit bull in this early twentieth-century photograph from Germany listens intently during a conversation with his mistress. At this time, pit bulls were one of the most popular dog breeds, especially in the United States, where they were featured on military recruiting posters during World Wars I and II. Pit bulls were so popular they became logos for companies such as RCA Victor (Nipper) and the Brown Shoe Company (Buster Brown and his dog, Tige).

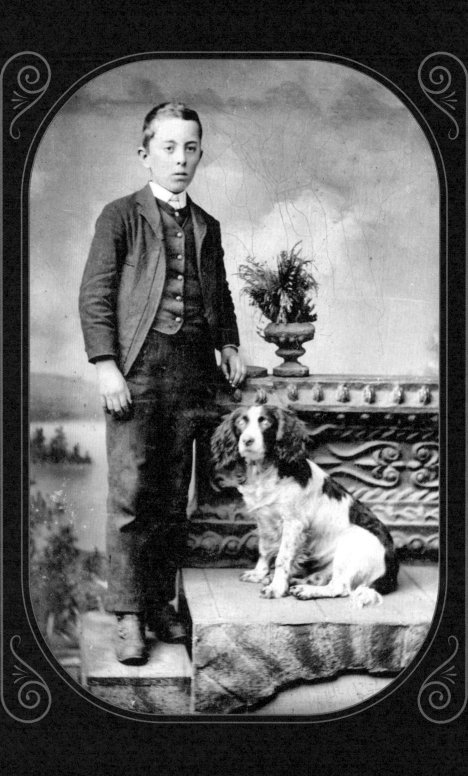

THOUGH THEY MAY exist in a variety of colors, cocker spaniels are recognizable by their luxuriant floppy ears and large loving eyes. Perhaps the most iconic cocker spaniel is Lady from the movie *Lady and the Tramp*, who epitomizes the gentle, affectionate, highly intelligent nature of this breed. There are two varieties of cockers: English and American. The English variety was used for hunting and was so beloved they were bred to produce the American variety, which is smaller and has a rounder head with a more pronounced brow. The English variety has a longer snout.

The breed is named after the Woodcock, the type of bird it was bred to hunt. In fact, the breed's keen sense of smell goes far beyond detecting prey. In 2004, a cocker spaniel named Tangle was the first dog trained to detect cancer cells in urine. Tangle learned his skill in just seven months in a project headed by Dr. John Church at Amersham Hospital in Amersham, United Kingdom.

While Lady from *Lady and the Tramp* has a brown and tan coat, cocker spaniels come in a variety of colors from solid black to what is classified as ASCOB, or "any solid color other than black." They may also be parti-color (white and black or white and liver) or tricolor (for example, black, white, and rust). The cocker spaniel in this ferrotype from the 1870s *(opposite)* appears to be of the dark blue roan variety. Roan describes a coat that has a main color interspersed with hairs of another color.

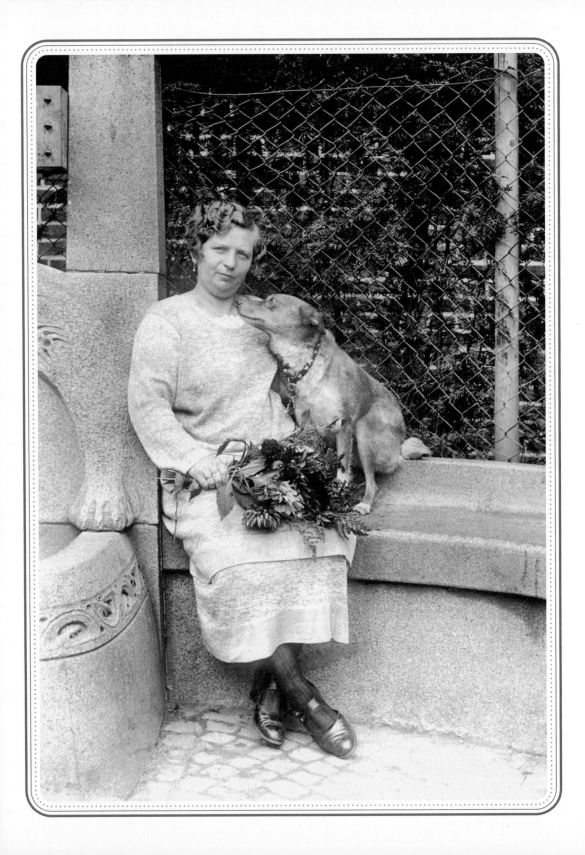

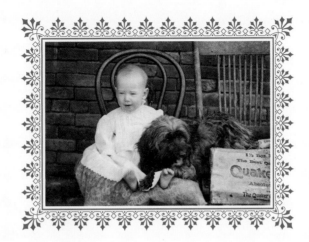

# Oats and Dogs: A Healthy Choice

WHILE IT HAS been proven that oats are good for your health, a loving pet can boost human well-being, too. Currently, on their website, the Centers for Disease Control and Prevention list the following among the health benefits of owning a dog: increased opportunity for socialization, exercise, and outdoor recreation as well as a decrease in blood levels of cholesterol, triglycerides, and the stress hormone cortisol. Dog owners are less likely to suffer from feelings of loneliness, depression, and anxiety, while the simple act of petting a dog can lower blood pressure and stimulate the release of endorphins and the feel-good hormone oxytocin.

*Opposite:* It's the look. You know the look; it's that look of love.

*Above:* This dog would not stay in its Quaker Oats box during this photography session, opting instead to share a chair with its young companion. This image was taken in Florida several years before the iconic tubular Quaker Oats box was created in 1915.

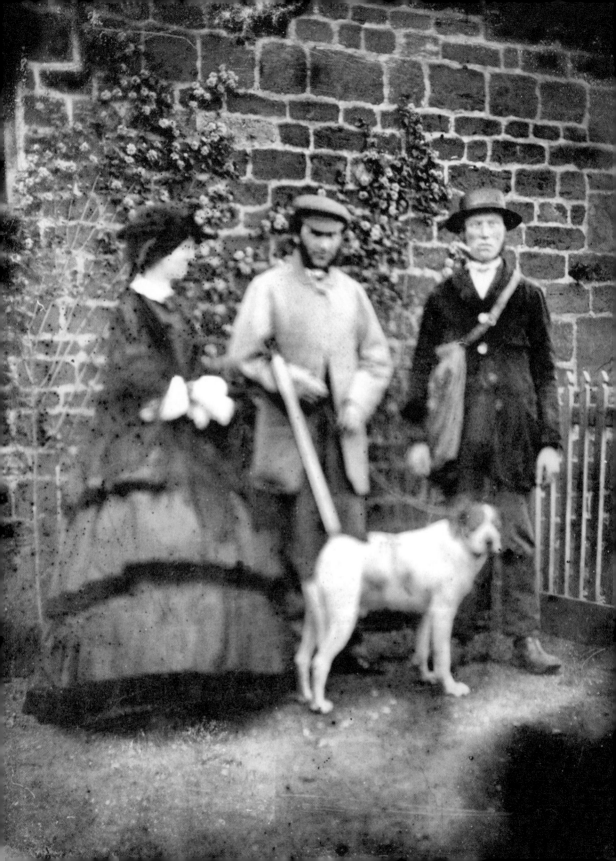

PHOTOGRAPHS TAKEN OUTDOORS during the early days of photography are rare and highly prized by collectors. Images from this time were produced by the collodion wet plate process, which did not lend itself to producing images with ease. Outdoor photography required portable dark rooms such as tents or even enclosed wagons. In these cramped working conditions, the glass photographic plate was evenly coated in collodion, a viscous, highly flammable solution of alcohol, ether, and nitrocellulose. The photographer then made the plate light-sensitive by placing it in a bath of silver nitrate for a few minutes, loaded it into a slide, then inserted it into the camera. Once the photograph was taken, it had to be developed immediately. The entire process had to be completed in a span of fifteen minutes or less; drying of the plate resulted in failure to obtain a clear image.

This extraordinary image *(opposite)*, an ambrotype, was taken during the 1850s. The slight blurring in the dog and in the woman's hoop skirt indicates movement during the exposure.

Imagine this group as they chatted and posed for the photographer more than 165 years ago. The presence of a rifle indicates a hunt of some type is about to occur. The dog and the man with the game bag suggest the intended quarry is small, perhaps rabbit or some type of fowl.

Ambrotypes, known as collodion positives in the United Kingdom, like daguerreotypes, are unique, one-of-a-kind images that can only be duplicated by photographing the completed photograph; there was no negative that could be copied. Ambrotypes, like daguerreotypes, are laterally reversed, which means that, in fact, the woman in this image was standing to the extreme right rather than the left. The images are laterally reversed because they are seen from the sitter's perspective.

As an example, imagine holding a book in front of a mirror, with the book representing the person being photographed and the mirror representing the photographic plate. The type on the book cover is backward (laterally reversed); this is how the photographic plate records the image. Taking a photograph of the finished image reverts the type to a legible form.

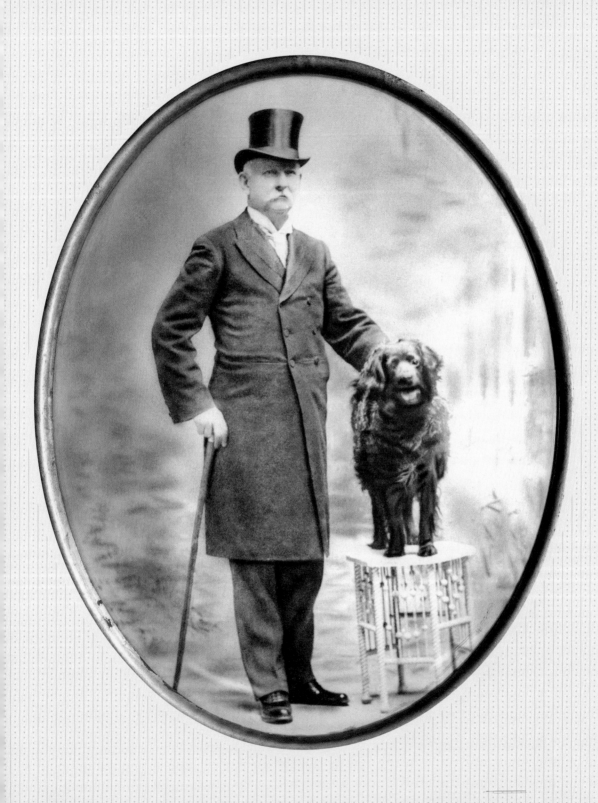

*Opposite:* This American water spaniel, photographed during the 1880s with his gentleman, must have been greatly loved. The large photograph, which is 11 by 14 inches, is framed in brass and meant to hang on a wall rather than be tucked into a photo album.

. . . . . . . . . . . . . . . . . . . . . . . . . . . . . . . . . . . . . . . . . . . . . . . . . . . . . . . . . . . . . . . . . . . . . . . . . . . . . . . . . . . . . . . . . . . . . . . . .

*Above:* Mixed breed terriers, like the dog in this circa-1890s photo, have become quite popular among dog lovers today. These hybrid, or designer, dogs can be any terrier breed mixed with another breed, such as a Yorkshire terrier and a miniature poodle. Today, there are at least twenty-five trendy terrier mix breeds available for dog lovers; none are recognized as breeds by the American Kennel Club.

SOMETIME DURING THE first decade of the twentieth century, this woman *(opposite)* posed with her dog. It is uncertain how long afterward the words "In Loving Memory of Mabel" were added to the image. More than a century later, this photograph still evokes a sense of sadness.

# A Dog Adieu

### FOR ALL THE DOGS WHO HAVE SHARED MY LIFE SINCE CHILDHOOD

*No bounding, eager, playful leaps,*
*a bed where he no longer sleeps.*
*An empty bowl, neglected toys—*
*no panting, barking, happy noise.*

*Yet, some days, I'll cock my ear.*
*I listen and hope to hear*
*the tapping nails upon the floor,*
*his run to greet me at the door.*

*But there is no tail that wags,*
*no jingle from his collar tags.*
*I am alone, and so forlorn.*
*His absence I'll forever mourn.*

—AJC, January 2021

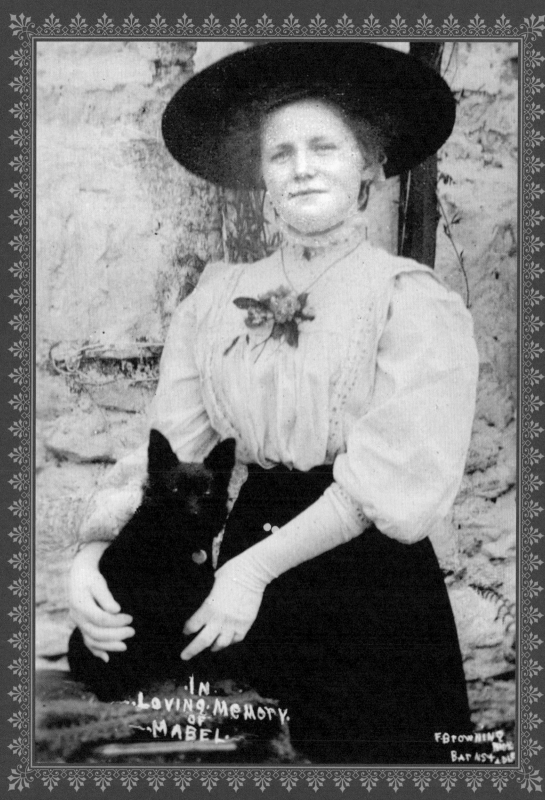

IN
LOVING MEMORY
OF
MABEL

F. Browning
Barnstaple

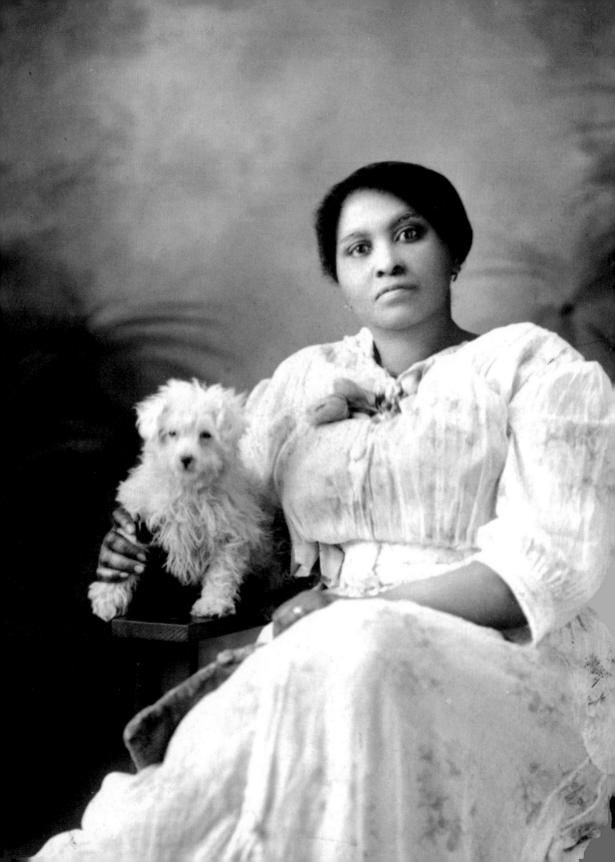

# From Rescued to Rescuer: Bailey's Story

**B**AILEY, A SHIH tzu–Lhasa apso mixed breed, began his life as Pancho in Passaic, New Jersey. When he was eight weeks old, his owner, who didn't have the money to pay his dental bill, used him as a form of payment. The man's dentist loved dogs and took the puppy, but he had a dog of his own and quickly found another home for Bailey.

Bailey's third owner neglected him, keeping him in a dog crate most of the day. After several weeks of ownership, this man decided he no longer wanted him and returned him to the dentist. The dentist found Bailey another home, but the situation was no better. Bailey's fourth owner had many animals, which he kept in a dark garage. He was not only uncaring, but abusive, and eventually decided that he, too, no longer wanted Bailey. The poor animal—by this time blind in one eye and partially blind in the other due to the third owner's mistreatment—was again returned to the dentist. There was a fifth owner—and then a sixth.

My friend Theresa Gallo was not thrilled when her daughter, Brianna, returned home one day with a scraggly, aggressive dog she had agreed to board for two weeks while Owner Number Six was away. Brianna appealed to her mother, explaining that Bailey had had a tumultuous life, and that love and attention would soon make Bailey less hostile.

*Opposite:* The bond between this adorable pup and his mistress is evident in this circa-1910 photograph.

During the two-week dog-sitting period, Theresa noticed that Bailey began to bond with Brianna. She thought Brianna, who is a severe diabetic, sensed something wonderful in Bailey. Brianna quickly earned the dog's trust and was soon able to pet and hold the dog without being bitten. They established such a strong bond over that short period that when the owners returned, they offered Bailey to Brianna on a permanent basis. Brianna accepted their offer, much to Theresa and her family's annoyance, though; they had all been victims of Bailey's aggressive nature.

Early one morning, about 3:00 a.m., while the household was asleep, Bailey came into Theresa's bedroom and began jumping at the bed and pulling at the sheets. At first, she thought he needed to go outside. She walked to the kitchen and opened the back door, but Bailey did not follow: He stood at the top of the stairs that led down to a lower floor where Brianna slept. Bailey barked at Theresa and became very excited. He then took a couple of steps down, turned around, and came back up. He did this a couple of times; Theresa quickly understood that Bailey wanted her to follow him. She did.

By the time she entered Brianna's room, Bailey was on the bed licking Brianna's face. Brianna was not responding to him. Theresa tried to wake her, but she couldn't. She immediately called for help. Paramedics arrived and determined that Brianna was in a diabetic coma. They transported her to a hospital, where doctors were able to stabilize her blood glucose levels.

Theresa said, "I nearly collapsed with relief and then I thought about Bailey, the dog no one wanted, the dog I was not pleased to have in my house. I knew then that the story would have ended tragically if Bailey hadn't alerted me to Brianna's critical condition. I was also proud of Brianna for her compassion and her ability to see the potential in this abused, unwanted dog."

At the time of this writing, Bailey has been with the Gallo family for seven years. Theresa says, "He has bonded with us all—and he still becomes agitated when Brianna's blood sugar levels become unstable."

*"Even the tiniest poodle is lionhearted, ready to do anything to defend home, master and mistress."*

—LOUIS SABIN, *All About Dogs as Pets*, 1983

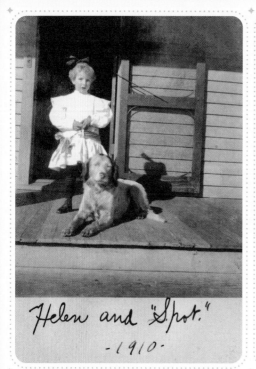

*Helen and "Spot."*

*-1910-*

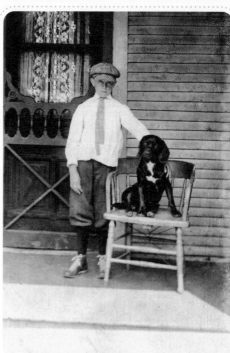

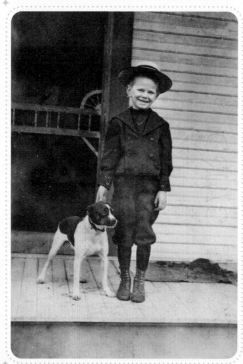

**S**ITTING ON THE porch or stoop with your dog was a quite popular pastime during the late nineteenth and early twentieth centuries. In my collection, I have about one hundred such photos taken during that time.

........................................................................................................

*Opposite, top left:* Helen and Spot, Oklahoma, 1910.

........................................................................................................

*Opposite, top right:* East Linn Street, Marshalltown, Iowa, around 1910.

........................................................................................................

*Opposite, bottom left:* Circa 1900s and inscribed to "Aunt Ada," the image is a real photo postcard, an early twentieth-century innovation that was as popular as selfies are today. In the summer of 1888, George Eastman introduced the first Kodak cameras with preloaded rolls of film; each roll contained one hundred exposures. This innovation made cameras available to the general public for the first time. Suddenly, people began taking photographs with their own cameras. When the roll was finished, they sent their camera to Kodak, where the film was removed, developed, and printed. Once processed, the photographs, along with the camera loaded with a new roll of film, were returned to the customer. During the early twentieth century, Kodak customers had the option to have multiple prints of a photograph printed as postcards. They've become a subcategory of photograph collectibles.

........................................................................................................

*Opposite, bottom right:* Candid photo of young child in a wicker rocking chair with her terrier-mix friend.

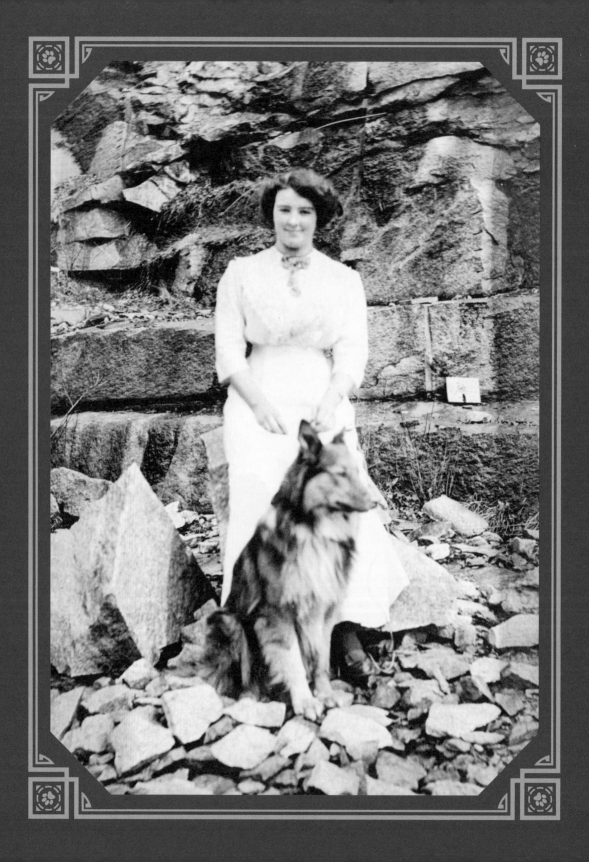

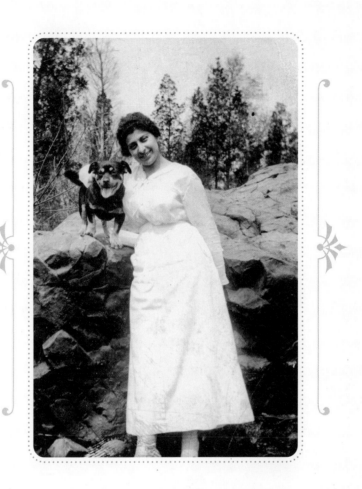

*Opposite:* It's unknown where this photo circa 1910 originated, but it was sent with "Love from Mary" and her collie to "Mrs. M. E. Carpenter, Bank Street, New London, CT."

*Above:* The back of the sweet 1911 photograph is inscribed, "*Alla mia cara e amata famiglia, ricordare vostra figlia e sodella, Maria Ubertini, Saluti e baci,*" which translates to, "To my dear and beloved family, remember your daughter and sister, Maria Ubertini, Greetings and kisses." Maria sent this postcard to her family in Italy after she emigrated from Italy to the United States. It is especially poignant when you consider that many of those immigrants never saw their families again.

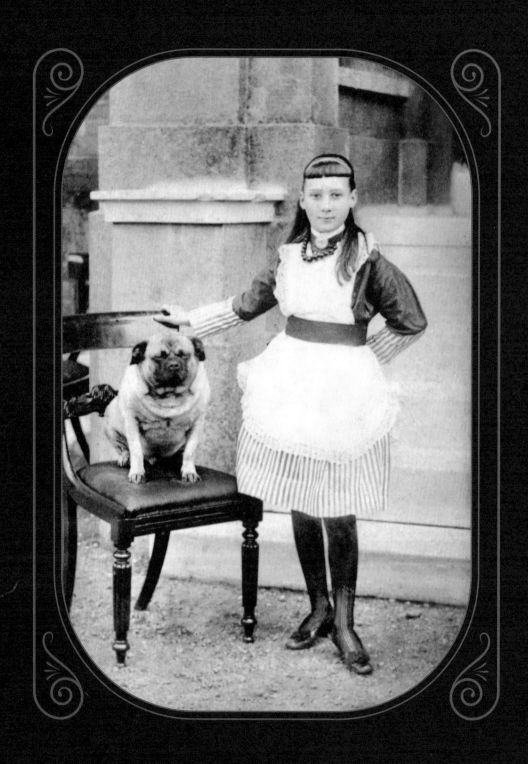

## "The pug is living proof that God has a sense of humor."

—**MARGO KAUFMAN**, from *Clara: The Early Years: The Story of the Pug Who Ruled My Life*, 1998

*Opposite:* The pug in this image from England, circa-1890s, is proof that some dog owners believe that food is love.

. . . . . . . . . . . . . . . . . . . . . . . . . . . . . . . . . . . . . . . . . . . . . . . . . . . . . . . . . . . . . . . . . . . . . . . . . . . . . . . . . . .

*Above:* In Sweden during the early 1900s, this young girl accessorized her miniature pinscher with a ribbon bow for the special occasion of her portrait. In my collection of almost six hundred vintage photographs of dogs with their people, almost all small- to medium-size dogs are posed on a chair, table, or pedestal. This positioning puts the smaller dogs in a more central spot and makes for a more intimate composition than if the dog were at their owner's feet.

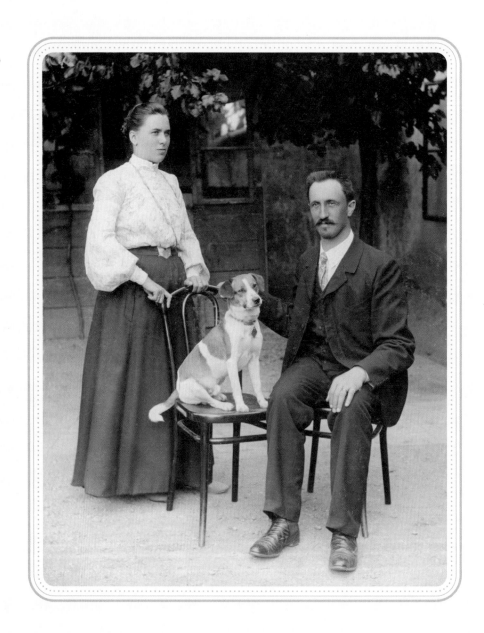

*Above:* Hound mixed breed, Austria, 1908.

*Opposite:* Papillon mixed breed, Michigan, 1915.

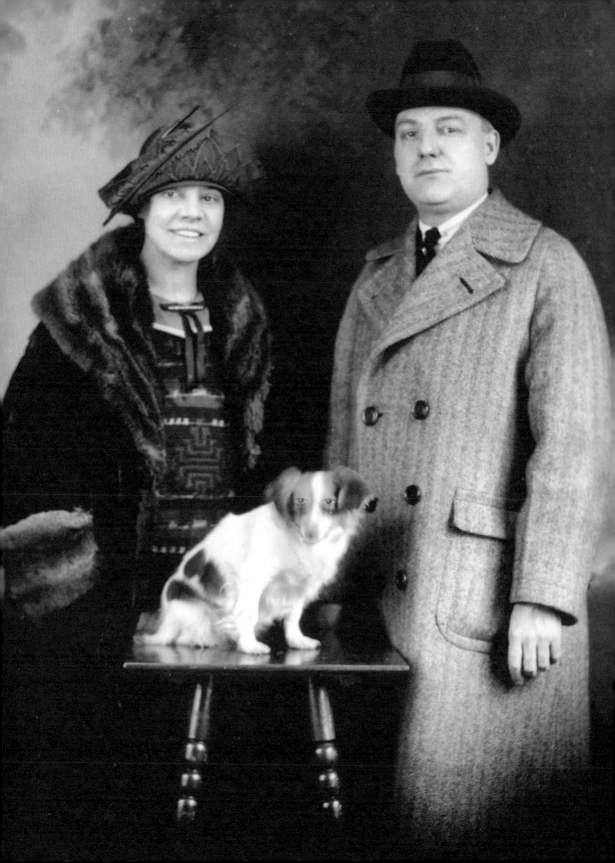

*Opposite, top left:* The young farm boy in the forefront of this photograph, shot circa 1910, is seated next to his dog on an Irish Mail hand car, which was invented in 1902 by Hugh Hill of the Hill-Standard Company in Anderson, Indiana. Unlike other toy vehicles, it was propelled by the arms and steered with the feet. It was named after the Irish Mail, the fastest train in the world at that time.

. . . . . . . . . . . . . . . . . . . . . . . . . . . . . . . . . . . . . . . . . . . . . . . . . . . . . . . . . . . . . . . . . . . .

*Opposite, top right:* When I came across this 1880s photograph of a Scottish hunter, I was immediately reminded of a family letter a friend, Candace Latham, had shared with me, and I've never been able to separate the image from the letter ever since.

The letter, written in the 1860s by Amarette McGibbon, relates a story about her great-grandfather (Candace's great-great-great-great-great-grandfather), Lemuel Badger (1754–1839), a New Hampshire resident and veteran of the American Revolution. Badger and his dog, "wolf hunter," had set out from New Hampshire to travel to Harpursville, New York, and the letter chronicles that journey.

Here is an excerpt:

*Great-grandfather Badger got a big, young dog to take with him into the wilderness and when they came to cross the Hudson River, by some accident, the dog was left behind, and finding himself left, he swam to the west side. Meanwhile, great-grandfather discovered the absence of his dog when he landed and went back—he and the dog crossing each other. The dog thus failed to find his master when he reached the land so swam back to the east side arriving just too late to join him and so swam the third time across the river before they got together. This is authentic. The dog was a famous wolf hunter, always going off to the chase when he heard the wolves on the hills and returning, perhaps torn and bleeding, but with an air of triumph.*

. . . . . . . . . . . . . . . . . . . . . . . . . . . . . . . . . . . . . . . . . . . . . . . . . . . . . . . . . . . . . . . . . . . .

*Opposite, bottom:* Two young Estonian women pose in the early 1910s with their terrier mixed breed in a vendor's handcart typical of the time.

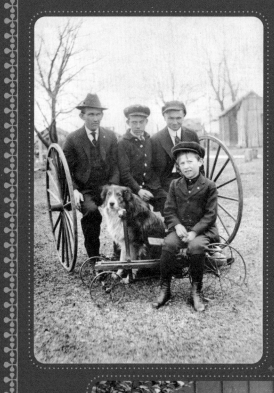

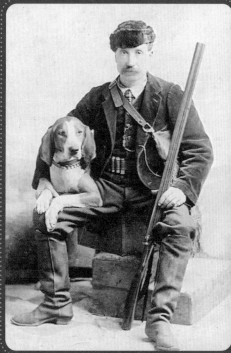

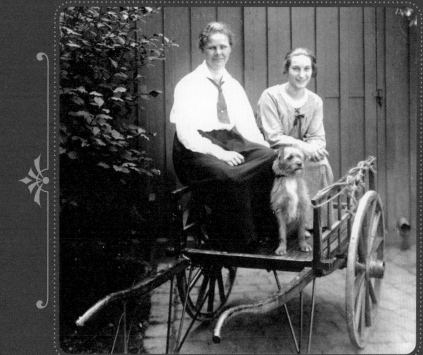

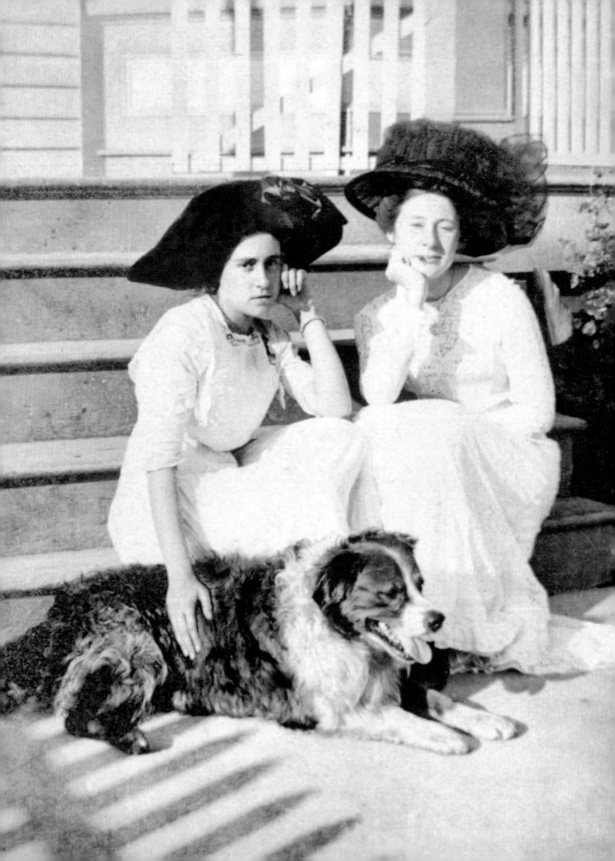

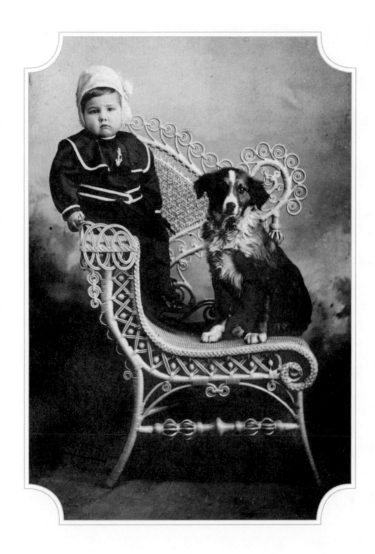

*Opposite:* The two young women in this image wear classic examples of "Victorian whites" along with the oversize hats that were de rigueur at the time. "Victorian whites" is a contemporary name given to the lightweight, breathable, loose-fitted clothing that defined the end of the Victorian and the beginning of the Edwardian eras. The bodices and dresses were made of cotton or linen or a mixture of both in material such as batiste, voile, and dotted Swiss.

.......................................................................................................

*Above:* The photograph of this young boy and his spaniel from Washington State was taken around 1900.

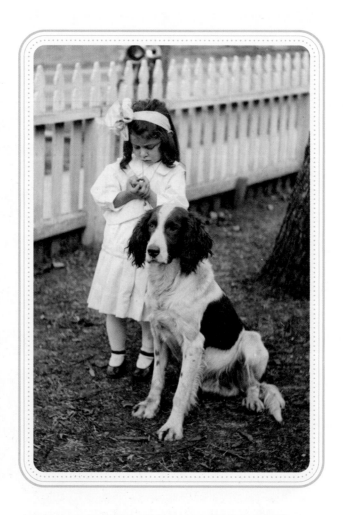

*Above:* This young Californian's white ribbon and dark hair appear to mimic her English springer spaniel's markings, circa 1910.

. . . . . . . . . . . . . . . . . . . . . . . . . . . . . . . . . . . . . . . . . . . . . . . . . . . . . . . . . . . . . . . . . . . . . . .

*Opposite:* The chiaroscuro effect of contrasting light and shadow in this turn-of-the-twentieth-century image gives it a painting-like feel that is further enhanced by the photographer's decision to photograph these Danish women in profile and their dog face forward. The lighting in this image comes from the left rather than the front, which yields a dramatic effect on the light and dark surfaces. The sentiment on the back of the photos wishes "*En Glædelig Jul*," Danish for "A Merry Christmas."

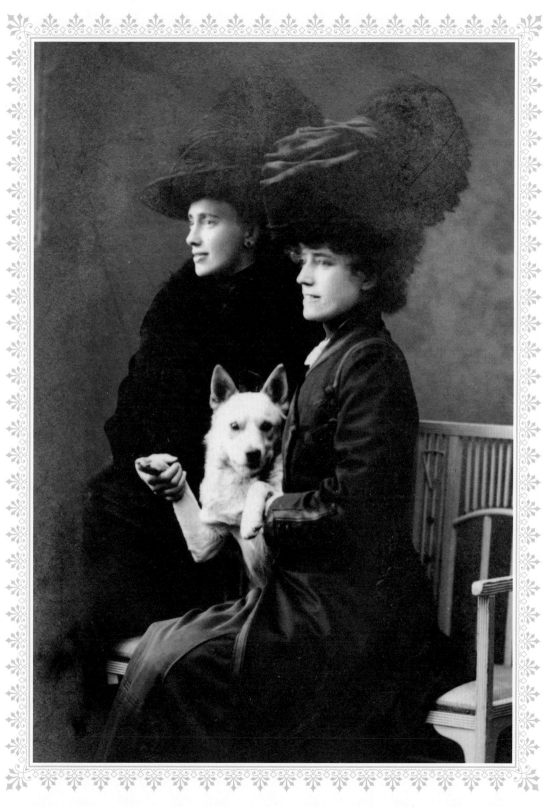

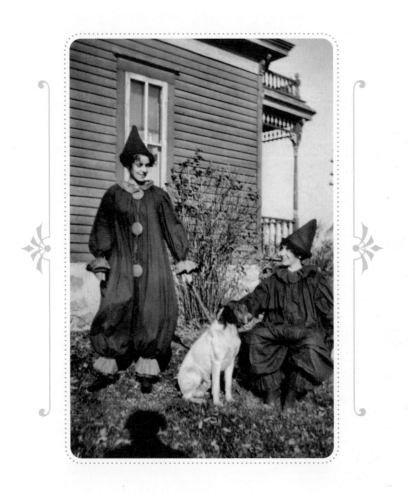

"The great pleasure of a dog is that you may make a fool of yourself with him and not only will he not scold you, but he will make a fool of himself too."

—SAMUEL BUTLER, from *The Note-Books of Samuel Butler*, 1921

*Opposite:* The pup takes center ring in this family circus, circa 1910.

. . . . . . . . . . . . . . . . . . . . . . . . . . . . . . . . . . . . . . . . . . . . . . . . . . . . . . . . . . . . . . . . . . . . . . . . . . . . . . . . . . . . . . . . . . . . .

*Above:* "Denmark, Harry, Evelyn and dog Herbie, 1920."

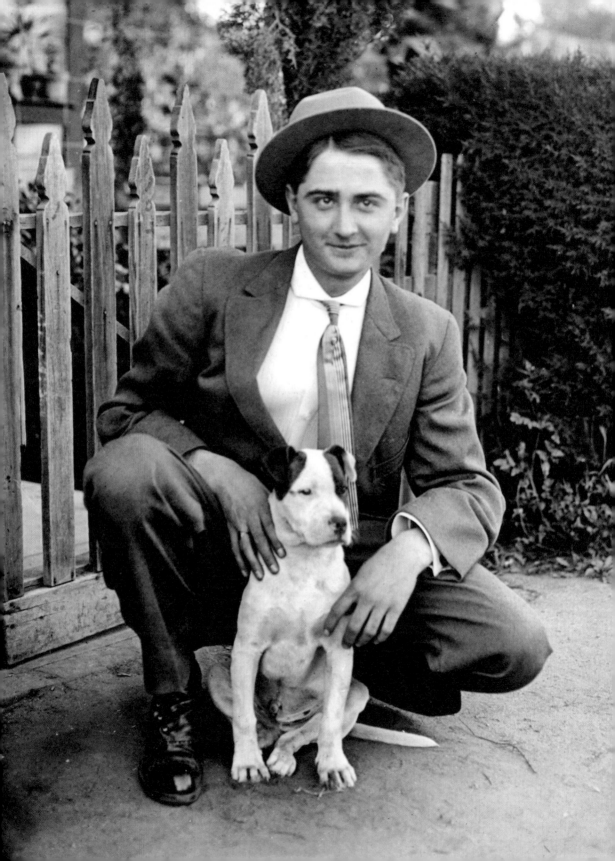

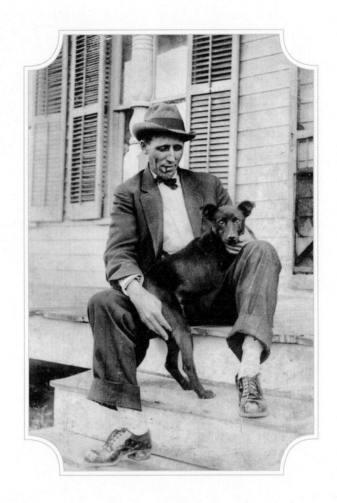

*Opposite:* This young California man who wore his hat nonchalantly on the crown of his head in 1910 posed proudly with his mixed breed Jack Russell terrier and boxer, seemingly unaware that the moment was fleeting. Thankfully, the occasion was captured by an amateur photographer.

. . . . . . . . . . . . . . . . . . . . . . . . . . . . . . . . . . . . . . . . . . . . . . . . . . . . . . . . . . . . . . . . . . . . . . . . . . . . . . . . . .

*Above:* The man's casual pose, his deeply cuffed pants, his crooked tie, and the cigar clenched at the corner of his mouth are a good portrait of a typical citizen in 1910. If a dog's ears face forward, this indicates interest, and this particular dog's curiosity regarding the photographer is clear, especially in combination with his intent stare. The overall simplicity of rustic, sun-beaten steps and shutters gives this photograph a warm, bucolic charm.

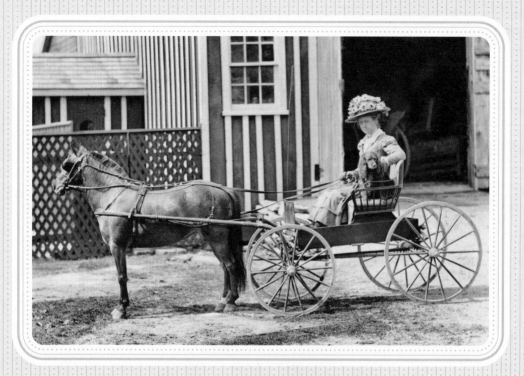

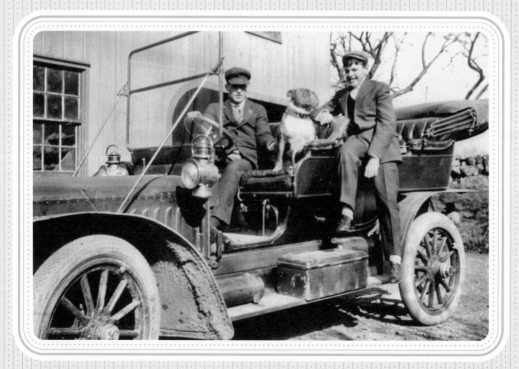

# Doggone with the Wind

OGS LOVED A ride long before there were automobiles. Even at their fastest, a horse and buggy could only attain a speed of ten to fifteen miles per hour—not exactly an ear-flapping pace, but certainly enough to get the wind racing through their nostrils.

An open car window not only offers dogs the soothing sensation of wind through their fur, it also offers a jumble of new and enticing odors—and danger. Dogs should never ride in a car with their head out of the window. No matter how much confidence you have in your pet, they may fall or even jump from the car given the right enticement, such as a bird or squirrel. Projectiles are also a danger. If a pebble can crack your windshield, imagine what it could do to your dog's eye.

There are numerous ways to keep your pet safe during travel in a vehicle. A harness seat belt, a plush carry box used along with a dog harness, and a crate are only a few. Find what works best for your dog to ensure they are properly secured before you set off or open the window; your pet will get all the fun and benefits of the breeze with few of the dangers.

........................................................................................

*Opposite, top:* Pat and her cocker spaniel, Logo, July 30, 1910, Canada.

........................................................................................

*Opposite, bottom:* A bulldog rides shotgun in this 1910 snapshot. The cylinder-shaped carbide generator on the running board was used to power the headlamps, which were pretty much obsolete by 1912.

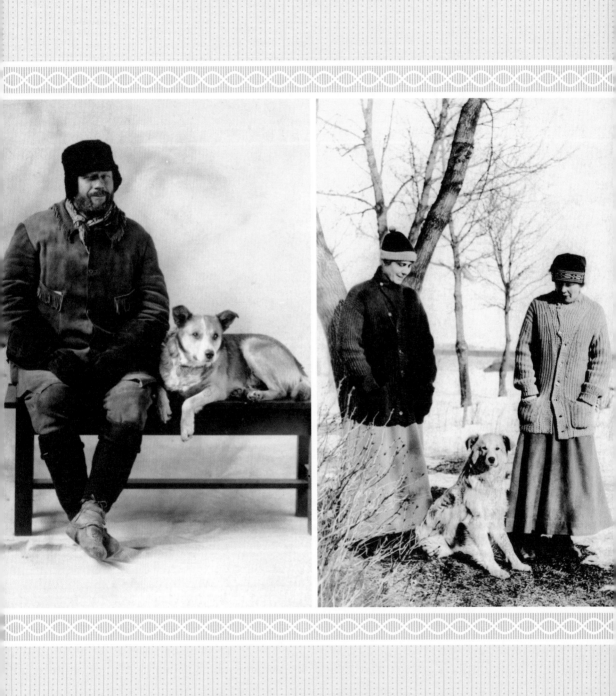

# How Cold Is Too Cold for a Dog?

**T**HE ANSWER DEPENDS on the breed, but the PEDIGREE Foundation warns that smaller breeds, puppies, older dogs, and dogs with thinner coats can become uncomfortable when the temperature goes below 45 degrees Fahrenheit (7.2 degrees Celsius). Breeds not bred for cold weather should wear sweaters or coats once the temperature reaches 32 degrees Fahrenheit (0 degrees Celsius).

. . . . . . . . . . . . . . . . . . . . . . . . . . . . . . . . . . . . . . . . . . . . . . . . . . . . . . . . . . . . . . . .

*Opposite, left:* This bundled-up man from Victoria, British Columbia, and his Norwegian elkhound appear to be as comfortable in front of a camera as they are with each other, early 1910s.

. . . . . . . . . . . . . . . . . . . . . . . . . . . . . . . . . . . . . . . . . . . . . . . . . . . . . . . . . . . . . . . .

*Opposite, right:* These young women, with their not particularly fashionable but practical, bulky, heavy coats and sweaters show us how people dressed for cold weather during the first decade of the twentieth century. The woman at the left is wearing a knit cap that would not appear out of place today.

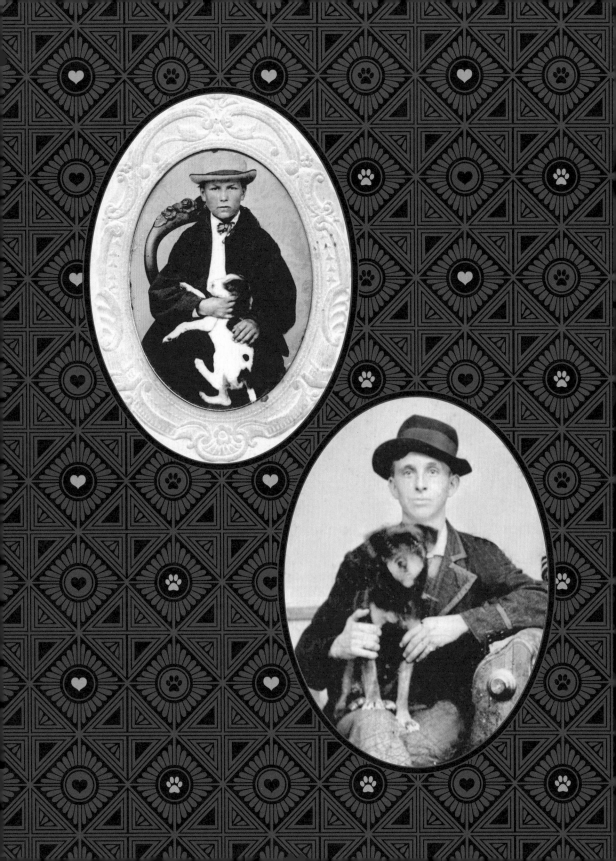

T HIS FERROTYPE OF a puppy struggling to maintain a comfortable position on his young friend's lap *(opposite, top)* is housed in a decorative Potter's Patent paper sleeve. Potter's sleeves were made specifically for ferrotypes, not only as a fancy way to display photos but to prevent them from becoming scratched. The paper sleeve was basically an envelope with an open end into which the image could be inserted. The elliptical or rectangular opening formed a frame around the image. The areas around the opening were often highly embossed to mimic an actual picture frame; sometimes the "frame" around the opening was printed.

Early ferrotypes are unique, but later innovations, such as the 1858 thirty-six-lens camera and the 1860 nine-lens camera, made it possible to capture multiple images at once. Of course, as the number of lenses increased, the size of the photograph decreased. The thirty-two-lens camera, for example, could yield thirty-two images, each around the size of an American penny. First described in 1853, ferrotypes were the dominant photographic image during the early 1860s, then their popularity steadily declined. They were last used at carnivals during the 1940s.

Ferrotypes typically ranged in size from 1⅜ by 1⅝ inches up to 6½ by 8½ inches. Large ones were often mounted on cards or in albums. Smaller examples, like those shown here, were often smaller than a US quarter and were referred to as gems. They were used in jewelry such as lockets, bracelets, and pocket watches.

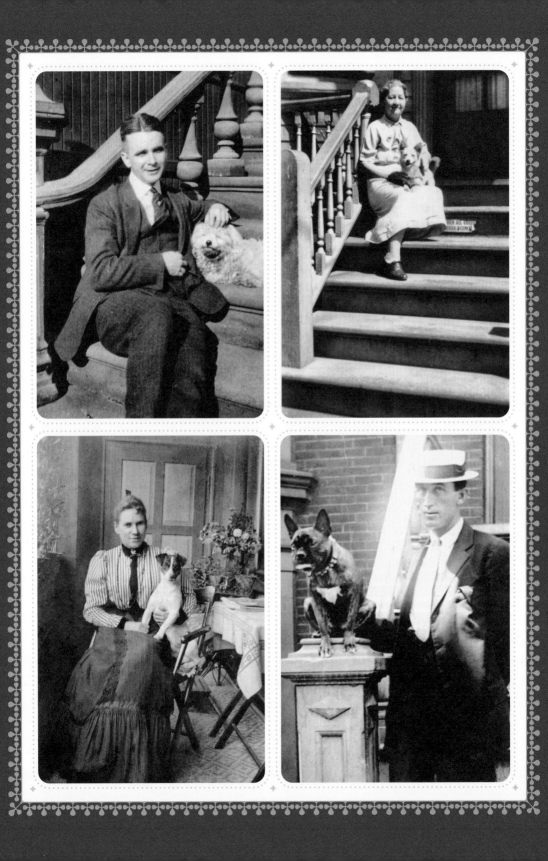

# On the Stoop

*Opposite, top left:* A New York City poodle enjoying a gentle head scratching by his owner, as he's warmed by the sun and the hot cement of the brownstone steps in the 1920s.

. . . . . . . . . . . . . . . . . . . . . . . . . . . . . . . . . . . . . . . . . . . . . . . . . . . . . . . . . . . . . . . . . . . . . . . . . . . . . . .

*Opposite, top right:* "Mom, Montrose Avenue, Jersey City, 1939."

. . . . . . . . . . . . . . . . . . . . . . . . . . . . . . . . . . . . . . . . . . . . . . . . . . . . . . . . . . . . . . . . . . . . . . . . . . . . . . .

*Opposite, bottom left:* A great early snapshot, circa the late 1890s. This woman, wearing classic turn-of-the-century garb, sits comfortably on her porch with her Jack Russell terrier.

. . . . . . . . . . . . . . . . . . . . . . . . . . . . . . . . . . . . . . . . . . . . . . . . . . . . . . . . . . . . . . . . . . . . . . . . . . . . . . .

*Opposite, bottom right:* This snapshot of this natty fellow in boater and tie and his French bulldog was taken with a handheld camera in the early 1900s.

ISTORICALLY, "PIT BULL" refers to any bulldog or bulldog mix that was used in the vicious, heartless pursuit known as bullbaiting rather than describing a specific breed. It is a term used to describe a group of dogs with the same behavioral tendencies as opposed to inherited characteristics.

When we look at a dog, though, we do not see behavioral tendencies; we see physical characteristics—and that is how most people identify a dog as a pit bull—by its looks. There is no specific DNA test to identify a pit bull; they are identified by physical characteristics (phenotye) rather than DNA (genotype).

Dogs who took part in bullbaiting were trained to do so; the viciousness did not occur to them naturally. Pitbullinfo.org explains that the dogs most people describe as pit bulls are a mix of more than four—and even up to twenty—different breeds.

A mixture of bulldog and terrier compose the four breeds usually associated with dogs identified as pit bulls. They are the American Staffordshire terrier, the American Bully, the American pit bull terrier, and the Staffordshire bull terrier.

*Opposite:* Taken during the first decade of the twentieth century, this photograph clearly captures the pride this woman has for her two white pit bulls majestically seated on her best pressback kitchen chairs. The automobile in the background hints at what their next escapade may be.

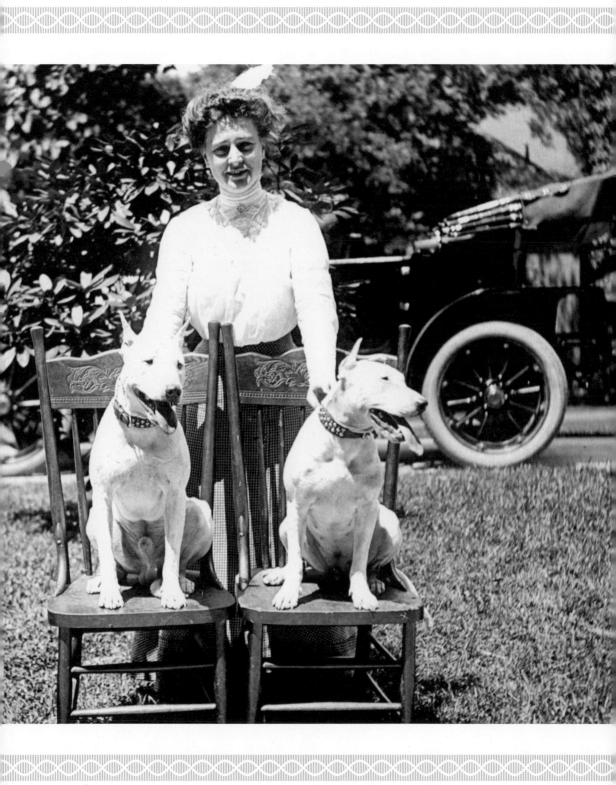

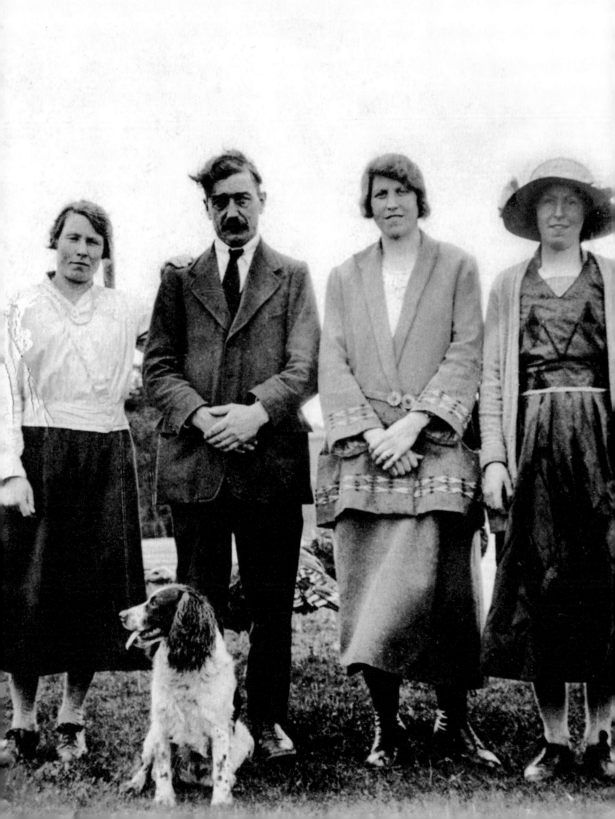

# Going Home: Toby's Story

TOBY WAS THE childhood dog of Susan Devine McGough, the mother of a close friend of mine. This story is testimony to the pure bond between dogs and their humans.

Susan said, "I turned ninety years old in 2020 and I still think of our Toby. Toby was a dog we had when I was a girl during the 1930s in Carrickmacross, Ireland. He was a lovely little doggie and he loved to sit in our front garden. One day, my mother was working in the garden and a man with a donkey and cart came along. He asked my mother if she wanted to sell Toby. Of course, my mother said no, she didn't want to sell him.

"It wasn't long after that that our Toby went missing. It wasn't like Toby to wander off. We searched and searched and couldn't find him. No one had seen him. In those days, everyone knew everyone or knew someone who knew someone who knew someone you also knew. Everyone watched out for our Toby, but Toby was nowhere in Carrickmacross.

"About two weeks later, on a Sunday at around 6:30 in the morning, my mother was starting up the stove in the kitchen when she heard a scratching at the door. She opened the door and there was Toby. The poor wee thing looked thin and had a rope tied tightly around his neck. The rope trailed behind him and the end of the rope was all frayed; you could see where the poor little fellow had chewed through it to escape. After he jumped all over our mother, he ran from bedroom to bedroom, jumping on our beds, waking us up, and kissing all of us. What a happy day.

"We never found out where he had been held, but he found his way home. After that, we kept an eye on him—and everyone in our lane kept a watch for that man with the donkey and cart."

........................................................................................

*Opposite:* Susan Devine McGough's dog Toby with her parents and aunts, Carrickmacross, Ireland, 1930s.

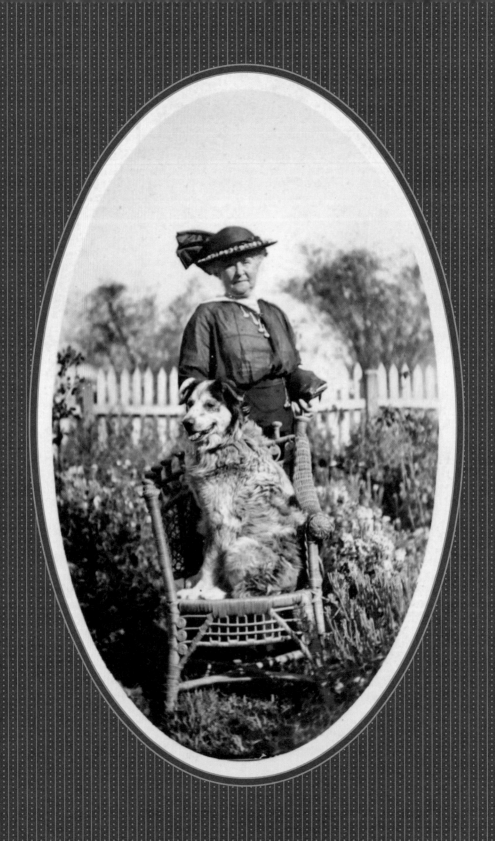

*Opposite:* "May, from Australia" is the simple inscription on the back of this photograph taken during the 1910s.

. . . . . . . . . . . . . . . . . . . . . . . . . . . . . . . . . . . . . . . . . . . . . . . . . . . . . . . . . . . . . . . . . . . . . . . . . . . . . . . . . . . . . . . . .

*Above:* "Mary, age 14 months, and Peter." Mary from Pennsylvania is adorable, but Peter the spaniel is clearly the main attraction.

# A Universal Celebration
# of Dogs

THE FESTIVAL OF Tihar is a yearly celebration held by Nepalese Hindus in late October or early November. The festival celebrates family ties as well as the relationship between humans and four specific animals: the crow, the dog, the cow, and the ox. The second day of the festival, Kukur Tihar, is dedicated to dogs for their companionship and devotion.

In Chinese tradition, the second day of the new year is considered the birthday of the dog and as such, dogs, whether household pets or strays, are well fed.

The "birthday of all dogs" is celebrated in Bolivia on August 16, the feast day of Saint Roque, the Catholic patron saint of dogs. People groom and often dress their dogs before bringing them to church for a blessing.

The Mystic Krewe of Barkus parade takes place during Mardi Gras in New Orleans. Featuring floats and hundreds of dogs in costumes, the parade's theme varies from year to year. Everyone is free to join in, and there is no fee. Details can be found on the Mystic Krewe of Barkus website.

The largest dog festival in North America is Woofstock in Toronto. Woofstock offers fashion shows, contests, and exhibitions displaying the latest in dog products of every type. Woofstock takes place in May.

...........................................................................

*Opposite:* Two shepherds from Illinois, circa 1906.

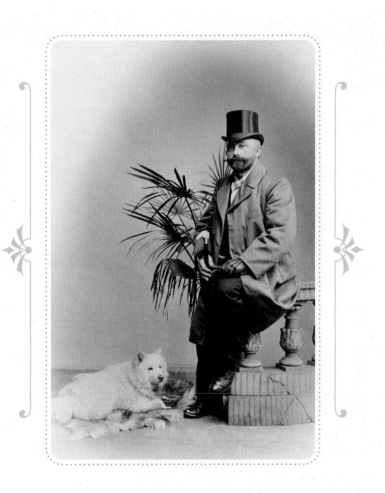

*Opposite:* A young woman with her spitz, Egypt, 1920s.

*Above:* Putting on my top hat, my white tie—and we'll both wear tails. The fellow in this photograph taken in Germany during the 1880s has all the accessories distinguishing a true gentleman of the day. In addition to his beautifully tailored overcoat, he's accessorized magnificently with a shiny beaver-skin top hat, leather gloves, leather shoes, a large watch chain, and a walking stick with an ivory handle.

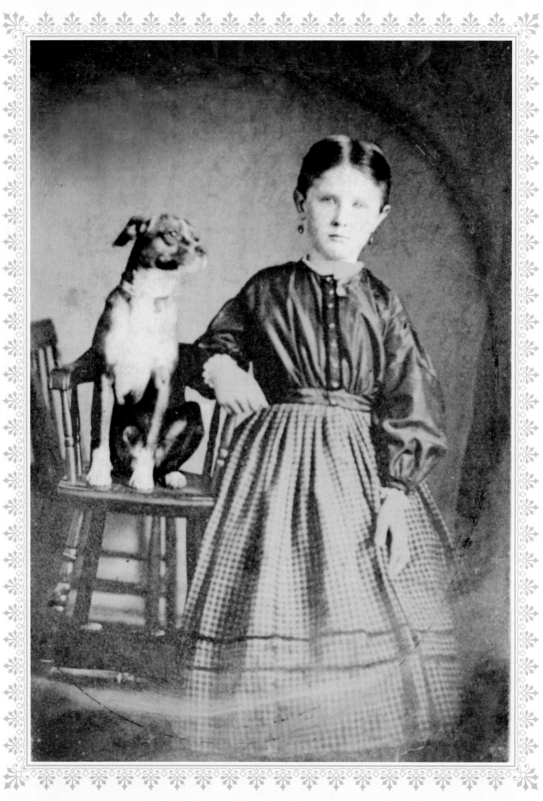

THIS YOUNG GIRL and her dog *(opposite)* were photo-graphed by William H. Dole, an ambrotype photographer who operated a studio on Hanover Street in Boston's North End from 1862 to 1865. The girl looked directly into the camera while her dog—pos-sibly distracted by her parents or the photographer's assistant—looked off to the side. The image is remarkably clear despite its age and the fact that this pair would have had to remain motionless for twenty to sixty seconds depending on the available sunlight.

This image is known as a carte de visite (visiting card), so called because it was the approximate size of the calling cards people used at the time. These paper photographs were mounted on card stock to yield an image that was 2½ by 4 inches. Cartes de visite were introduced during the mid-1850s, reached their peak of popularity during the mid-1860s, and ultimately waned in popularity by the turn of the century. Several exposures could be made at once, and the original negatives could be stored for future prints. These images are known as albumen prints because the process required coating the photographic plate with egg whites.

There is a tax stamp on the back of this image, which indicates that it was taken between August 1864 and August 1866. During that time the United States government found a way to effectively tax sunlight for a small portion of the population: photographers and their subjects. A tariff was placed on all photographs, with the surcharge depending on the cost of the image. Since Dole was active until 1865, the date of this image is somewhere between August 1864 and sometime in 1865.

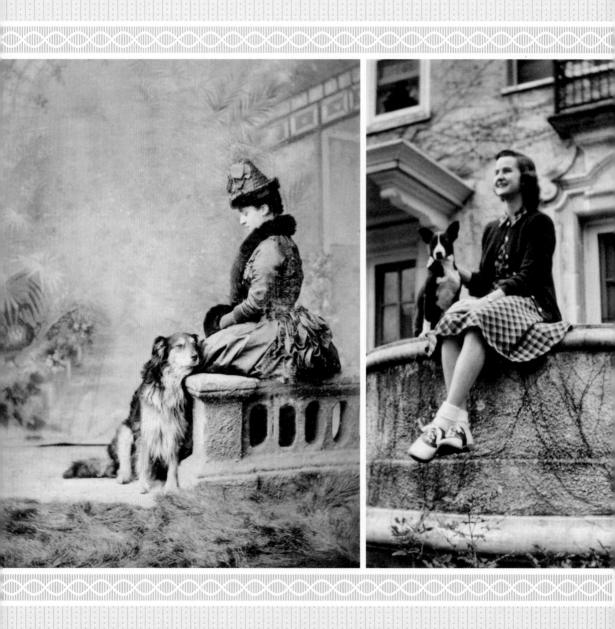

THE YOUNG WOMAN in 1880s England *(opposite, left)* and the American teenager photographed in the late 1930s or early 1940s *(opposite, right)* may both be perched on cement balustrades, but that is the only similarity in these two images taken fifty years apart. The change in women's fashion over that period is remarkable.

To begin with, the Englishwoman would have been wearing at least four layers of clothing. There were above-the-knee stockings held by garters, cotton drawers with a split in the center for using the toilet, and a knee-length chemise. Over that, she wore a steel-ribbed or whalebone corset to pull in her waist and push up her bustline.

To achieve the desirable bell shape of her gown, she wore a flexible steel cage, known as a crinoline, which at the height of its popularity could reach a circumference of 15 to 18 feet at the hem. Next, a camisole went over the corset to protect the inside lining of her clothing from sweat. A plain petticoat covered the steel crinoline to protect the next layer of fancy embroidered petticoats from the steel crinoline. A second petticoat helped hide the lines of the steel cage crinoline and had a fancy hem that would be revealed when the skirt rode up while walking, stepping into a coach, or climbing stairs.

Finally came the actual dress that always had a high neck and long sleeves for daytime. And after that, the young woman adorned herself with the required accessories: gloves, bonnet, shawl, and parasol. The woman in this photograph carried a muff and wore a bustle, too. It is hard to imagine acclimating to such restriction, though her dog certainly looks comfortable, sitting in a dreamy repose.

As for the American girl, a simple dress and sweater were all she needed to look appropriate. Her black-and-white saddle shoes are a nice match—intended or not—with her dog's coat. Saddle shoes are most closely associated with teenage girls of the 1940s, often called bobby-soxers—a reference to the popular ankle-high socks worn by these enthusiastic fans of pop music and the singers of the day. Although saddle shoes originated in 1906, they did not reach the apex of their popularity until the 1950s.

# Romey's Story:
## Hero of the Johnstown Flood

ON MAY 31, 1889, 14 miles above the city of Johnstown, Pennsylvania, the South Fork Dam broke, unleashing more than 10 million tons of water on the city. The dam was the largest earth dam in the United States at the time, at 900 by 72 feet, but it had not been maintained due to the local canal system's decline and the railroad's rise as a preferred means of transporting goods. The day before the flood, it had rained persistently, and the dilapidated dam became clogged with detritus, then burst. Water swept down at 40 miles per hour through the valley in which Johnstown was located, causing the deaths of more than 2,200 people. The raging flood was so powerful that bodies were found more than 100 miles away in Ohio.

During the flood, Charles Kress, his wife, their young daughter, and a housemaid sought refuge on the roof of their home, along with their Newfoundland, Romey, and three other people. The house was quickly swept away beneath them, leaving the desperate survivors floating on the wildly pitching roof. Great waves swept across the roof and, one after the other, Mrs. Kress, the Kresses' daughter, and the housemaid fell into the churning waters. Romey jumped into the swirling water and, one by one, pulled each of them safely back to the roof. Mrs. Kress was washed from the roof a second time and again Romey, without hesitation, dove into the debris-filled waters and pulled her to safety. The Kress family, their housemaid, and the others who took refuge on the Kresses' roof all survived the deluge.

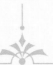

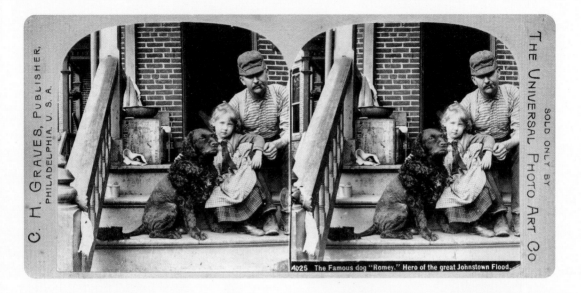

4025    The Famous dog "Romey." Hero of the great Johnstown Flood.

*Above:* This stereoscopic image, taken in 1889, is of Charles Kress, his daughter, and their Newfoundland, Romey.

*Right:* This 1880s ferrotype of a man dressed in a somewhat shabby suit, no tie, and a bowler hat with his large Labrador and golden retriever mixed breed is a perfect example of the photographer's familiarity with depth of field. The man and his dog stand out in the foreground, while the background is blurred.

The bowler hat, as it is known in England, is a hat associated with the working class, while the top hat was worn by the upper class. Bowlers were first made in 1849 by Lock & Co. Hatters. They were designed specifically for gamekeepers who rode horses through wooded areas. The hat's low crown made it less likely to be knocked off by low-hanging branches. In the United States, the hat is called a derby because it was worn by derby riders.

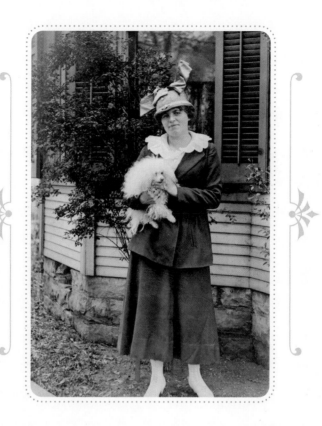

*Opposite:* This quite stylish young girl made a most fashionable portrait in Philadelphia, 1910, with her white dress and stockings, ankle-strap shoes, and parasol. Her large, broad hat and little dog as accessory echoed the latest in grown-up fashion at the time.

. . . . . . . . . . . . . . . . . . . . . . . . . . . . . . . . . . . . . . . . . . . . . . . . . . . . . . . . . . . . . . . . . . . . . . . . . . . . . . . . . . . . . . . . . . . . .

*Above:* Some dog breeds have fur; others have hair. The difference between hair and fur in a dog is that fur reaches a certain length and is shed naturally, whereas a dog with hair needs cutting to keep their hair trim. As a result of breeding, poodles like the one seen here looked a bit different one hundred years ago than they do today. Their hair was fluffy, rather than curly. Poodle fur, like human hair, responds to hormonal changes. Female poodles can experience hair-thinning and loss after delivering a litter.

This poodle's mistress wears a hat reminiscent of that worn by Mercury; one would almost expect to see winged sandals.

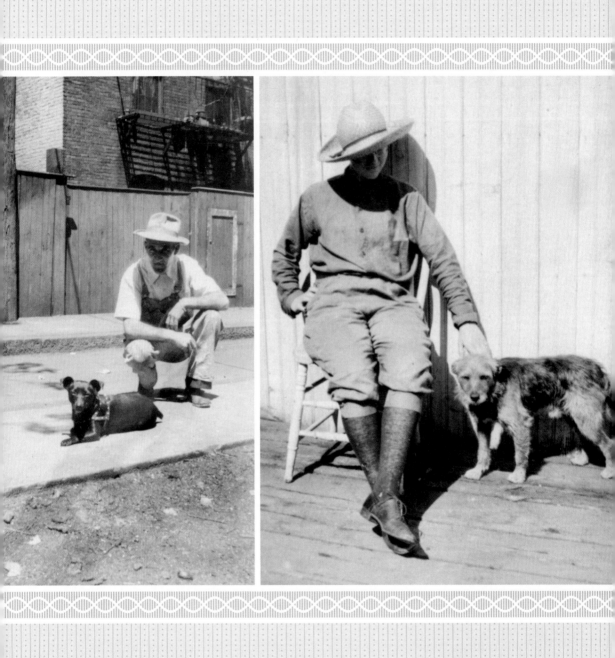

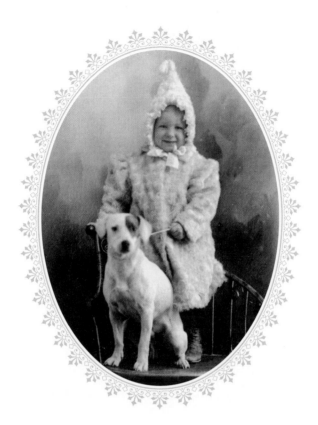

*Opposite, left:* Aside from the wonderful little New York dog from the 1910s who lies so patiently to have his photo taken, it is the light and shadow of the urban landscape that make this photo so appealing. The viewer's eye is taken from the dark dog on the light ground to the man in light-color clothing and up to the striped shadows of the fire escapes.

. . . . . . . . . . . . . . . . . . . . . . . . . . . . . . . . . . . . . . . . . . . . . . . . . . . . . . . . . . . . . . . . . . . . . . . . . . . . . . . .

*Opposite, right:* This photograph was shot in Massachusetts circa 1910. The way in which the photographer uses light and shadow and treats his subjects captures a relaxed attitude that is almost palpable. The woman with her large-brimmed, jauntily placed hat, dark stockings, knee-breeches, and crossed ankles is almost reclining in her bow-back Windsor chair against the sun-bleached barn as she reaches down to stroke her dog.

. . . . . . . . . . . . . . . . . . . . . . . . . . . . . . . . . . . . . . . . . . . . . . . . . . . . . . . . . . . . . . . . . . . . . . . . . . . . . . . .

*Above:* This happy, winter-ready young girl proudly posed with her terrier mix in Washington State, circa 1900.

# Loyal Legends: Greyfriars Bobby and Hachikō

**D**OGS ARE RENOWNED for their loyalty. There are two dogs in particular whose examples of loyalty have become legend.

In Edinburgh, Scotland, there is a monument to a Skye terrier known as Greyfriars Bobby. Bobby and his owner, John Gray, were inseparable. When John died in 1858, he was buried in Greyfriars Cemetery; Bobby kept watch over his master's grave for fourteen years, even in terrible weather. At that time in Edinburgh, dogs without a license were destroyed as strays, so the Lord Provost of Edinburgh, William Chambers, paid for Bobby's license every year. Bobby also made daily trips to a local eatery where Gray had stopped for meals; about four years after Gray died, the place was bought by John Traill and became Traill's Coffee House. Traill who was also the curator of the cemetery, continued to feed Bobby when he showed up at the restaurant. Bobby died in 1872 and was buried in the same cemetery, not far from John.

In Japan, outside the Shibuya Station in Tokyo is another monument to a dog famous for his loyalty. Hachikō, an Akita Inu born in 1923, accompanied his master, Hidesaburō Ueno, a professor, to the train station each day beginning in early 1924. He also returned to meet the man each evening when he arrived home. Ueno died suddenly on May 21, 1925, while at work. Each afternoon, for the next ten years, Hachikō returned to the station at the usual time to wait for his master. He died in 1935 and was buried alongside Ueno.

........................................................

*Opposite, top:* A woman and her Skye terrier enjoying an outdoor Pennsylvania setting in style, complete with a crewelwork settee and Oriental carpet, circa 1905. Skye terriers were first bred on Scotland's Isle of Skye to kill rodents, otters, badgers, and foxes. This dog sports the classic Skye peekaboo bangs associated with the breed.

........................................................

*Opposite, bottom:* "Czechoslovakia, September 19, 1921." This photograph is interesting in that the right and left halves are almost mirror images. The men are dressed very much the same.

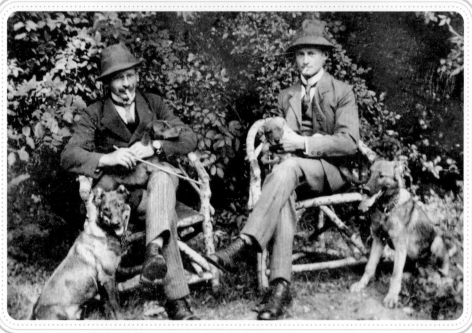

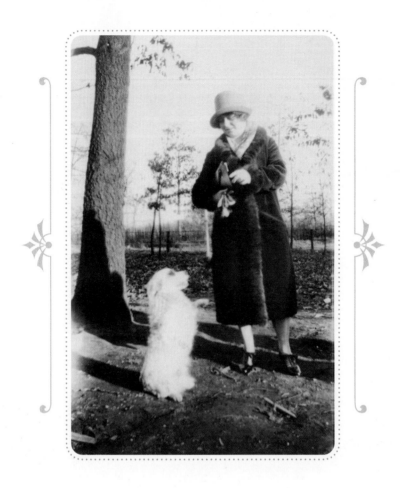

# Begging for attention.

*Above:* A snapshot, location unknown, 1920s.

........................................................................................................

*Opposite:* California, 1909.

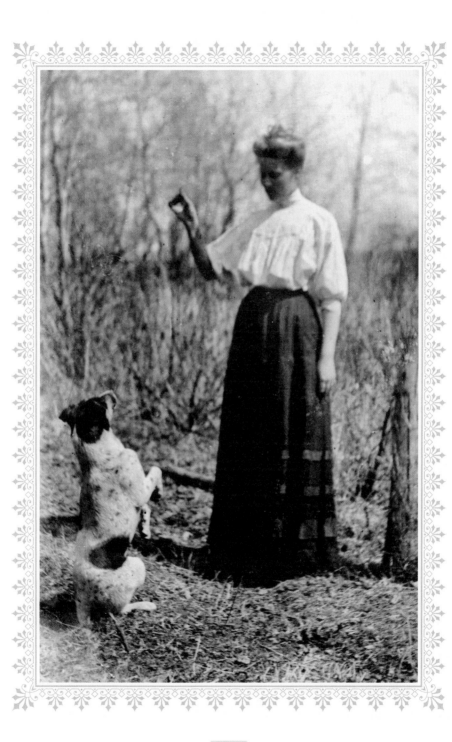

# Mercy Dogs

**M**ERCY DOGS SCOURED the battlefield in search of wounded soldiers to whom they would provide emergency medical supplies. The dogs performed one of the most dangerous jobs during the war and thousands of them were killed in the line of duty. They were trained to retrieve an article of clothing from the wounded, return it to a medic, then lead the medic to the wounded man. They would also lie alongside the wounded and dying until help could be rendered. Mercy dogs were even able to detect life in those who were considered dead.

More than fifty thousand Red Cross dogs, or mercy dogs, served both the Central Powers and the Allied Powers during World War I. Mercy dogs were specifically trained for this duty in Germany during the nineteenth century. During World War I, most countries had mercy dog training programs. Boxers, German shepherds, Doberman pinschers, collies, pointers, and setters were all used for this purpose.

In addition to identifying and tending to the wounded, dogs were trained to carry munitions and other supplies from battlefield headquarters to men in the trenches. They were stealthy, swift, and able to crawl through barbed wire to deliver messages to the front and from the battlefield to command centers.

Terriers, whose name comes from the Latin *terra*, meaning "earth," were named for their ability to track and capture small animals both above and below ground. During World War I, trenches, usually twelve feet deep, were dug throughout war-torn Europe. Troops spent anywhere from a day to weeks in these earthen slits that were littered with human refuse, garbage, and, very often, rotting corpses. These conditions attracted rodents, especially rats, that decimated food stores and often bit soldiers as they slept. Terriers, notorious ratters, were extremely efficient in combatting these vermin.

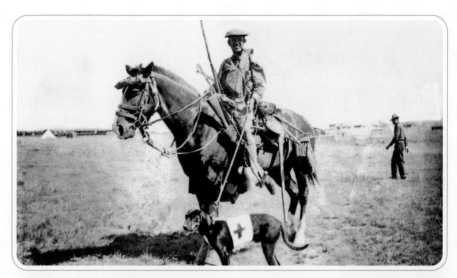

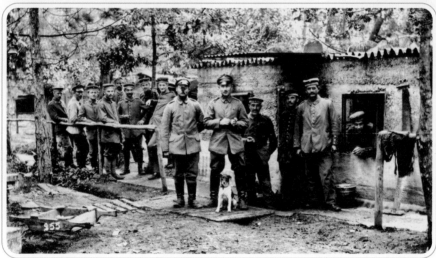

*Top:* Bill and his mercy dog at Fort D. A. Russell in Marfa, Texas, circa 1917. The back of the photo is inscribed: "Dear Mrs. Barry, I am sending this picture of a fully equipped soldier. Note the gas mask on horse and wireless. Bill."

*Bottom:* This World War I image, dated September 22, 1917, shows a group of German soldiers with their tiny terrier, who not only protected them from rats, but provided companionship and comfort under unimaginable conditions.

*Above, left:* A studio photograph of a very well-dressed young boy in a one-piece shorts outfit, white cotton stockings, and leather boots with his Airedale terrier. The elaborate trompe l'oeil backdrop indicates the image was taken in an exclusive photography studio.

. . . . . . . . . . . . . . . . . . . . . . . . . . . . . . . . . . . . . . . . . . . . . . . . . . . . . . . . . . . . . . . . . . . . . . . . . . . . . . . . . . . . . . . .

*Above, right:* Helen and her Boston terrier mixed breed, Florida, circa 1910.

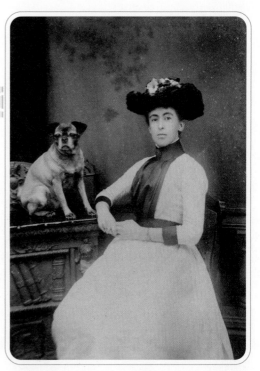

*Above, left:* Is it possible to have a canine doppelgänger? A young woman and her pug, March 1884.

*Above, right:* While the pup in this 1890s picture is no Toto doppelgänger, his mistress bears an uncanny resemblance to Miss Gulch.

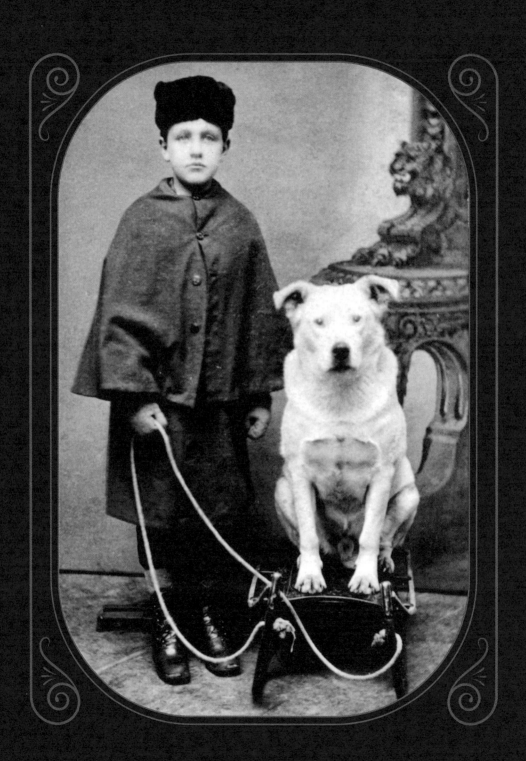

*Opposite:* This large shepherd mixed breed posed on a sled with his boy companion during the 1870s in Salamanca, New York, a city within the Allegany Indian Reservation and governed by the Seneca Nation of New York. This image was taken by the distinguished photographer J. H. Blessing, who has been recognized for his images of members of the Seneca Nation. His most famous photographs were of Ah-Weh-Eyu ("Pretty Flower"), also known as Goldie Jamison Conklin. Blessing's image of Conklin was used by the Cattaraugus Cutlery Company of Little Valley, New York, to sell a line of their knives.

. . . . . . . . . . . . . . . . . . . . . . . . . . . . . . . . . . . . . . . . . . . . . . . . . . . . . . . . . . . . . . . . . . . . . . . . . . . . . .

*Above:* The sled in this circa-1900 image from Canada is most likely meant to haul wood for the fire, although this pair—one a pointer, the other a retriever—is certainly strong enough to pull their mistress if she needed a ride.

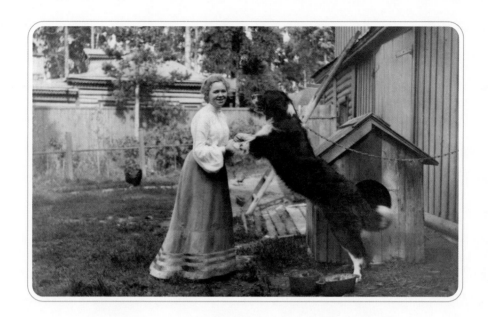

# In the Doghouse

**D**OGHOUSES, ONCE QUITE commonplace, are seldom seen today. During the nineteenth and well into the mid-twentieth century, many dogs slept or even lived in these shelters—some during the warm months and others year-round. There were practical reasons for this, especially during the warm months when flea activity was high and available remedies were few. Having a dog outside the house at night also served to alert homeowners to trespassers and potential burglars.

*Opposite:* In 1924, Elsie took time out of her road trip to pose with her two dogs and her Chevrolet Coach automobile in Michigan.

*Above:* This photograph was taken in Russia during the 1890s, when the country was still under czarist rule.

*Above:* England, early 1910s.

. . . . . . . . . . . . . . . . . . . . . . . . . . . . . . . . . . . . . . . . . . . . . . . . . . . . . . . . . . . . . . . .

*Opposite:* Maryland, circa 1900.

*Above:* An Englishman with his mixed breed Saint Bernard, circa 1890s.

*Opposite, top:* Only a true friend would help with the yard work. Notice the two dogs, a pug and a terrier mixed breed, in the leaf bin. Connecticut, circa 1910.

*Opposite, bottom:* Setter mixed breed, New York, circa 1910.

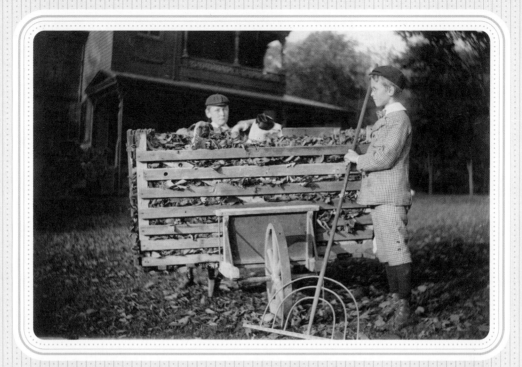

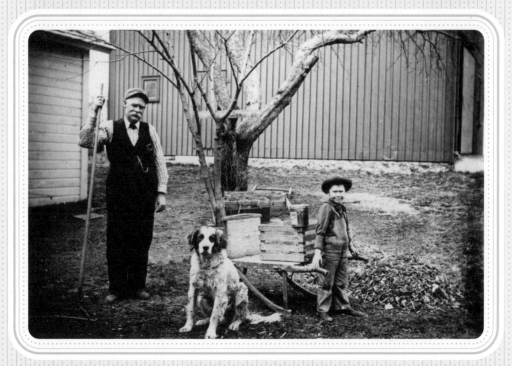

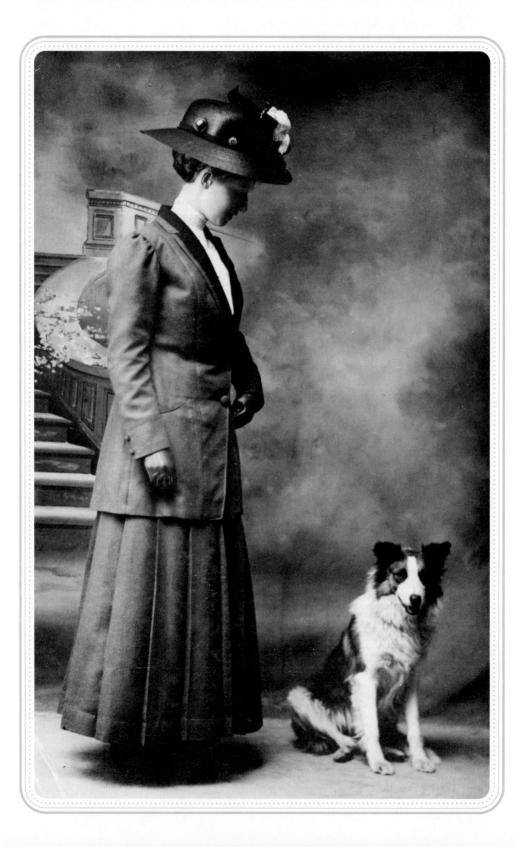

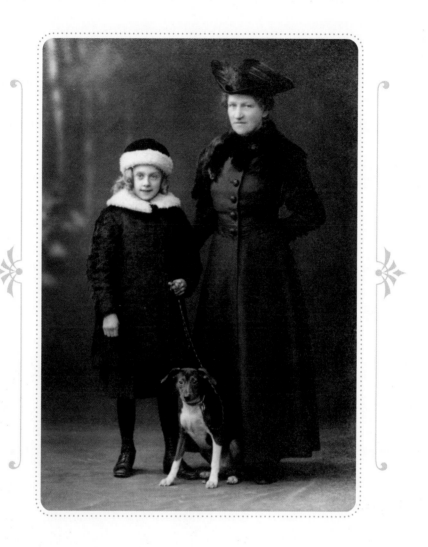

*Opposite:* Alma and her collie, Psyche, Kansas, circa 1915. On the back of the photo is the following inscription: "What do you know about Psyche and me? She is a whole year old now, and a big dorgie [*sic*]. Write pretty soon, Alma."

. . . . . . . . . . . . . . . . . . . . . . . . . . . . . . . . . . . . . . . . . . . . . . . . . . . . . . . . . . . . . . . . . . . . . . . . . . . . . . . . . . . . . . . . . . . . . . . . .

*Above:* A mixed breed terrier and friends in Sweden, circa 1915.

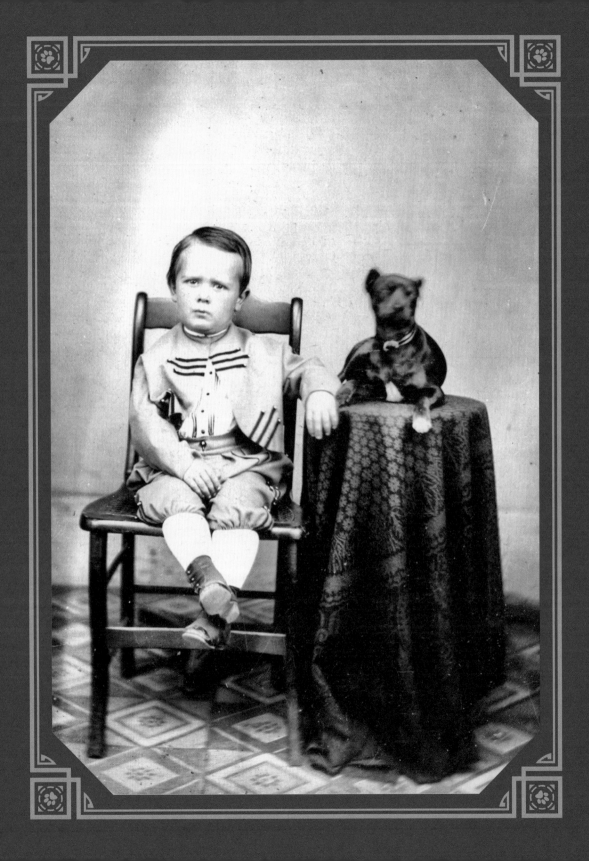

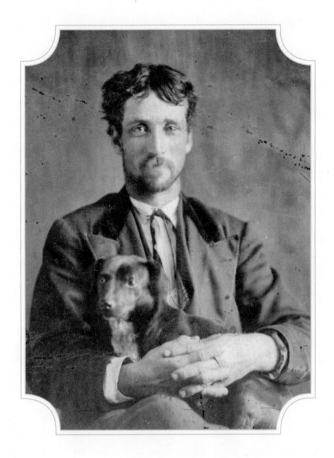

*Opposite:* The slight blur in this image indicates that the small black dog in this ferrotype from the 1860s was unable to keep his head perfectly still during his time in front of the camera.

..............................................................................................................................

*Above:* The first animal shelter meant to house homeless and stray animals until they could find permanent homes was established in 1869 by Caroline Earle White in Bensalem Township, Pennsylvania. By 1900, the notion of obtaining a pet from a shelter had been firmly established. Originally called the Women's Humane Society for the Prevention of Cruelty to Animals, White's shelter is still operating today as the Women's Animal Center. There are now about fourteen thousand shelters and rescue groups in the United States alone. According to the American Pet Products Association, since the shelter-in-place restrictions of the COVID-19 pandemic took effect, more than twelve million American households have gotten a pet. The image here of the man and his mixed breed dog is a ferrotype, circa 1865.

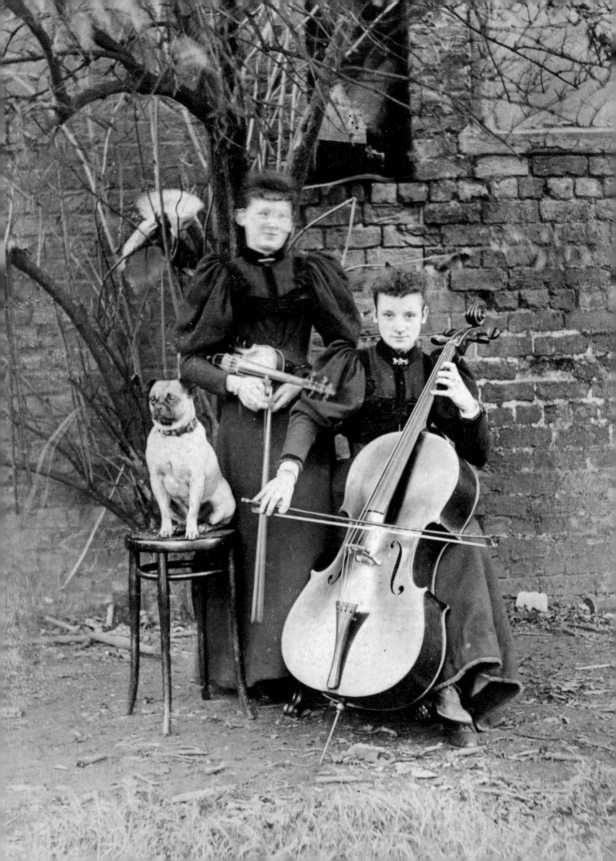

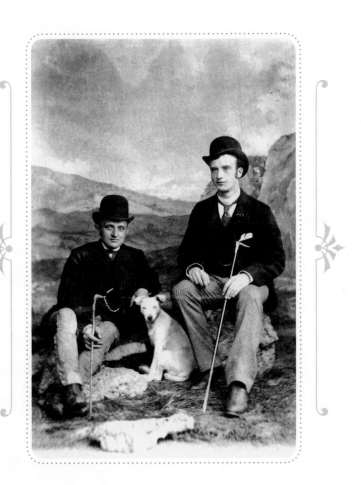

*Opposite:* Just what possessed these two young women from England to pose in their garden with a cello, a violin, and a pug is something we'll never know for sure, but it certainly made for an interesting photograph. The large leg-of-mutton sleeves on the dresses indicate that this image was taken during the mid-1890s.

*Above:* A dog keeps company with two English gentlemen in suits, bowler hats, and identical walking sticks in this 1880s portrait. That the men would dress in their best clothing and include their dog in the photograph signifies the dog's importance to them.

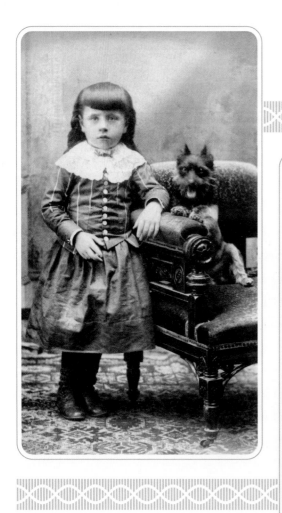

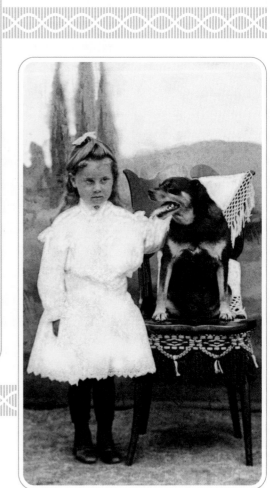

*Above, left:* Massachusetts, 1880s.

........................................................................................................................

*Above, right:* A simple kitchen chair decorated with a fringed shawl and festooned with embroidery served as the prop upon which this dog sat for his photograph with his young mistress in California around 1905.

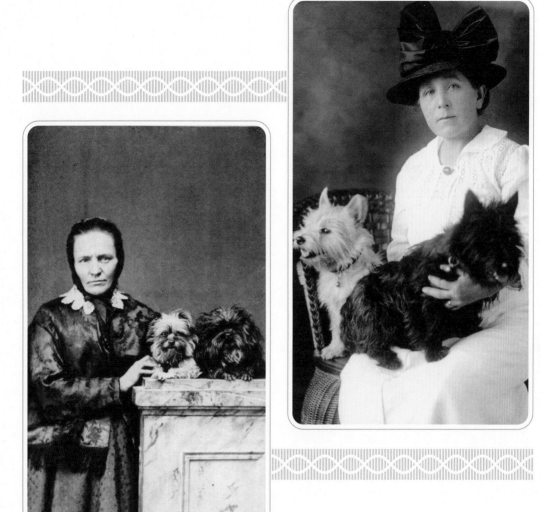

*Above, left:* Two affenpinschers and their owner, Austria, 1880s.

. . . . . . . . . . . . . . . . . . . . . . . . . . . . . . . . . . . . . . . . . . . . . . . . . . . . . . . . . . . . . . . . . . . .

*Above, right:* This woman with her West Highland white terrier and Scottish terrier seemed to color coordinate her outfit with her dogs. Pennsylvania, circa 1910.

*Opposite, top left and right and bottom left:* These three images, all of the same family with their large curly-coated retriever, were taken in Scotland during the 1850s.

The curly-coated retriever, originating in the early eighteenth century, is among the oldest of the retriever breeds and was bred to retrieve game from land or water. The crisp waves and curls of its double coat are resistant to brambles and thorns. The coat is waterproof and especially resistant to cold water temperatures. Excellent swimmers, these dogs are descendants of three breeds, the English water spaniel, the retrieving setter (both extinct), and the Irish water spaniel.

Today's curly-coated retriever may look a bit different from the dog in these images from the 1850s. According to the American Kennel Club, it is believed the curly-coated retriever was mixed with the poodle to tighten its curls sometime during the 1880s.

. . . . . . . . . . . . . . . . . . . . . . . . . . . . . . . . . . . . . . . . . . . . . . . . . . . . . . . . . . . . . . . . . . . . . . . . . . . . . . .

*Opposite, bottom right:* Although this photograph from around 1920 was found in Tennessee, both humans wear a curly cashmere sheepskin formal sporran, a pouch that replaces pockets on kilts. He wears a plaid glengarry hat and she a traditional Billie skirt. Their retriever mixed breed dog takes posing in stride. Note the shadow of the photographer and his camera.

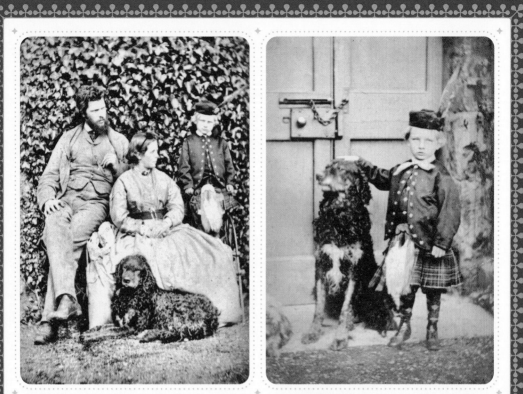
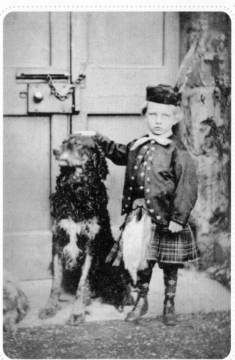
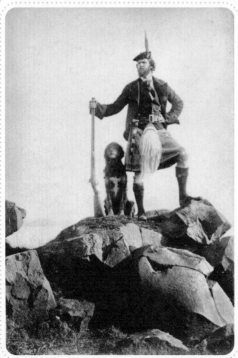
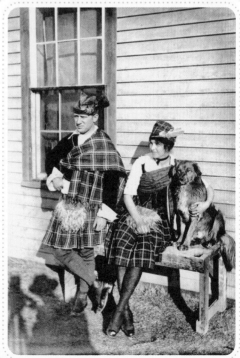

THIS YOUNG FAMILY *(opposite)*, who posed in Northampton, Massachusetts, during the mid-1890s, included their dog in their photograph. From the dog's position in the image, it's clear their pet was a cherished member of the family. With all four subjects looking directly into the camera, the photograph is quite intimate.

There are many subtle clues in vintage photographs that help to date the image and that might also reveal more about the subjects than what is seen at a passing glance. The photograph was taken by Amand J. Schillare, a professional photographer who advertised, "Large work a specialty." Schillare wrote a note on the back of the photograph that says, "wants the hand to be seen." The photographer's note and the position of this child's hand suggest she may have suffered a brachial plexus injury during birth. (The brachial plexus is a large network of nerves that carries signals from the spinal cord to the shoulder, arm, and hand and is often damaged due to neck trauma.) The large leg-of-mutton sleeves on the woman's dress were fashionable during the mid-1890s, as was the man's off-center hair part.

This photograph is a cabinet card, a paper photograph mounted on card stock with an average size of 4¼ by 6½ inches. Cabinet cards, like cartes de visite, are also known as albumen prints because the photographic plate is coated with an egg-white emulsion.

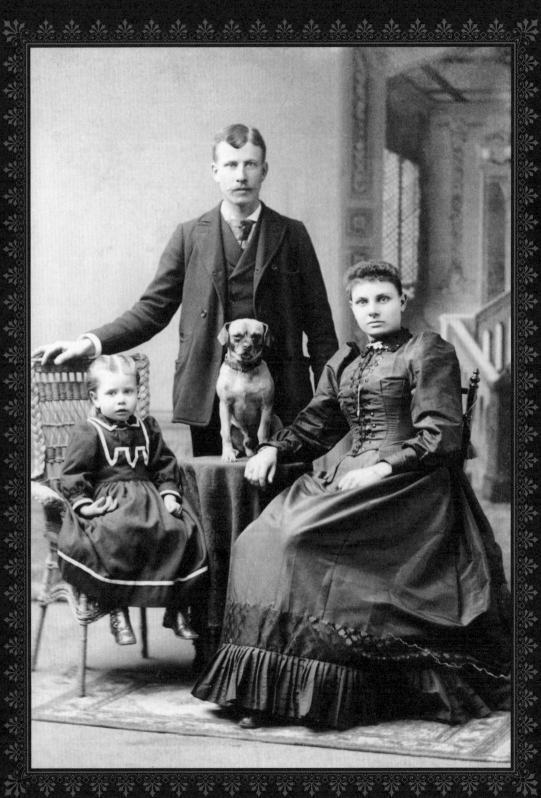

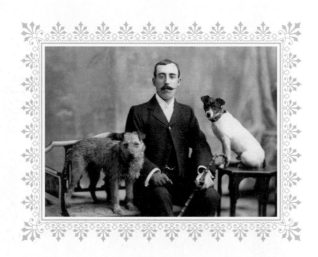

# A Dog . . . or Two?

WHEN DECIDING WHETHER TO HAVE ONE dog or two (or more), there are many considerations, especially cost. Whether you buy a purebred dog from a breeder for thousands of dollars or rescue a dog for a more modest adoption fee, you will have healthcare bills for vaccinations and health maintenance. And as the dog grows older, like humans, healthcare needs are greater. There is also food, treats, toys, bedding, and possibly training. The benefits of having two dogs, however, may outweigh the financial obstacles. Your dogs will always have company and a built-in playmate, which can mitigate the separation anxiety from which so many dogs suffer. You will have more to love and be given more love in return, and you just may save another dog's life if you rescue.

*Above:* A gentleman with his cairn terrier and Jack Russell terrier, England, circa 1900.

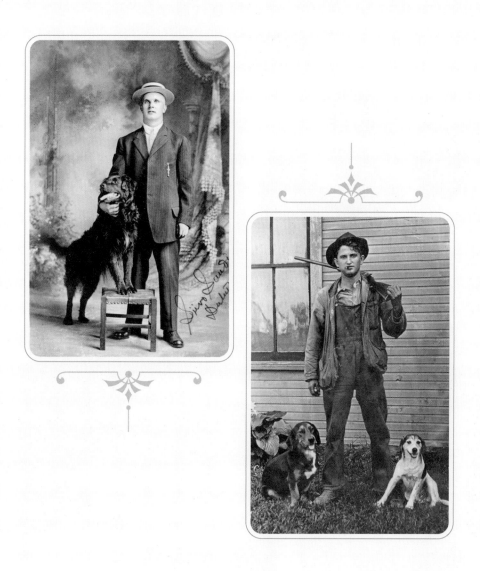

*Above, left:* A good-looking mixed breed black spaniel posed with his forelegs on a stool in this photograph with his owner, Süvo Saudin, in Duluth, Minnesota, circa 1915.

. . . . . . . . . . . . . . . . . . . . . . . . . . . . . . . . . . . . . . . . . . . . . . . . . . . . . . . . . . . . . . . . . . . . . . . . . . . . . . . . . . . . . . . . . . . .

*Above, right:* The beagle we know today was bred in England during the 1830s. Beagles are exceptional hunters of small game, especially rabbit and fox. These beagles posed with Frank in Indiana in the early 1900s. It appears Frank was prepared to go hunting.

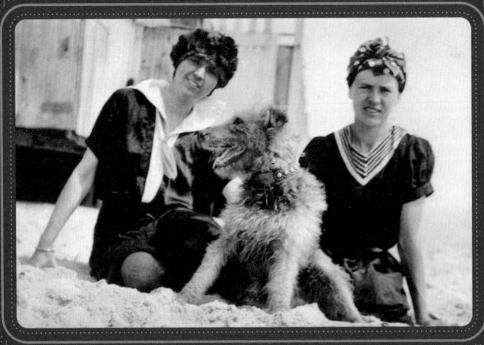

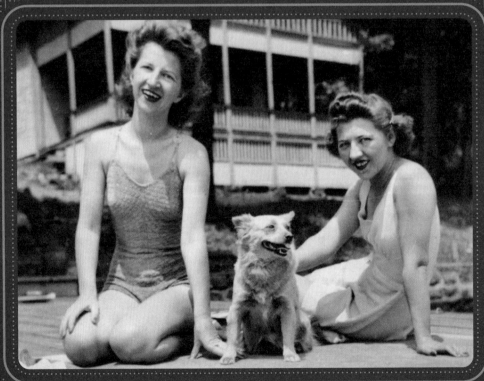

# In the Swim

THE AMERICAN KENNEL Club recognizes sixteen breeds of dog as excellent swimmers. Not surprisingly, thirteen of them have webbed paws. The strongest swimmers are Newfoundlands, who can swim great distances. They have large lung capacities and heavy coats that protect them from icy waters. Poodles, whose name comes from the German word *pudeln*, which means "to splash," were originally bred to hunt waterfowl.

Other breeds known to be excellent swimmers are retrievers (Labrador retriever, golden retriever, Chesapeake Bay retriever, Nova Scotia duck tolling retriever), setters (Irish setter, English setter), spaniels (Irish water spaniel, American water spaniel), and the Portuguese water dog.

Dogs with flat or broad faces and short legs are notoriously poor swimmers. This group includes bulldogs, pugs, Pekingese, basset hounds, dachshunds, boxers, corgis, shih tzus, bull terriers, and chow chows.

........................................................................

*Opposite, top:* Fun at the beach, 1910.

........................................................................

*Opposite, bottom:* Sisters Margaret and Erna have fun at Lake Hopatcong, New Jersey, in 1940. Bathing suit fashion may come and go, but dogs are always in style.

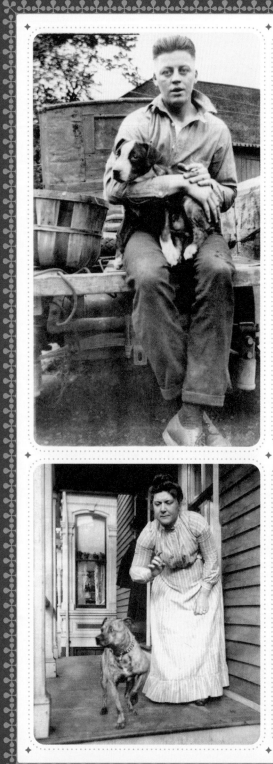
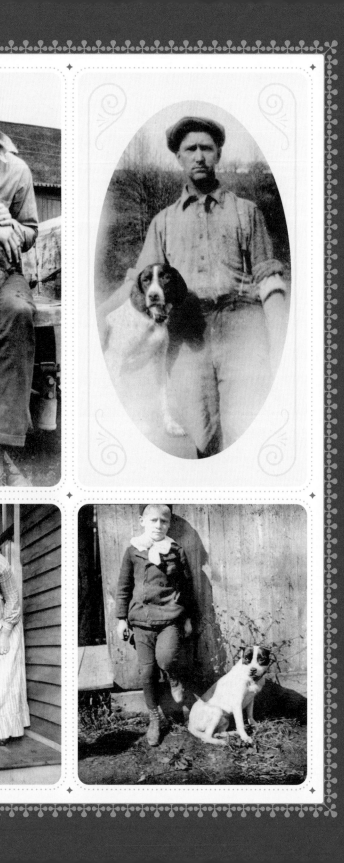
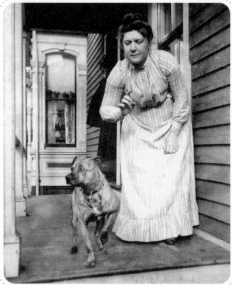
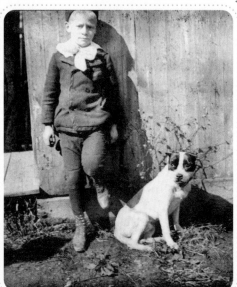

# The Pit Bull Debate

URING THE VICTORIAN era, long before they had a reputation for being vicious, pit bulls were prized as pets. While there may be cogent arguments on both sides of the pit bull debate, the American Temperament Test Society, Inc.—established in 1977 with the purpose of providing, according to their website, "a uniform national program of temperament testing of purebred and spayed/neutered mixed-breed dogs"—conducts tests on an annual basis. They gave pit bulls a high sociability score at the time of this writing (2021). The website also states that pit bulls scored higher for characteristics such as temperament, friendliness, stability, and protectiveness than did many other breeds, including beagles, bichon frises, chihuahuas, collies, Lhasa apsos, Pomeranians, and Skye terriers. Admittedly, an attack on an adult by any one of these breeds would prove less serious than one by a pit bull.

*Opposite, **top left:*** A snapshot of Arthur and his pup on the back of a truck, circa early 1930s.

*Opposite, **top right:*** A man and his springer spaniel, circa early 1930s.

*Opposite, **bottom left:*** Something has caught this pit bull's eye from the front porch, 1900.

*Opposite, **bottom right:*** A young boy from Washington posed with his American pit bull terrier during the mid-1890s.

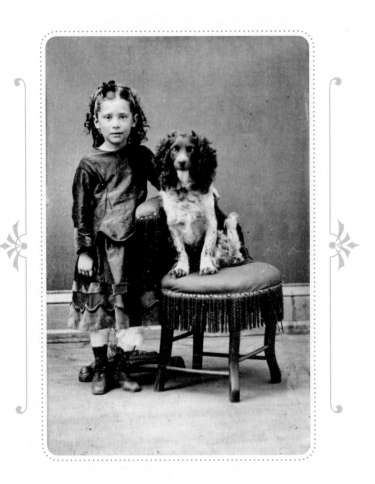

*Above:* In this ferrotype, taken during the 1870s, one might venture a guess that the young girl and her spaniel have the same hairstylist.

*Opposite:* This ferrotype was taken by an itinerant photographer during the 1880s. Itinerant photographers traveled from town to town in rural areas where access to photography and photo studios was limited. They set up tents in which they took photographs and used their wagons as darkrooms. The painted backdrop in this image is a wall hanging as opposed to a proper wall, and the studio props are meager. Nevertheless, the photographer produced an appealing photograph of a young girl and her pug.

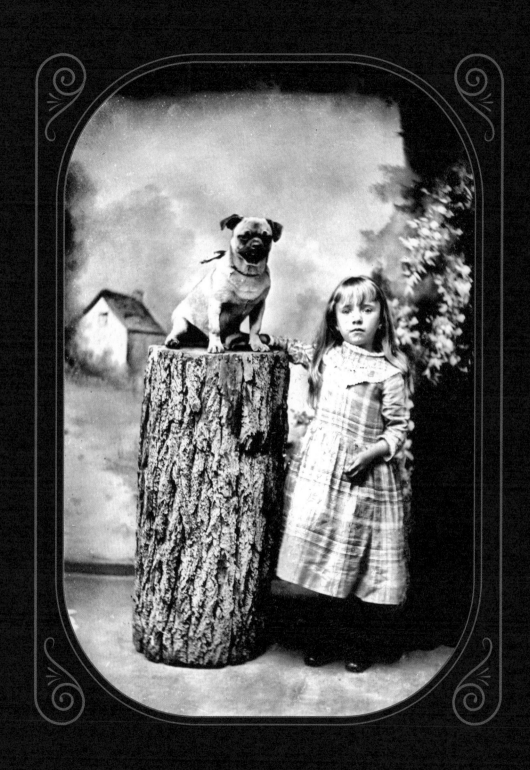

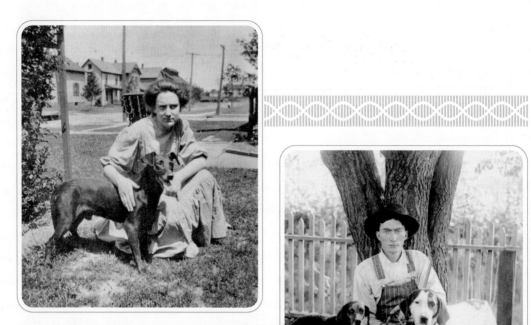

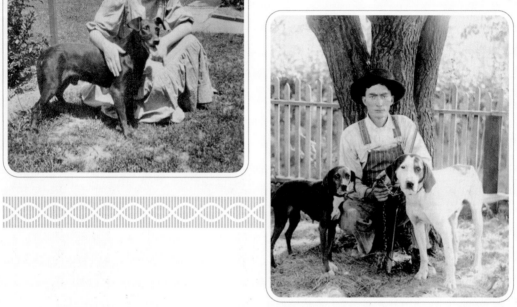

*Above, left:* All we know about this young woman and her good-looking black pointer is the date—June 24, 1911—offered on the back of the photograph.

*Above, right:* Overalls, or bib-and-brace overalls, like these worn by this rifle-bearing young man from North Carolina setting out on a hunt with his pair of hounds, circa 1910, have not changed very much since the late nineteenth century. Overalls have existed in a number of forms since the early nineteenth century, but it wasn't until Levi Strauss and Jacob Davis began to mass-produce one-piece overalls during the 1890s that they became well known and worn by the working class. Housepainters wore white overalls, railroad workers wore striped ones, and everyone else donned pure blue denim.

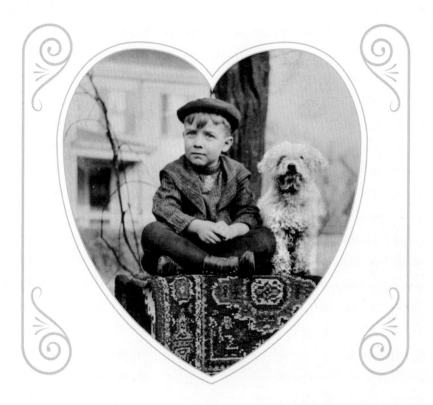

# Love Is the Drug

**I**F YOU'VE EVER wondered whether your dog loves you or is only connected to you because you're the source of food and shelter, you can take comfort in a 2012 study by Outi Vainio, a professor at the University of Helsinki. The study examined oxytocin, one of the hormones of love and attraction secreted by humans and dogs alike, to see if it affected both species similarly. Published in *Frontiers in Psychology* in 2017, Vainio's study found "that the interaction between owners and their dogs results in increasing levels of oxytocin in both . . ." and that oxytocin promotes "dog-human communication and the development of affectionate relations."

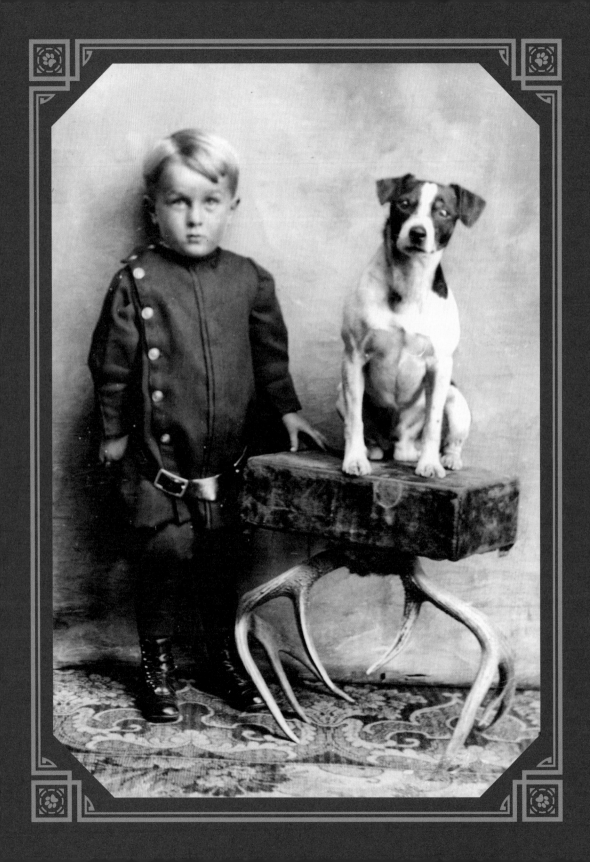

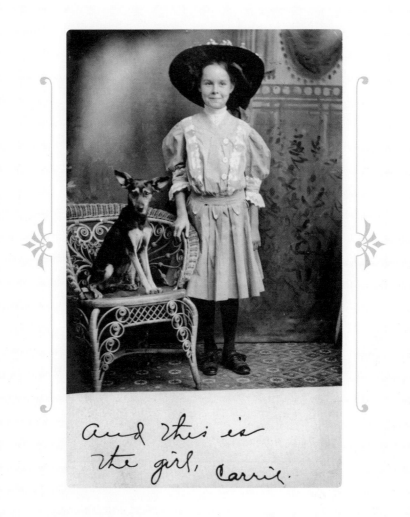

*and this is
the girl, Carrie.*

*Opposite:* Both the young boy and his pointer, sitting on a battered cushion mounted on a set of antlers, appear transfixed by the photographer and his camera in this image taken in Minnesota during the first decade of the twentieth century. Chairs and tables made of animal horns and antlers were quite common during the nineteenth and early twentieth centuries.

*Above:* "Carrie, October 30, 1907." With her smile, large flowered hat, and box-pleated dress, this young girl posing with her miniature pinscher mix breed is a charmer.

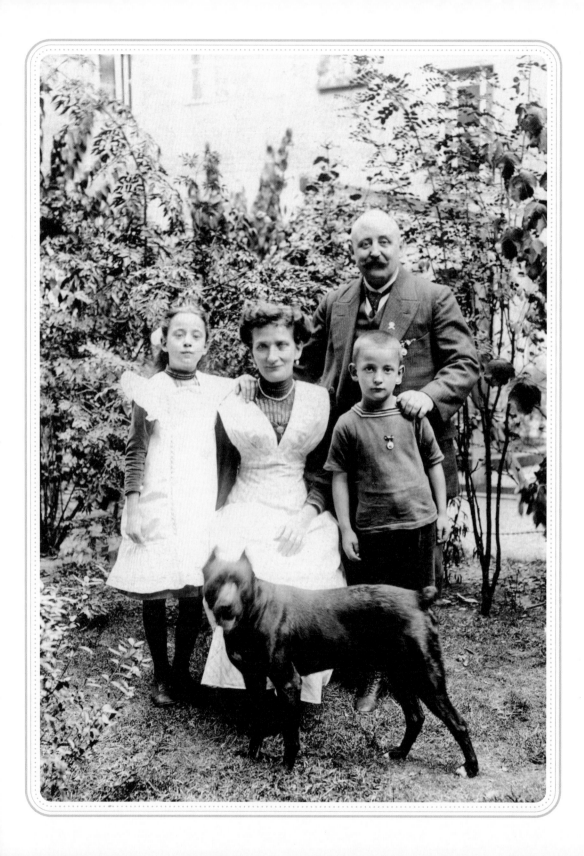

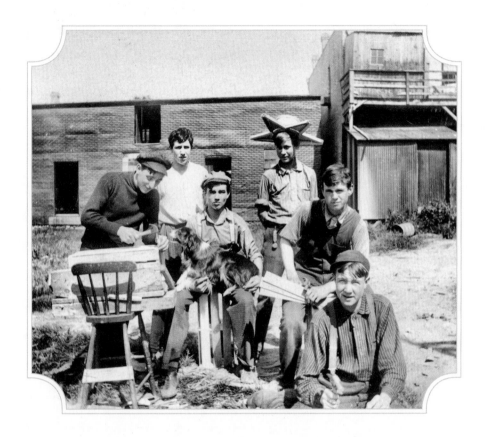

*Opposite:* A real photo postcard of a family in Germany posing in the garden with their bull terrier, circa early 1900s.

......................................................................................

*Above:* This real photo postcard of woodworkers and their dog, obviously an integral member of their crew, was taken in San Francisco around 1910.

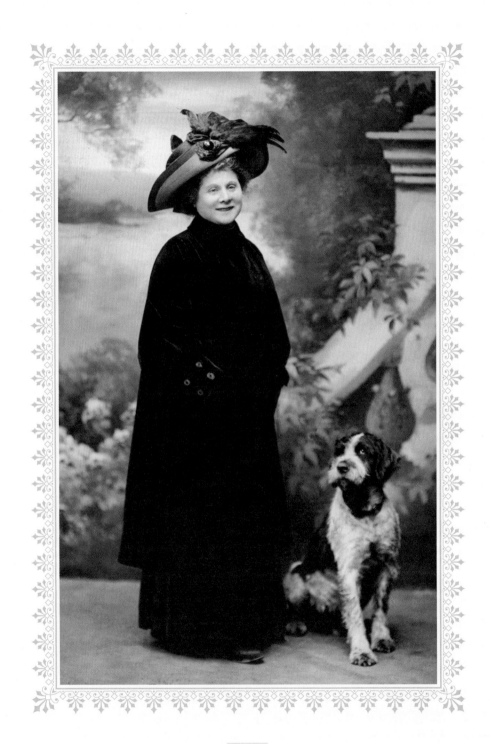

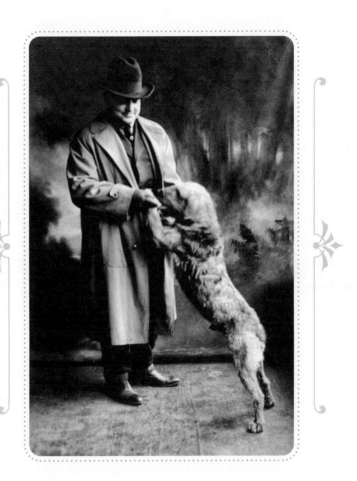

*Opposite:* The elaborate painted trompe l'oeil backdrop seems to be the perfect setting for this spaniel and its elegantly dressed mistress. Her chic, large, feathered, and beribboned hat is almost as wide as her shoulders. This image was taken in Germany around 1900.

*Above:* This mixed breed terrier from Missouri stood on its hind legs—with a little help from a friend—for this photograph, taken around 1910. It is not unusual for a dog to stand on its hind legs for a few moments. The boxer is the only dog who will naturally stand unassisted on its hind legs and appear to box for short periods of time during play.

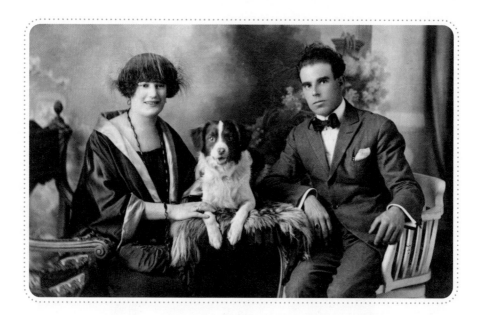

URING THE LATE 1920s, this well-dressed couple *(above)* posed with their beautiful spaniel mix at an upscale photography studio in Italy. Dogs are capable of being attached to multiple family members, but typically show favoritism toward one. That person is usually the one who cares for, feeds, and walks them. Here, the woman and dog clearly dominate the viewer's attention. There seems to be a special bond between them: She rests a reassuring hand on the dog's leg, and the dog leans closer to her than to the man.

*Opposite:* This American foxhound and his friends enjoyed a warm day in Georgia during the late 1890s. American foxhounds are gentle, easygoing dogs that were bred to run down, but not kill, foxes. They are typically gentle with other animals and even get along well with cats. They are a very active breed and must be exercised daily and kept busy or they have a tendency to become depressed and spiteful. The American foxhound is distinguished from the English foxhound by its longer legs and slightly arched rump.

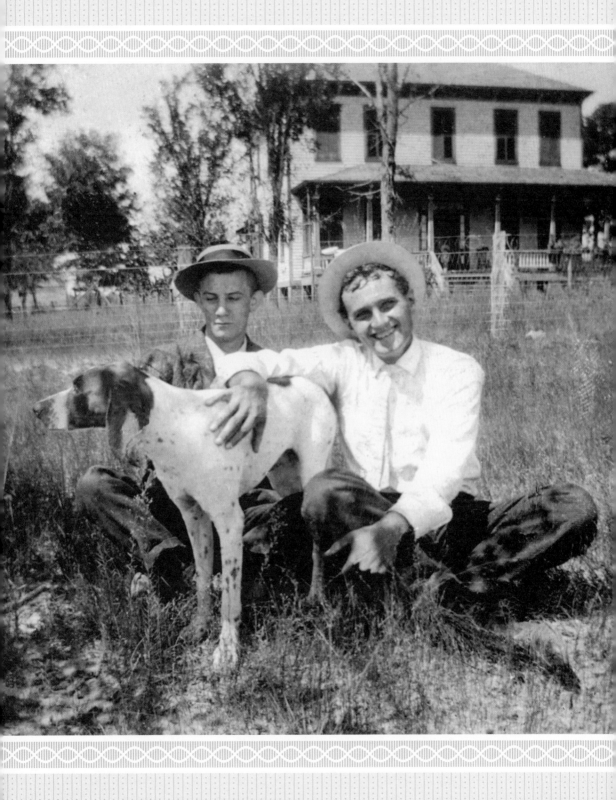

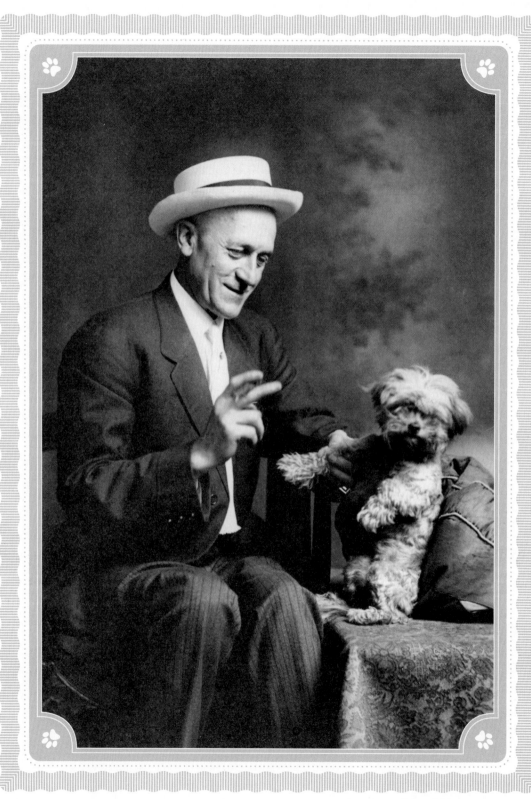

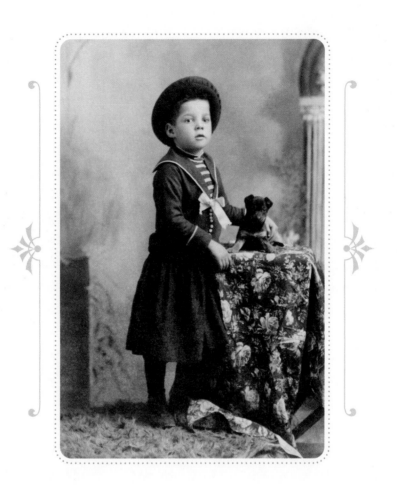

*Opposite:* This small terrier is more interested in the photographer than its owner's conversation. This image was shot in Illinois, circa 1915.

*Above:* Young Frank in Willows, California, posed with his beribboned shepherd puppy during the late 1880s. The ribbon on the puppy may indicate that the pet was a gift; however, there are many vintage photographs of dogs of all ages wearing ribbons.

During the nineteenth century, boys wore dresses until age five or six. Here, Frank wears a dress with a middy, or sailor, blouse and a large sailor-style hat.

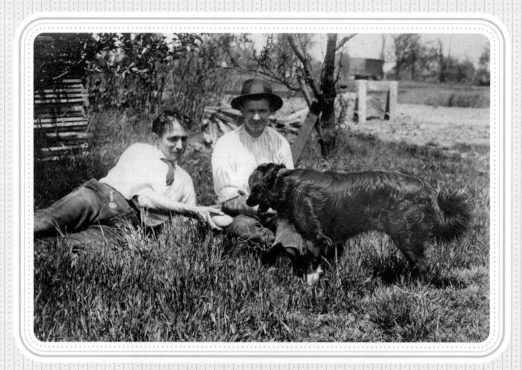

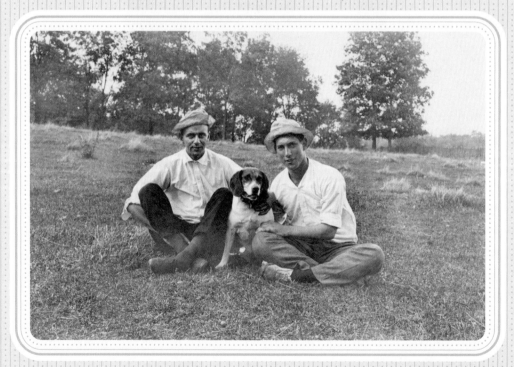

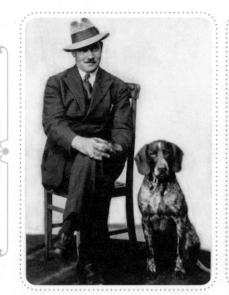
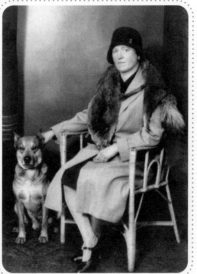

*Opposite, top:* Dining with friends alfresco: Mr. Gustavson, Mr. John, and a black border collie named Tauser enjoyed a picnic during the 1910s.

. . . . . . . . . . . . . . . . . . . . . . . . . . . . . . . . . . . . . . . . . . . . . . . . . . . . . . . . . . . . . . . . . . . . . . . . . . . . . . . . . . . . .

*Opposite, bottom:* Two's company, three's allowed. The beagle in this circa-1910 photo taken in Ohio appears ready to bolt if not for the restraining hands of his companions. Beagles were bred to hunt, which accounts for two physical features: their ears and their tails. Beagles have floppy ears that are long enough to reach their noses. These large flap-like ears collect scent particles and bring them close to the dog's nose. The end of a beagle's tail is usually white. This is a feature that was bred into them so that they would be easy to follow as they raced through the brush after their prey.

. . . . . . . . . . . . . . . . . . . . . . . . . . . . . . . . . . . . . . . . . . . . . . . . . . . . . . . . . . . . . . . . . . . . . . . . . . . . . . . . . . . . .

*Above, left:* This photo was taken in Latvia on November 9, 1931. During the 1930s, men's suits were broad at the shoulder with very wide, notched lapels. The soft-brimmed fedora dipped slightly to one side this fellow is wearing was the style then, too. His large spaniel doesn't seem impressed by his natty owner, as he stares inquisitively at the photographer.

. . . . . . . . . . . . . . . . . . . . . . . . . . . . . . . . . . . . . . . . . . . . . . . . . . . . . . . . . . . . . . . . . . . . . . . . . . . . . . . . . . . . .

*Above, right:* Draped fox furs, cloche hats, and Mary Jane shoes were all considered very chic when this photo was taken in Poland in the 1920s.

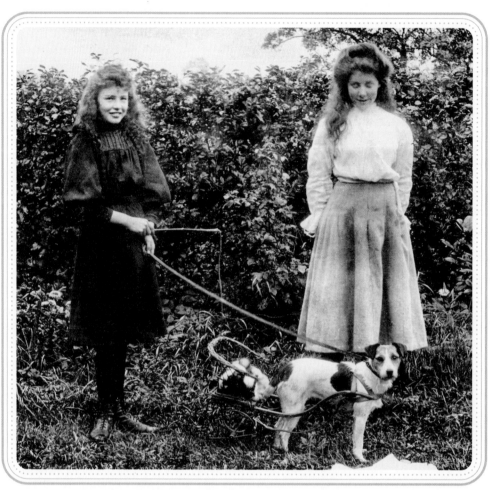

*Above:* With Kodak's 1888 slogan, "You point and shoot—we do the rest," came the birth of the vernacular photograph. Suddenly, people of all ages were taking pictures. In 1900, around the time this candid photograph was taken, Kodak introduced the inexpensive Brownie camera. The Brownie sold for one dollar. By 1905, more than ten million Brownies were sold and the number of photographs taken by amateur photographers increased dramatically.

With the advent of the snapshot came a certain authenticity not previously seen in the professionally staged photo studio images. This shot, taken more than 120 years ago, portrays a proud mother dog—joined by some human pals—taking her pups for an outing.

· · · · · · · · · · · · · · · · · · · · · · · · · · · · · · · · · · · · · · · · · · · · · · · · · · · · · · · · · · · · · · · · · · · · · · · · · · · · · · · · · · · · · · · · · · · · · · · · · · · · · · · · ·

*Opposite, bottom:* Normarene and her pal on the running board of their car, Florida, 1920s.

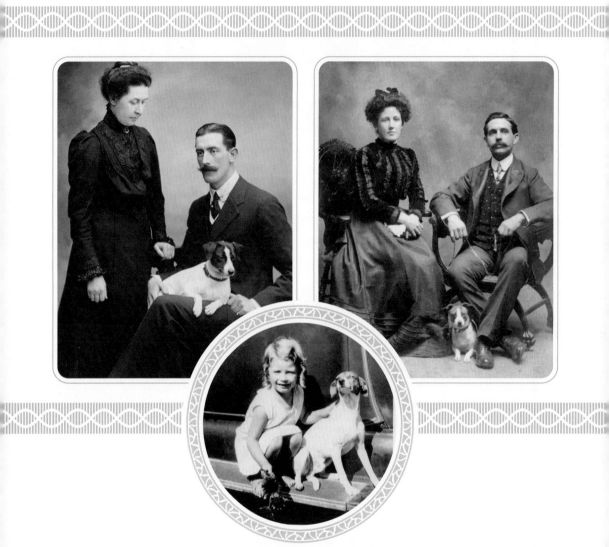

*Above, left:* This cabinet card from the late 1890s captures a rather serious-looking English couple with their fox terrier, whom they referred to on the back of the image as "My dear boy."

...............................................................................

*Above, right:* In Canada during the same era, the little terrier in this cabinet card peeps out from between the legs of his people.

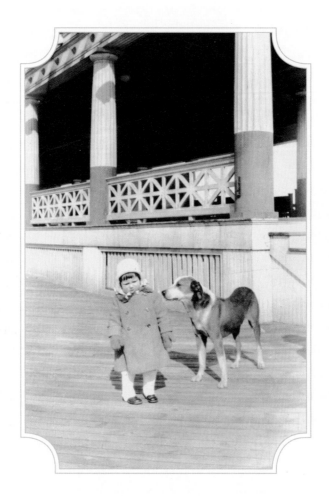

*Above:* In this snapshot, dated March 1924, this young girl and her American foxhound take a chilly stroll on a boardwalk. It's hard to say whether she welcomes her pup's attention or is finding it hard to stand still to have her picture taken.

...............................................................................

*Opposite, top:* The inscription on the back of this photograph from Washington State reads, "Opal and the dog that always went with her for the mail, 1907."

...............................................................................

*Opposite, bottom:* A fox terrier and family, Sweden, 1890s.

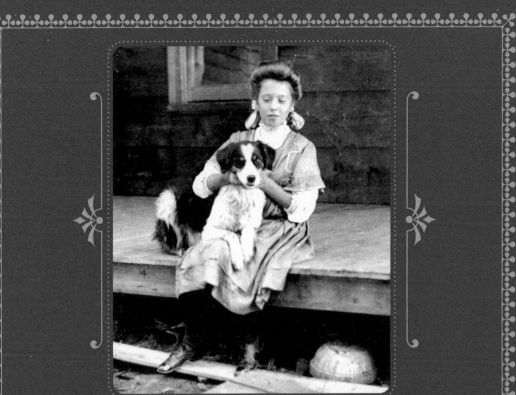

# Wear a Big Hat and Carry a Little Dog

FROM THE LATE 1890s into the early 1900s, a fashionable woman's hatbox was bigger than her dog. Carrying a miniature dog and wearing a huge hat was considered the epitome of chic. The dog was often beribboned (as is the pup in the picture on the facing page), treated royally, and carried everywhere the lady went. Although mistresses were devoted to their miniature pets, they were somewhat fickle in this regard, as what was considered a desirable breed changed as often as fashion trends did.

Of course, not all toy dog breeds were bred to be lapdogs. Many of the toy breeds, such as the affenpinscher, Chinese crested, and Yorkshire terrier, were bred for the purpose of entering small, tight places to flush out and kill rodents. Other toy breeds such as the shih tzu, papillon, Cavalier King Charles spaniel, and toy poodle were bred primarily as companion dogs. The American Kennel Club recognizes twenty-one distinct breeds in the toy group.

...........................................................................................................................

Two snapshots, one from the late 1890s *(opposite)*, and one from the early 1900s *(above)*.

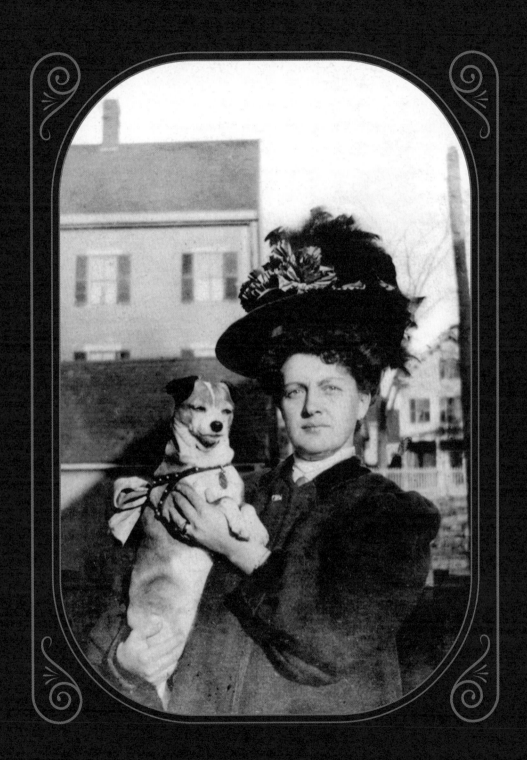

# Hollywood's Dogwalk
# of Fame

**R**IN TIN TIN, Lassie, and Strongheart are the only three dogs with their own stars on Hollywood's Walk of Fame.

Rin Tin Tin, a German shepherd and arguably one of the most famous dogs in motion picture history, was a rescue dog. His owner, Corporal Lee Duncan, rescued him from a German kennel in Lorraine, France, that had been bombed during World War I. Rin Tin Tin went on to become a top earner in the movies, earning the equivalent of $26,000 a week in today's dollars. Rin Tin Tin appeared as a wolf in his first film, *The Man from Hell's River* (1922). In 1923, Warner Bros. signed Rin Tin Tin to star in his own films; that year, Rin Tin Tin starred in his first feature film, *Where the North Begins*. In total, he starred in twenty-seven Hollywood films.

Although Rin Tin Tin died in 1932, Lee Duncan, Rin Tin Tin's owner, trained four generations of Rin Tin Tin's descendants for subsequent films and television shows. The one exception was for a television series made during the 1950s. Rin Tin Tin IV did not pass his screen test for the show, so another German shepherd named Flame, who belonged to dog trainer Frank Barnes, got the part.

Lassie, a male collie whose actual name was Pal, fared even better, financially speaking. During the 1950s, Pal earned a weekly salary equivalent to $56,000 in today's dollars. In *Lassie Come Home* (1943), his first film, Pal starred with Elizabeth Taylor and Roddy McDowall, and

in the sequel, *Son of Lassie* (1945), Peter Lawford and June Lockhart. In 1946, he costarred again with Elizabeth Taylor in *Courage of Lassie*. Pal starred in seven films altogether, which led to the *Lassie* television series, which ran from 1954 to 1973.

Pal lived to the age of eighteen years. There were nine Lassies, all descendants of the original, Pal. Although all nine Lassies were males, they played the role of a female collie. The reason males played the role is that when female collies go into heat, which is twice a year, they lose much of their coat, altering their appearance.

Strongheart, a German shepherd, was the first major canine star. While he was not as well known as Rin Tin Tin, he certainly paved the way for him. Born in Germany in 1917 and originally named Etzel von Oeringen, his first job was as a police dog in Berlin, and he later served in the German Red Cross during World War I. Etzel's owner was left poverty stricken by the war and could not care for the dog. He wanted his three-year-old pet to have a better life, so he sent him to live with a friend in the United States.

In 1920, Etzel was discovered at a German shepherd dog show by Laurence Trimble, a film director. Trimble persuaded his screenwriter to buy the dog; Etzel's new owner renamed him Strongheart. Strongheart starred in four silent films, beginning with *The Silent Call* (1921). He was destined to star in more features, but he received burns from a hot studio light, which caused a tumor that ended his life at age eleven in 1929.

· · · · · · · · · · · · · · · · · · · · · · · · · · · · · · · · · · · · · · · · · · · · · · · · · · · · · · · · · · · · · · · · · · · · · · · · · ·

*Opposite:* A collie and a well-dressed friend, Arizona, mid-1920s.

· · · · · · · · · · · · · · · · · · · · · · · · · · · · · · · · · · · · · · · · · · · · · · · · · · · · · · · · · · · · · · · · · · · · · · · · · ·

*Above:* "Paul and his shepherd," Moonachie, New Jersey, circa 1910.

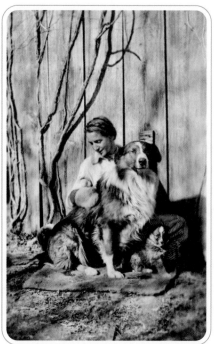

*Above, left:* Young Bill and his mother sat on the stoop of their St. Louis, Missouri, home with their dog for this photograph, circa 1900.

. . . . . . . . . . . . . . . . . . . . . . . . . . . . . . . . . . . . . . . . . . . . . . . . . . . . . . . . . . . . . . . . . . . . . . . . . . . . . . . . . . . . .

*Above, right:* A collie hovers over her pup as she is groomed, Canada, 1910s.

. . . . . . . . . . . . . . . . . . . . . . . . . . . . . . . . . . . . . . . . . . . . . . . . . . . . . . . . . . . . . . . . . . . . . . . . . . . . . . . . . . . . .

*Opposite, top:* A terrier rides shotgun in this 1910 touring car in Missouri.

. . . . . . . . . . . . . . . . . . . . . . . . . . . . . . . . . . . . . . . . . . . . . . . . . . . . . . . . . . . . . . . . . . . . . . . . . . . . . . . . . . . . .

*Opposite, bottom:* In 1887, the Garton Toy Company became the first American company to make toy pedal cars. By the 1930s pedal cars were being produced by at least two hundred manufacturers. Production of toy pedal cars was interrupted by the need for metal during World War II, but resumed during the 1950s. Here, a young boy rides in a circa-1910 pedal car while his collie waits patiently.

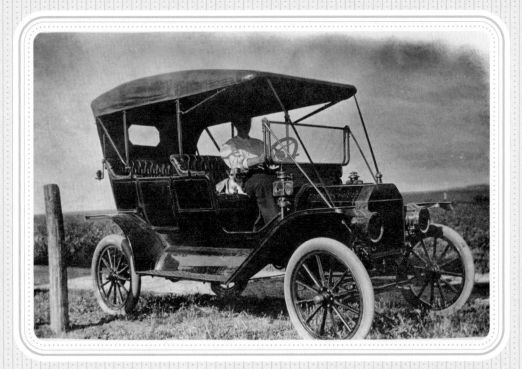

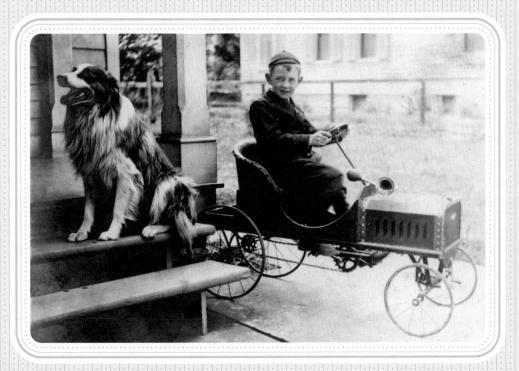

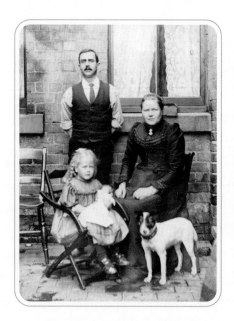
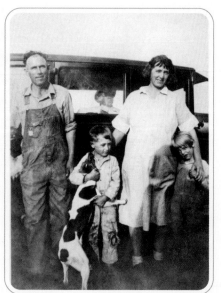

# A beloved dog is part
# of the family.

*Above, left:* This English family posed in the courtyard of their home with their dog during the mid-1890s.

. . . . . . . . . . . . . . . . . . . . . . . . . . . . . . . . . . . . . . . . . . . . . . . . . . . . . . . . . . . . . . . . . . . . . .

*Above, right:* During the Great Depression, many families had to resort to migrant work to keep themselves fed. Whatever the circumstances of this family were, their love for one another and their dog is apparent in this 1930s image.

. . . . . . . . . . . . . . . . . . . . . . . . . . . . . . . . . . . . . . . . . . . . . . . . . . . . . . . . . . . . . . . . . . . . . .

*Opposite, left:* A large collie shares a wicker settee with a young boy for this photograph taken in England, circa 1900.

. . . . . . . . . . . . . . . . . . . . . . . . . . . . . . . . . . . . . . . . . . . . . . . . . . . . . . . . . . . . . . . . . . . . . .

*Opposite, right:* This terrier mix makes a little room for his mistress in Pennsylvania, early 1900s.

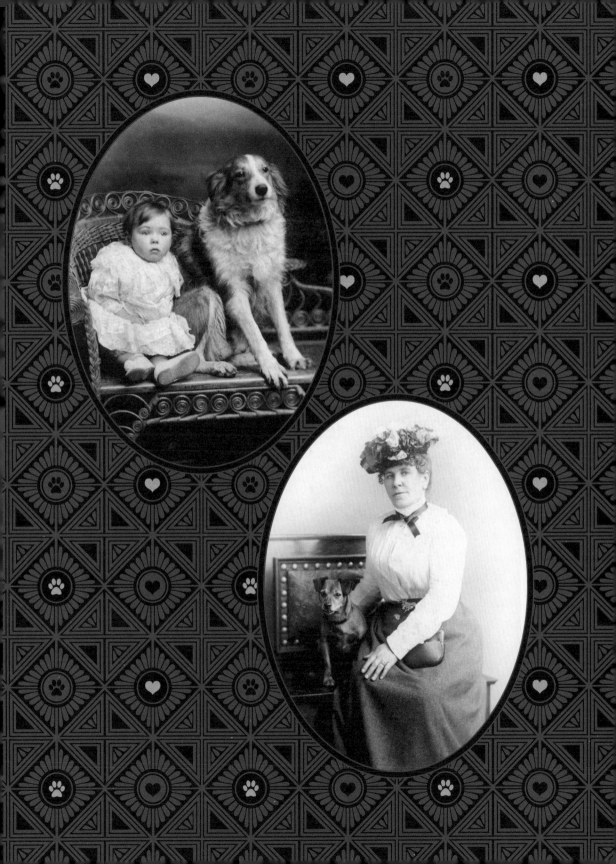

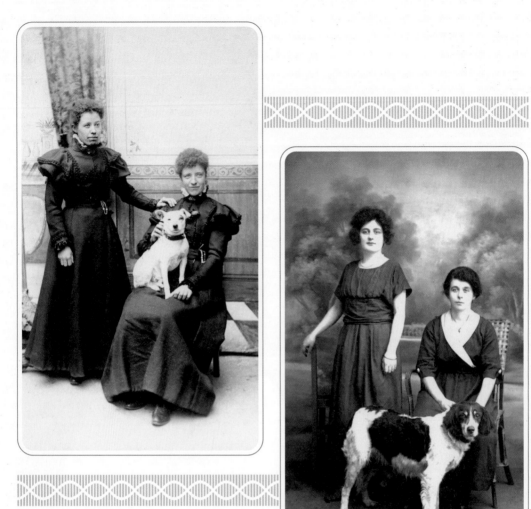

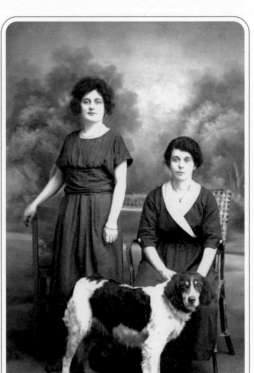

*Above, left:* Two women, similarly outfitted in dresses with ruffled epaulets, posed with their little terrier in 1896, England.

........................................................................................

*Above, right:* Marie and Louise posed with their spaniel for this photograph taken in Saint-Vallerin, France, on February 14, 1921.

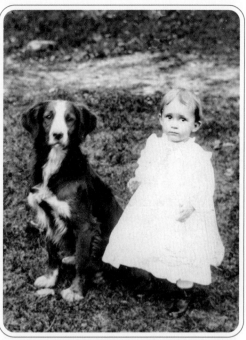

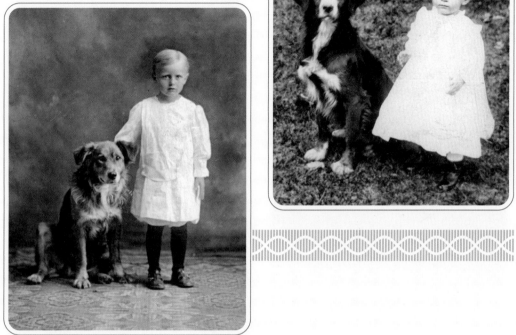

*Above, left:* "Catherine and Sancho," her collie mix, California, circa 1908. Sancho seems to have been a popular name for dogs during the late nineteenth and early twentieth centuries. In my collection of more than five hundred vintage dog photographs, there are eleven dogs clearly identified as "Sancho."

*Above, right:* Border collies, so named because their breed developed along the border of Scotland and England, were bred to herd sheep. It was during the 1860s that the border collie began to become differentiated from the modern collie. The Border Collie Museum, an online museum dedicated to the breed, recognizes one dog, Old Hemp (1893–1903) as "the progenitor" of the breed. Old Hemp was owned and trained by a breeder named Adam Telfer, and during his lifetime, this fellow sired more than two hundred dogs.

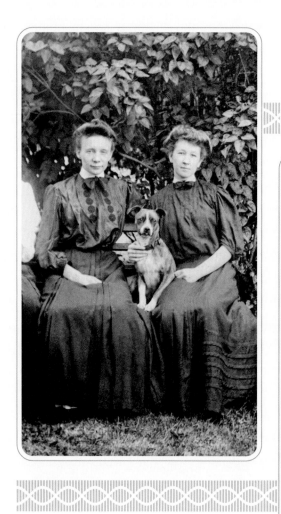

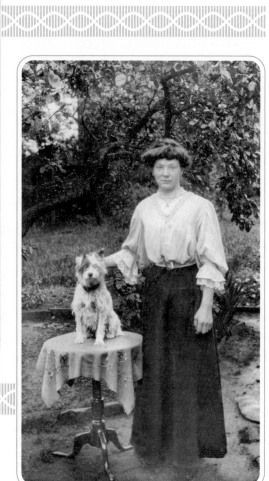

These garden portraits of terrier mixed breeds and their people were both taken during the first decade of the twentieth century in Washington State *(above, left)* and in England *(above, right)*, where a lace-covered, Queen Anne–style, pad-foot, tilt-top tea table was used as a platform.

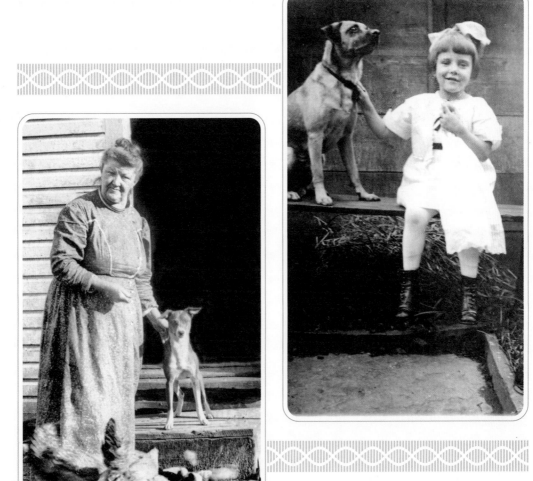

*Above, left:* Terriers are notorious for chasing any small animal, so this one must have been well trained to not harm the chickens running loose at his paws. Nevada, circa 1915.

. . . . . . . . . . . . . . . . . . . . . . . . . . . . . . . . . . . . . . . . . . . . . . . . . . . . . . . . . . . . . . .

*Above, right:* A young girl with her hound mix, Ohio, early 1900s.

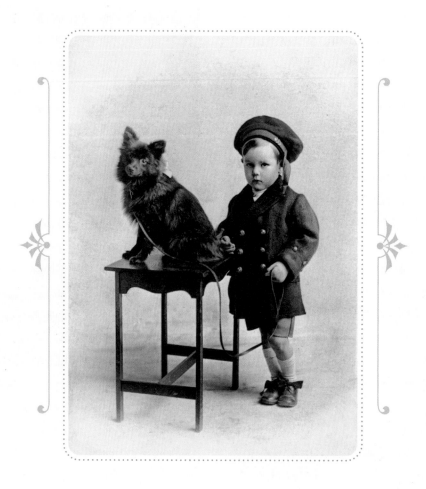

*Above:* A young boy in a sailor cap poses with his spitz, England, 1910s.

*Opposite:* Dogs are wonderful creatures who give us so much more than we deserve sometimes. They adore us, as imperfect as we are. We are beautiful to them first thing in the morning and at the end of a weary day. Whether we belong to them or they belong to us remains undecided, but there is no question that we belong together. Their time with us may not be long, but their gifts to us will endure, for this is a partnership that transcends time.

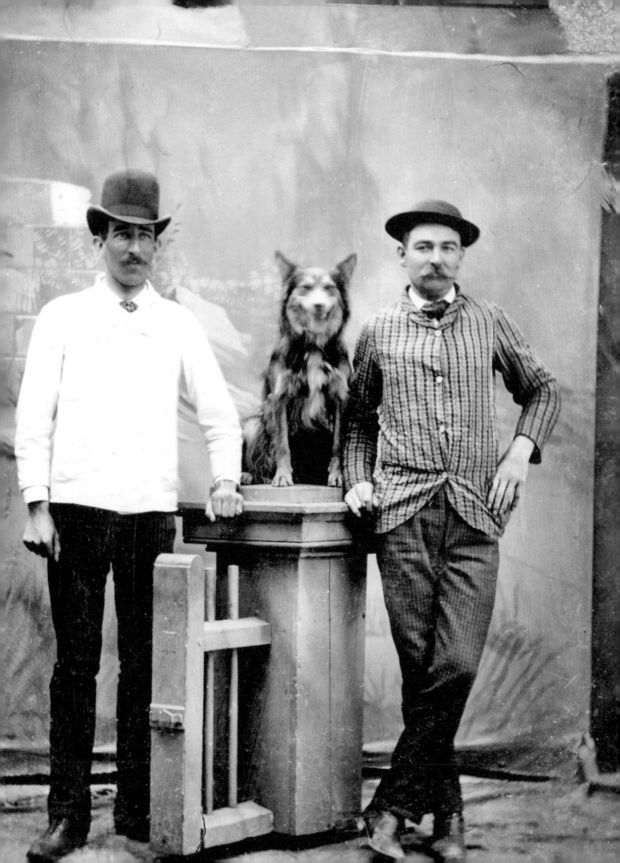

# ACKNOWLEDGMENTS

I WOULD VERY MUCH LIKE TO THANK MY EDITOR, Elizabeth Viscott Sullivan, for her invaluable advice, constant encouragement, immeasurable input, and insightful guidance. You took me through the maze, and I only walked into a few walls (well, maybe more than a few). I can't thank Liz without also thanking Lillian and Henry, her cocker spaniels, for providing her support and companionship on this journey.

Many thanks to my agent, Wendy Keller, of Keller Media, Inc., who always managed to surprise me when I wasn't sitting down, for her invaluable guidance and for always shooting from the hip. I was on the path, but she turned me in the right direction. Wendy, you always managed to say the right thing at the right time. You can stop banging your head on the desk now.

And to Dr. Barry Buchalter, DVM, for sharing his vast knowledge of dogs and all things of interest about them.

A very special thanks to my family, for all the times they peeled me from the ceiling and dragged me in off the ledge. I love you all. And to my friend Ita, who listened to me babble over a thousand cups of tea, thanks for not blocking my calls.

And to Sharen Pyne-Weissman, for sharing insights that have helped make sense of it all. You are a wonderful presence in my life.

And to Raphael Geroni, thank you for bringing the vision to life. I wrote the book, but you made it beautiful.

And thank you to everyone at Harper Design, especially Stacey Fischkelta. I'm also grateful for my copyeditor Kim Daly, and Soyolmaa Lkhagvadorj for the editorial support. But mostly, I am grateful to God, for His many blessings.

# SELECTED BIBLIOGRAPHY

American Association for the Advancement of Science. "A Dog's Sense of Smell." ScienceNetLinks. September 25 (no year cited). http://sciencenetlinks.com/daily-content/9/25/. Accessed July 24, 2021.

American Kennel Club. "American Foxhound." February 14, 2015. https://www.akc.org/dog-breeds/american-foxhound/. Accessed June 26, 2021.

———. "Curly-Coated Retriever." February 14, 2015. https://www.akc.org/dog-breeds/curly-coated-retriever. Accessed June 19, 2021.

———. "Newfoundland." February 12, 2015. https://www.akc.org/dog-breeds/newfoundland/. Accessed July 8, 2021.

American Temperament Test Society, Inc. https://atts.org/. Accessed July 14, 2021.

Barnett, Lindsay. "Hollywood Star Walk—The Dogs." *Los Angeles Times.* March 9, 2010. http://projects.latimes.com/hollywood/star-walk/category/dogs/page/1/. Accessed July 20, 2021.

Bergroth, Eija, MD, and Sami Remes, MD, Juha Pekkanen, MD, PhD, Timo Kauppila, MSc, Gisela Büchele, PhD, and Lee Keski-Nisula, MD, PhD. "Respiratory Tract Illnesses During the First Year of Life: Effect of Dog and Cat Contacts." *Pediatrics*, Volume 130, Number 2, August 2012. DOI: https://doi.org/10.1542/peds.2011-2825. Accessed April 4, 2018.

Brady, Lois Jean, MA, CCC-SLP, CAS. "Animal Assisted Therapy—A Brief History." Professional Development Resources. January 3, 2017. https://blog.pdresources.org/animal-assisted-therapy-a-brief-history. Accessed March 16, 2021.

Bryner, Jeanna. "The 10 Most Popular Dog Breeds." Live Science. April 4, 2016. https://www.livescience.com/17574-popular-dog-breeds.html. Accessed March 18, 2021.

Camp Greyhound. "Interesting Greyhound Facts." https://www.campgreyhound.ca/interesting-greyhound-facts. Accessed July 21, 2021.

Centers for Disease Control and Prevention. "Keeping Pets and People Healthy." April 15, 2019. https://www.cdc.gov/healthypets/health-benefits/index.html. Accessed December 16, 2020.

Courtenay-Smith, Natasha. "The Dog That Can Sniff Out Cancer." *Daily Mail.* April 12, 2005. https://www.dailymail.co.uk/health/article-344596/The-dog-sniff-cancer.html. Accessed December 16, 2020.

Cvetkovska, Ljubica. "44 Shocking Animal Shelter Statistics & Sad Facts for 2021." Petpedia. May 18, 2021.

https://petpedia.co/animal-shelter-statistics/. Accessed December 22, 2020.

Doyle, Arthur Conan. "The Red-Headed League." *Strand Magazine*. August 1891. https://www.arthur-conan-doyle.com/index.php/The_Red-Headed_League#Text. Accessed January 15, 2021.

Dyreson, Mark (Ed.), and Jaime Schultz (Ed.). *American National Pastimes—A History*. First Kindle edition. Oxfordshire, UK: Routledge Publishing, 2016.

*Encyclopedia Britannica*. "Samuel Butler: Quotes." https://www.britannica.com/quotes/biography/Samuel-Butler-English-author-1612-1680. Accessed December 14, 2021.

Farr, Kendall, and Sarah Montague. *Pugs in Public*. New York: Stewart, Tabori & Chang, 1999.

Furstenberg, Patricia. "Amazing Roles Dogs Played in WW1, Part 1, Dogs in Trenches and Ratter Dogs." AlluringCreations.co.za. August 18, 2019. https://alluringcreations.co.za/wp/amazing-roles-dogs-played-during-ww1-part-1-dogs-in-trenches-and-ratter-dogs-via-patfurstenberg-dogs-war-trenches-ratters-history. Accessed December 2, 2020.

Guagnin, Maria, Angela R. Perri, and Michael D. Petraglia. "Pre-Neolithic Evidence for Dog-Assisted Hunting Strategies in Arabia." *Journal of Anthropological Archaeology*, Volume 49, pp. 225–36, March 2018.

Hays, Brooks. "Hormone Oxytocin Causes Dogs to Pay More Attention to Smiling Human Faces." United Press International. November 20, 2017. https://www.upi.com/Science_News/2017/11/20/Hormone-oxytocin-causes-dogs-to-pay-more-attention-to-smiling-human-faces/6191511198696/. Accessed December 2, 2020.

Internet Broadway Database. "Three Twins." https://www.ibdb.com/broadway-production/three-twins-6560. Accessed May 5, 2021.

Jigme, Catherine. "Tihar Festival." Tibet Vista. November 14, 2019. https://www.tibettravel.org/nepal-festival/tihar-festival.html. Accessed May 8, 2021.

Kaufman, Margo. *Clara: The Early Years: The Story of the Pug Who Ruled My Life*. Villard, NY: Plume, 1998.

Kelly, Kate. "Rin Tin Tin: The True Story." America Comes Alive. October 2020. https://americacomesalive.com/the-story-of-rin-tin-tin-2/. Accessed May 5, 2021.

Koh, Ignatius. "Hachiko Statue in Shibuya: Japan's Most Popular Meeting Point in the Heart of Tokyo." Japan Travel. May 17, 2018. https://en.japantravel.com/tokyo/hachiko-statue-in-shibuya/44644. Accessed May 7, 2021.

Litchfield, Norman E. H. *Militia Artillery, 1852–1909: Their Lineage, Uniforms and Badges*. Derby, UK: The Sherwood Press (Nottingham) Ltd., 1987.

Llera, Ryan, BSc, DVM, and Lynn Buzhardt. "Why Dogs Turn Around Before Lying Down." VCA. https://vcahospitals.com/know-your-pet/why-dogs-turn-around-before-lying-down. Accessed May 7, 2021.

Mace, O. Henry. *Collector's Guide to Early Photographs*. Radnor, PA: Wallace-Homestead Book Co., 1990.

Medrano, Kastalia. "Saudi Arabia: 8,000 Year Old Rock Art Is First Ever Depiction of Dogs—and Humans Had Them on Leashes." *Newsweek*. November 17, 2017. https://www.newsweek.com

/saudi-arabia-8000-year-old-rock-art-first
-ever-depiction-dogs-and-humans-
had-715114. Accessed May 12, 2021.

Must See Scotland. "Greyfriars Bobby:
Separating Facts from Fiction."
https://www.must-see-scotland.com
/greyfriars-bobby-fact-fiction.
Accessed June 3, 2021.

Nash, Ogden. *The Private Dining Room and
Other Verses.* New York: Little, Brown &
Co., 1953.

Newhall, Beaumont. *The History of
Photography.* New York: The Museum of
Modern Art and New York Graphic
Society Books; Boston: Little, Brown &
Co., 1982.

Nightingale, Florence. *Notes on Nursing:
What It Is and What It Is Not.* London:
Harrison, 1860; and https://www
.bartleby.com/essay/Animal-Assisted
-Therapy-The-Beginning-Of-A
-F3B9T7V3RZKW.
Accessed May 2, 2021.

Oljace, Beth. "Hugh Hill's Irish Mail Made a
Million Children Happy." *The Herald
Bulletin,* Anderson, IN. May 23, 2010.
https://www.heraldbulletin.com
/community/hugh-hills-irish-mail-made
-a-million-children-happy/article
_e7dc088b-e774-5979-94f7
-9c8b8264d52f.html.
Accessed May 02, 2021.

PEDIGREE Foundation. "How Cold Is Too
Cold for Your Dog?" March 3, 2017.
https://www.pedigreefoundation.org
/cold. Accessed May 3, 2021.

Pitbullinfo.org. "Facts, Information, and
Statistics About Pitbull-Type Dogs."
April 16, 2021. https://www.pitbullinfo
.org. Accessed May 5, 2021.

Richell USA, Inc. "Nose Print for Dog's
Identification!" December 28, 2017.

https://richellusa.com/nose-print-dogs
-identification. Accessed July 15, 2021.

Ripley, Katherine. "10 Things You Didn't
Know About the Cocker Spaniel."
American Kennel Club. August 30, 2016.
https://www.akc.org/expert-advice
/lifestyle/things-you-didnt-know-about
-the-cocker-spaniel.
Accessed June 13, 2021.

Roberts, Laura. "History of the Bowler Hat."
*The Telegraph.* October 6, 2010.
https://www.telegraph.co.uk/news
/uknews/8045026/History-of-the
-Bowler-Hat.html.
Accessed September 11, 2021.

Sabin, Louis. *All About Dogs as Pets.*
New York: Silver Burdett Press, 1983.

Schweers, Jeff. "Greyhound Racing Banned."
*Las Vegas Sun.* November 6, 1996.
https://lasvegassun.com/news/1996
/nov/06/greyhound-racing-banned.
Accessed July 25, 2021.

Sparrow, Katharine L. "The Story of the
Johnstown Flood 1889." *Owlcation.*
May 22, 2018. https://owlcation.com
/humanities/Story-of-Johnstown
-Flood-1889. Accessed July 25, 2021.

Stilwell, Blake. "These Were the Mercy Dogs
of World War I." We Are the Mighty.
June 19, 2020. https://www
.wearethemighty.com/mighty-history
/mercy-dogs. Accessed July 8, 2021.

Vainio, Outi, Christina M. Krause, Laura
Hänninen, Aija Koskela, József Topál,
Heini Törnqvist, and Sanni Somppi.
"Nasal Oxytocin Treatment Biases Dogs'
Visual Attention and Emotional Response
Toward Positive Human Facial
Expressions." *Frontiers in Psychology,*
October 17, 2017.

Willett, C., and Phillis Cunnington. *The
History of Underclothes.* New York: Dover
Publications, 1992.

First published in 2022 by
Harper Design
*An Imprint of* HarperCollins*Publishers*
195 Broadway
New York, NY 10007
Tel: (212) 207-7000
Fax: (855) 746-6023
harperdesign@harpercollins.com
www.hc.com

Distributed throughout the world by
HarperCollins*Publishers*
195 Broadway
New York, NY 10007

ISBN 978-0-06-320429-4
Library of Congress Control Number: 2021041652

Book design by Raphael Geroni
Decorative ornaments © shutterstock/AKaiser and shutterstock/bomg

Printed in Thailand

First Printing, 2022

# ABOUT THE AUTHOR

ANTHONY CAVO IS A CERTIFIED APPRAISER of art and antiques and a regular contributor to *Antique Trader* magazine. The son of an antique dealer, he began collecting photographs from the nineteenth and early twentieth centuries at the age of seven. As a boy, he used to trawl neighborhoods in Brooklyn, Queens, and Manhattan with his red wagon, collecting antiques from the curb and selling them at a variety of flea markets—most notably, the 26th Street Flea Market in Manhattan. He used his profits to buy photographs, continuing this pastime through grade school and high school, eventually becoming one of the youngest auctioneers at a New York City gallery. In addition to dealing, appraising, and writing about antiques, he conducts webinars on the subject. He lives in Maywood, New Jersey.